SIDE
WAYS

A SMA
RT AR
T PROJ
ECT

Sideways

A SMART ART PROJECT

The Sideways idea came up in 2006 during a retrospective exhibition for smart. The aim was to formulate the short history of the brand in the context of looking towards the future. The main issue centred on the question: How much future is to be found in the past? Not a particularly exciting project, you might think, for an automobile concept whose roots only reach back to 1970, but during the research into smart's origins, a simple and efficient company philosophy became clear: smart is driven by its attitude of questioning everything. Seen retrospectively, the whole development of today's smart fortwo seems more like a conceptual examination of the future of mobility than simply the development of a new car. This readiness to question everything related to the status quo of contemporary motoring is a consistently central issue for the brand. smart is not just about new technical developments but also about re-examining known facts. For example: in increasing metropolitan traffic situations, is engine power really a deciding factor in how fast we get through town? Where are bigger and bigger cars taking us when we have less and less resources? And why does a car in the city need four seats when on average only 1.3 people occupy each vehicle? It was exactly this questioning attitude and philosophy that provided the inspiration for this book.

THE POWER OF 100 QUESTIONS

Questions bring lasting answers.
If the status quo is to change then we need to ask questions, not give answers. If the success of the smart brand comes from posing creative questions, then why shouldn't creatives with questions about future challenges also be successful? Looking at how humanity handles the environment is the most significant task in the world today. What can be more important than putting the theme of ecology at the centre of attention? The Sideways book is intended to be a product of both this point of view and the power of having a questioning attitude. Sideways' top priority is to ask: who are the creatives that can progressively change the here and now? Many established artists and creatives are already entrenched in society's mores or bound in their thinking to their own creative schema. Both of which often stand in the way of being able to ask simple, fundamental questions. Our search therefore concentrated on the young and the wild, the ones who are not afraid to question the given and who shape the international metropolitan zeitgeist. Let's just call them the creative avant-garde. As a result of our search, 100 of just such freethinking individuals agreed to contribute to the design of Sideways.

THE CREATIVE AVANT-GARDE OF CONSUMER CULTURE

All the collaborating creatives on this project come from the field of consumer culture. They include illustrators as well as stylists, graphic designers, photographers, architects and fashion designers. And — because the environment recognises no national boundaries — Sideways is a global undertaking. Where does one find this creative avant-garde who often work anonymously with no obvious calling cards or search engine entries? The answer is: nowhere more easily than in the opinion-leading mouthpieces of our consumer culture. Thus the Sideways book is a collaboration with eleven of the world's most committed independent trend magazines that, through their constant hunt for the perfect representation of the zeitgeist, represent in themselves a perfect critical platform for contemporary creation. This qualifies them as more than competent curators for this project. On the following pages you will find creative contributions

from Amsterdam, Barcelona, Berlin, London, Mexico City, New York, Paris, Rome, Stockholm, Tokyo and Vienna. The magazines' makers have compiled an international selection of talents showing a highly varied selection of works related to the theme of the environment. Seen together in Sideways, their artworks form a single visionary statement.

The unifying factor in all these different works is that they don't just formulate answers and try and straight-jacket them into texts and images, but pose questions that come from a wide range of disciplines and viewpoints. They are approaches from people who spend their time observing and collecting cultural currents, tendencies and developments. They reflect the zeitgeist and influence it through their work. All are characterised by a feeling of responsibility, because their aim is to co-design the future.

SO FAR AND YET SO NEAR

In contrast to the great distance between the technical world of the automobile industry and the feuilletonistic notion of the zeitgeist, the proximity between smart and the magazines represented here is palpable. Both are bound by a desire to understand what makes the world turn. Both are united by the question: How can we shape our future path in a positive way? To this aim, both have sought out their own cruising radius, since both consider the source of change to lie within our international metropolises, and both believe urbanity to be the hothouse of creativity. This is why we decided to set a creative process in motion with eleven of the world's most creatively influential magazines. The intention is to show that ecological responsibility doesn't just involve tightening belts and going without, but can mean posing questions in the form of artistic statements that in turn help to find solutions. In this respect, smart understands itself as an impulse-giver, initiator and patron

who values the opinion of the creative avant-garde. This is why we believe that the contents of this book serve not as aesthetic ends in themselves, but as inspirational material.

CARS AND CREATIVITY

When the history of the smart brand began, two companies lent it their names: the former brand partner christened the little automobile the Swatch Mercedes Art Car and then shortened its name to s-m-art. Of all the twists and turns taken by smart in its (thus far) short but richly varied history, the car never adopted a retro-character and always sought to follow brave new paths. Sideways is a product of this history and as a project goes well beyond the boundaries of this book.

Many of the works collected here don't just take place between these pages but will also be seen all over the world in magazines and exhibitions. This book only gathers together some of the results of what is an international process along with part of a philosophy that keeps asking questions instead of just giving answers. This shared attitude and continuous association with contemporary creative spirits are the reasons why smart will always be more than just a brand of automobile.

»ECOLOGICAL ATTITUDE IS A REFLECTION OF THE SPIRITUAL AND INTELLECTUAL BALANCE OF A HEALTHY, CLEAN AND POSITIVE MIND. IT'S ALL IN OUR HEADS. EVEN THE SOLUTION. LET'S CLEAN OUR HEADS. LET'S CLEAN THE WORLD.«

Neo2 was founded in the early nineties in Madrid by Ramón Fano, Rubén Manrique and Javier Abio. The magazine started out as a hard-to-find and rather obscure small fanzine printed in two colours called Neomania. It was a cult object, no one knew when the next issue was coming out or in what strange venue the launch party was going to be held. The magazine's unique format soon attracted a following amongst the curious and the adventurous. Its pages were full of innovative graphic and conceptual ideas and the publication rapidly became a reference and source for the new cultural concepts multiplying both in Spain and internationally. But it wasn't only a case of 'right place, right time', Neo2 had then – and still does today – strong back-up in the form of the creative studio Ipsum Planet, a group of graphic designers and creatives, which also arose from the underground club culture back in the nineties, with a long list of fashion catalogues and advertising campaigns under their collective belts.

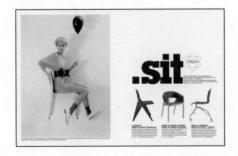

With time, Neo2 has evolved in every aspect and it's certainly not a small fanzine anymore. Almost fifteen years on it has not only grown in format size, but also in both quality and quantity. Today it is a monthly publication with a large print run, worldwide distribution and contributors from all over the globe. The only thing that hasn't changed from its early days is its philosophy to promote new cultural trends and new creatives.

Neo2's main aim is to be a window for new creatives of all disciplines, from photographers, artists, architects and fashion designers to industrial designers, film directors, actors, makeup artists, illustrators, musicians, writers, stylists and so-on. Above all the magazine is a showcase for new ideas, regardless of whether they come from a young professional or a well-established name or a brand. For the makers of Neo2, it's the ideas that matter, not who signs them. Neo2 also functions as a platform showcasing work from innovative and creative Hispanic and Spanish talents, giving them an opportunity to show their work to a broad international audience that is the Neo2 readership.

The magazine is mainly focused on fashion and design, but also explores other aspects of life such as art, music, gastronomy, films, new technologies, life styles, etc.

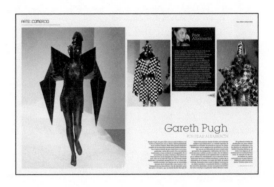

The formal aspect of the magazine is a good example of the philosophy of renovation and recycling – its design and editorial sections are undergoing a constant process of re-invention, with typography design being one of Neo2's main creative exponents. It is these principles that have given Neo2 its distinctive reputation amongst the international array of trend magazines – a fact that has become evident with its recent European expansion. Neo2 already has a special edition for the Portuguese market, making it the first Spanish trends publication to export its title to another country. This is a growth process that aims to consolidate itself in other places. Just like all great social changes and achievements, this will happen in small steps – just like Neo2.

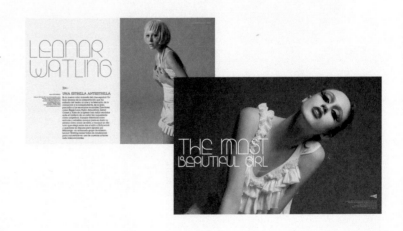

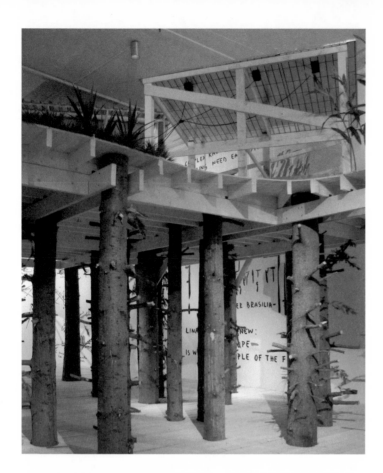
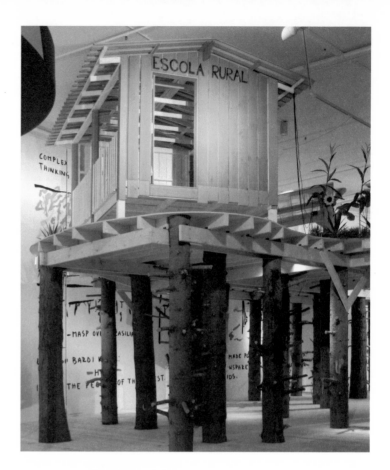
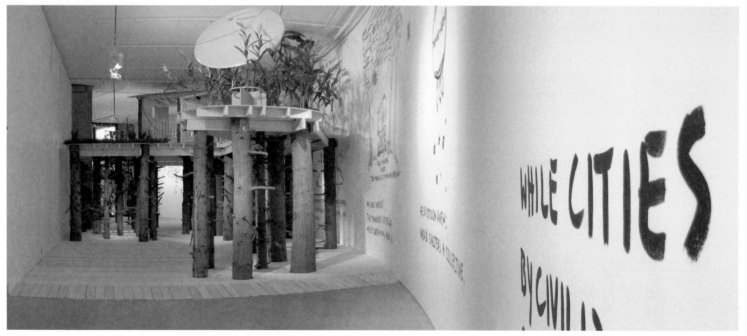

Forest Rising, 2007
A rural school, equipped with satellite dish and solar panels, stands on an island elevated by tree trunks. Visitors walk beneath a satellite, the elevated island and a helicopter platform. The project is based on practices developed by Amazonian communities in Brazil in response to the most pressing social, economic and environmental concerns of the 21st century. Their ideas for the future include the development of small-scale economies, a new citizenship, the University of the Forest, the protection of knowledge, the protection of territories, and global connectivity.
Forest Rising: Tree trunks, building materials, energy and communication infrastructure. The Curve, Barbican Art Gallery, London.
Commissioned by the Barbican Art Gallery, London. Photo by Lyndon Douglas.

Marjetica Potrč

Artist's origin: Slovenia
Profession: Artist and architect
Galleries. Barbican Art Gallery, London. Galerie Nordenhake, Berlin. Max Protetch Gallery, New York.

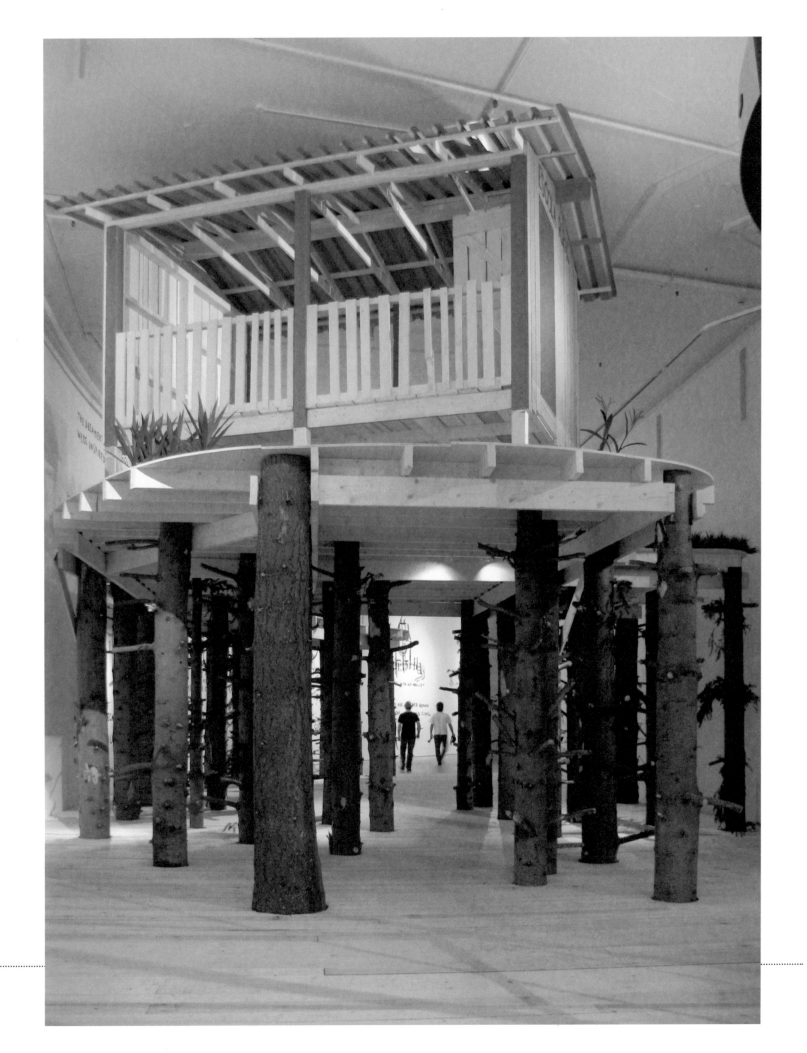

Pepa Prieto

Artist's origin: Spain
Profession: Artist

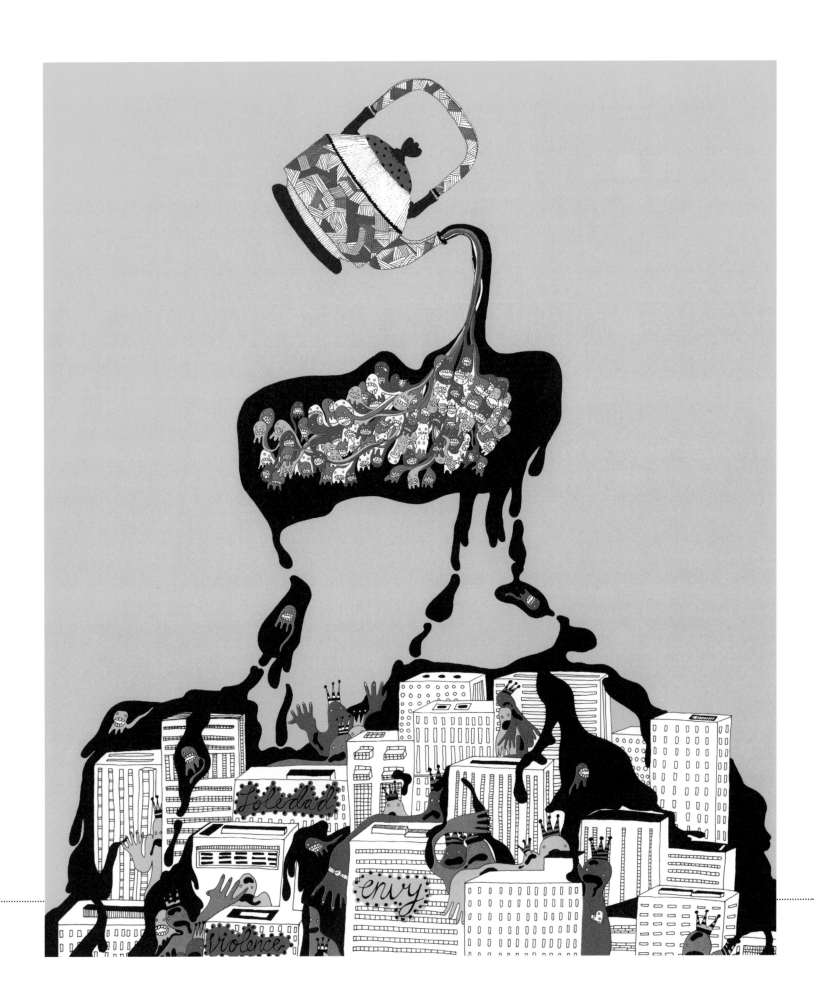

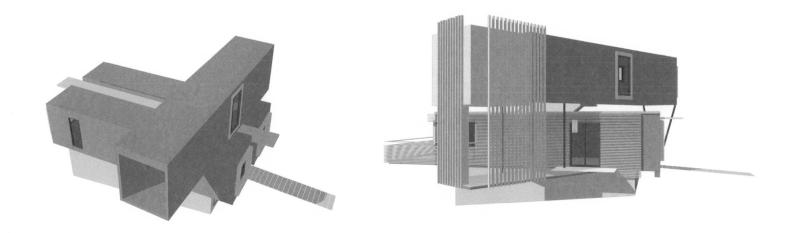

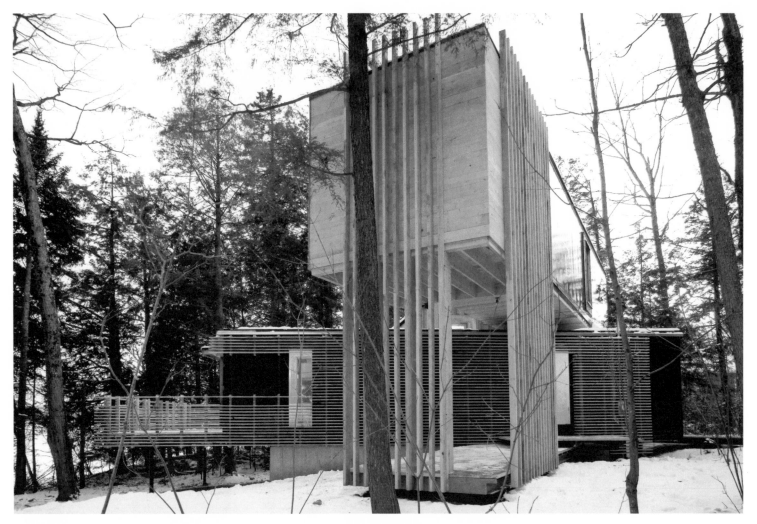

Chalet du chemin Brochu
A Pierre Morency Architecte's country house built using containers, that doesn't look it. This project won a bi-annual Excellence Award from the Quebec Order of Architects. The container house is in the $150,000 or less category.

Pierre Morency

Artist's origin: Canada
Profession: Architect

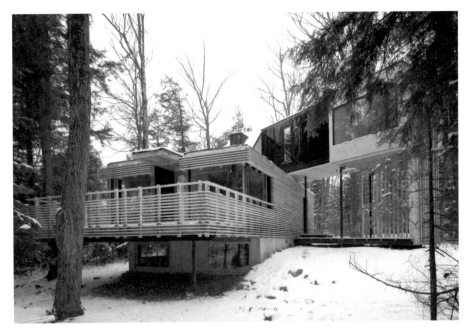

THE SMART BROWN FOX JUMPS OVER THE LAZY DOG.

Ipsum planet

Artist's origin: Spain
Profession: Graphic designers

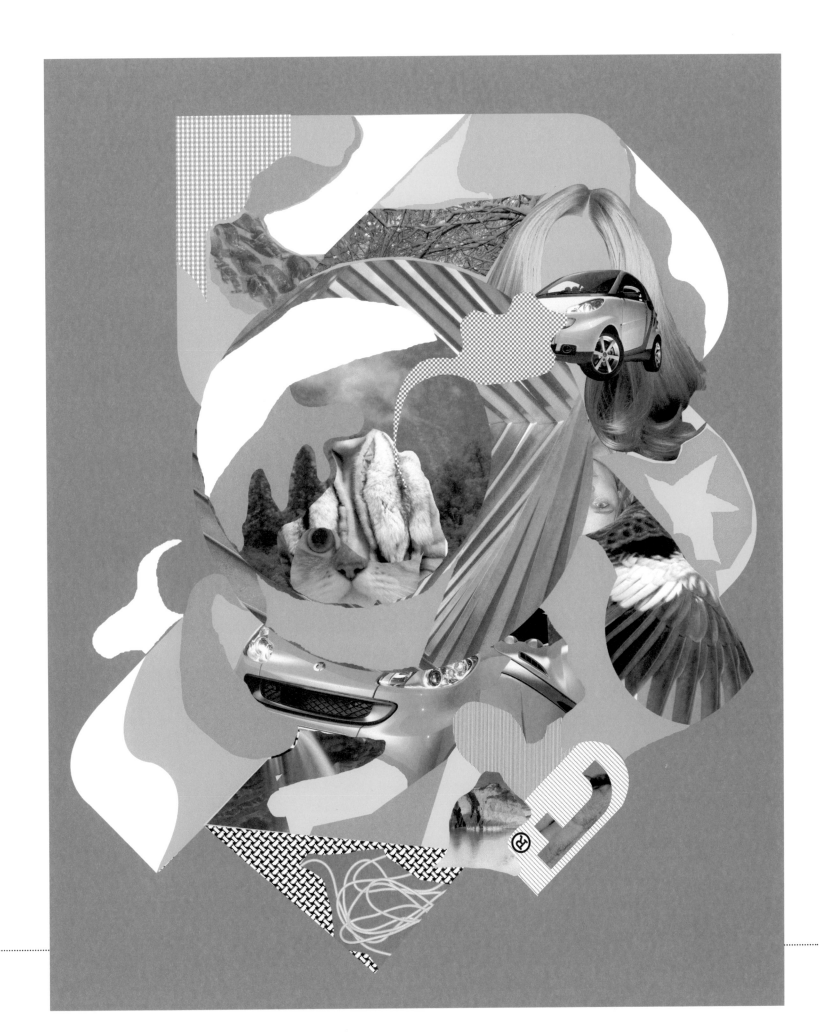

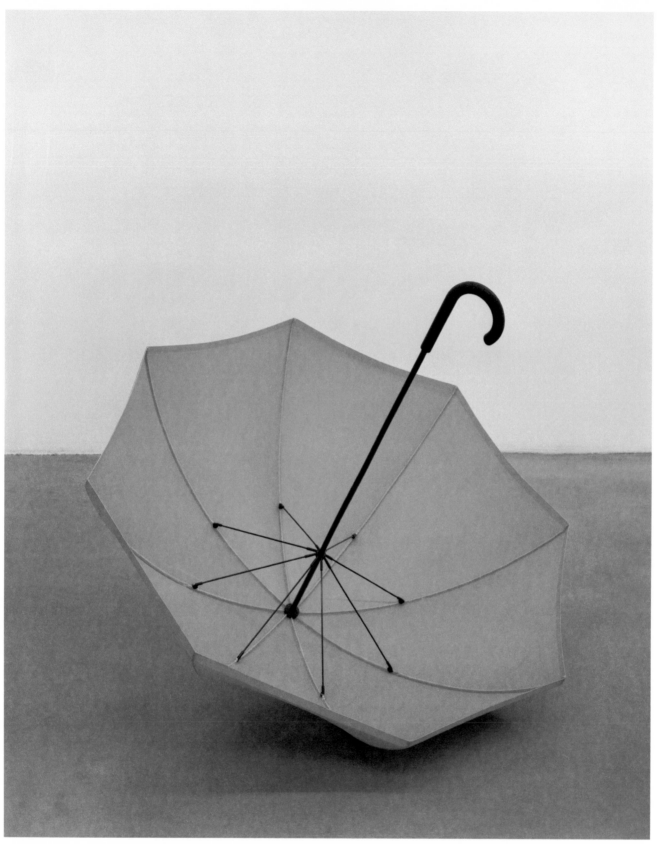

Top: Bulletproof umbrella, 2006
Kevlar, grafito, ABS rapid-prototyped polymer 91,4 x 91,4 x 83,8 cm.
Right: Cloud Prototype No.2, 2006
Fibra de vidrio y aleación de titanio 145.5 x 245.5 x 259.1 cm.

Iñigo Manglano-Ovalle

Artist's origin: Spain
Profession: Artist
Gallery: Soledad Lorenzo, Madrid.

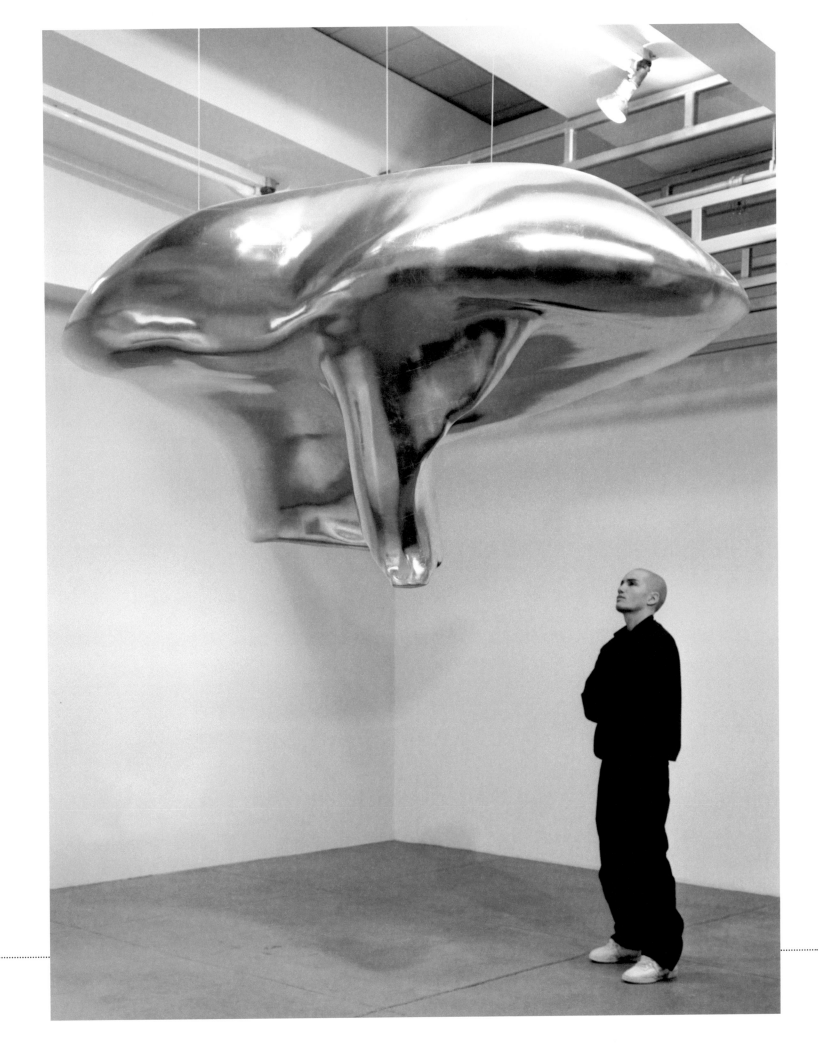

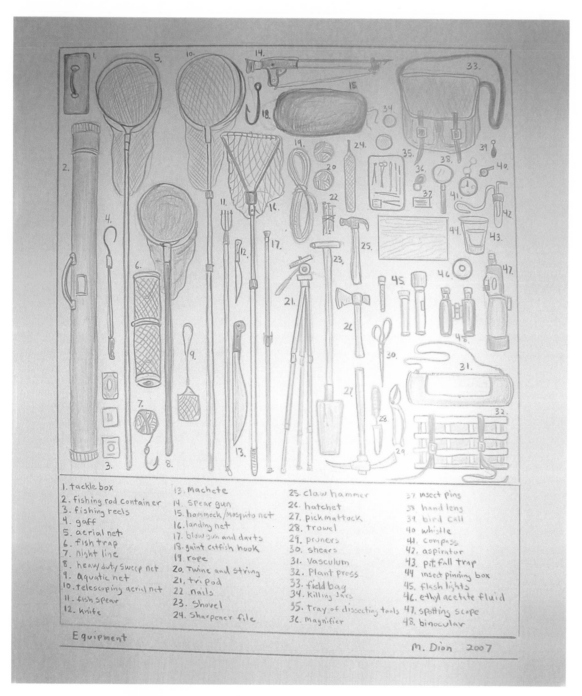

1. tackle box
2. fishing rod container
3. fishing reels
4. gaff
5. aerial net
6. fish trap
7. night line
8. heavy duty sweep net
9. aquatic net
10. telescoping aerial net
11. fish spear
12. knife

13. Machete
14. Spear gun
15. hammock/mosquito net
16. landing net
17. blow gun and darts
18. giant catfish hook
19. rope
20. Twine and String
21. tripod
22. nails
23. Shovel
24. Sharpener file

25. claw hammer
26. hatchet
27. pickmattock
28. trowel
29. pruners
30. shears
31. Vasculum
32. Plant press
33. field bag
34. Killing jars
35. Tray of dissecting tools
36. Magnifier

37. insect pins
38. hand lens
39. bird call
40. whistle
41. compass
42. aspirator
43. pit fall trap
44. insect pinning box
45. flash lights
46. ethyl acetite fluid
47. spotting scope
48. binocular

Equipment

M. Dion 2007

Top: Equipment
Red and blue pen on paper, framed. 38,3 x 32,3 cm. Courtesy In SITU abienne Leclerc, Paris.
Photo: Carole Lamour
Right. Iceberg and Palmtrees
Teddy Bear, tar, plastik plants, tightener, aluminium box, wood crate 330 x 170 x 100 cm. Courtesy In SITU
Fabienne Leclerc, Paris. Photo: Rebecca Fanuele

Mark Dion

Artist's origin: U.S.A.
Profession: Artist
Gallery: In SITU Fabienne Leclerc, Paris.

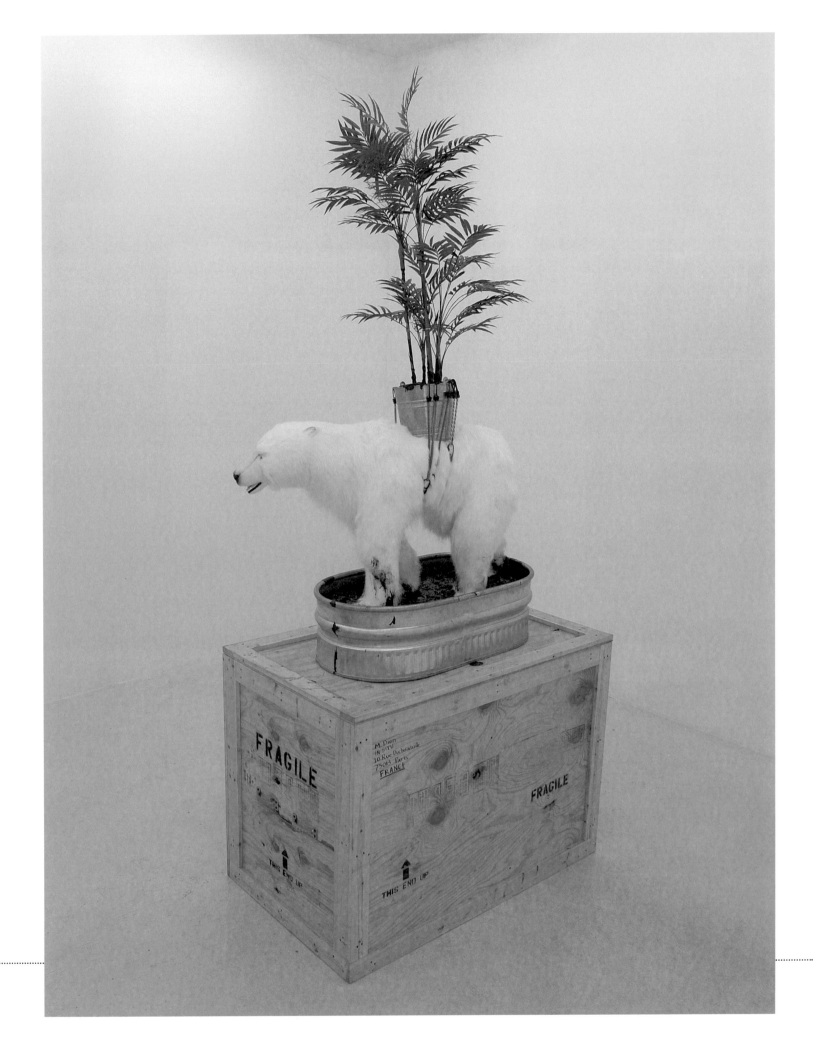

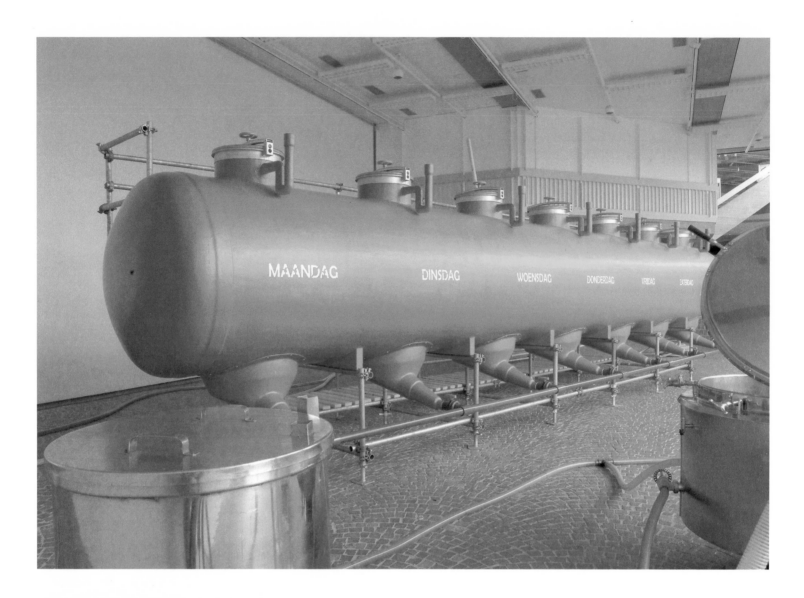

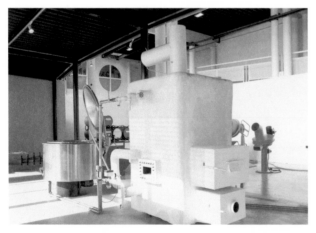

The Technocrat, 2003-2004
The Technocrat is a closed circuit of food, alcohol, excrement, and energy. In this system,
the human (burgher) is the biological cogwheel that generates enough raw material to produce valuable
biogas that is used to cook the food and produce alcohol to keep the humans functioning. The Technocrat
consists of four parts:
The Burghers: For the correct functioning of the Technocrat 1000 burghers are needed. The burghers are
efficiently stored in large bunkbeds. According to the supply of burghers and the availability of food their
lifespan can be manipulated.
The Total Faecal Solution: The Total Faecal Solution recycles human excrement in a maniacal way. The
excrement is sucked out of the burghers by vacuum power and pumped into the two biogas digesters, where
the slurry is mixed and heated. Under these special conditions, methane gas is produced by specific bacteria.
The gas is cleaned, dried and stored in the gas-o-meter for later use: cooking and distilling.
The Feeder: This machine produces and administers cheap food that generates a maximum output of feaces.
Calculate menu based on available ingredients and desired life expectancy of the burgher.
The Alcoholator: In order to keep the Burghers satisfied, alcohol should be administered. Making alcohol is a
two-step process: first you make a mash of an ingredient with high sugar or carbohydrate content and by
fermentation it is transformed into a liquid that contains approximately 15% alcohol. The distillery is used to
purify and increase the alcohol content to 96%.

Atelier Van Lieshout

Artist's origin: The Netherlands
Profession: Artist
Galleries: Tanya Bonakdar, New York. Distrito Cu4tro, Madrid. Gallery Krinzinger, Vienna. Tim Van Laere
Gallery, Antwerp. Albion Gallery, London. Gió Marconi, Milan...

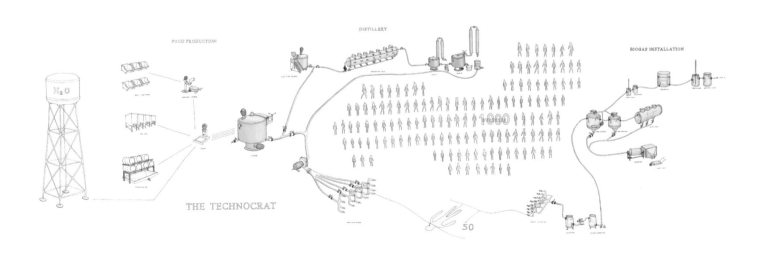

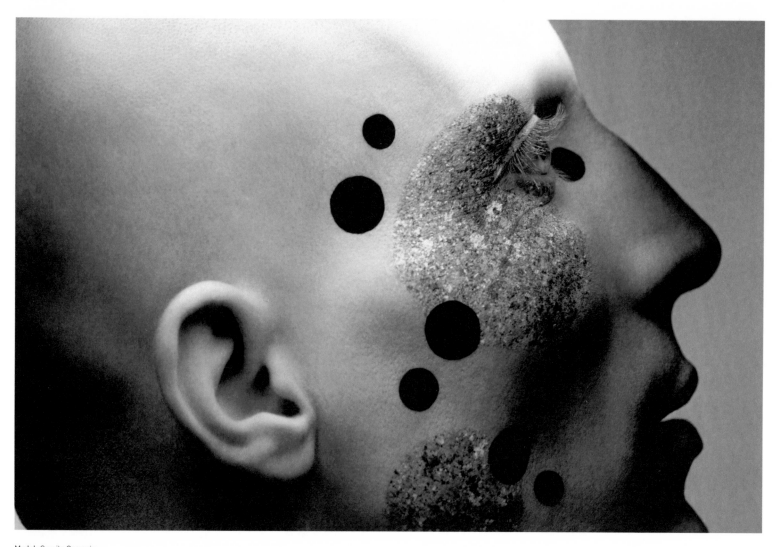

Model: Camilo Germein
Photographer Assistant: Richard Ramos
Hair: Daniel Martín
Digital Retouch: Paz Otero
Digital Assistant: Cristina Durán

MAKE UP ARTIST: **LEWIS AMARANTE (Max Factor)**
PHOTOGRAPHER: **EUGENIO RECUENCO**
TITLE: **BELLEZA DE CAMILO I & II**
COUNTRY: **SPAIN**

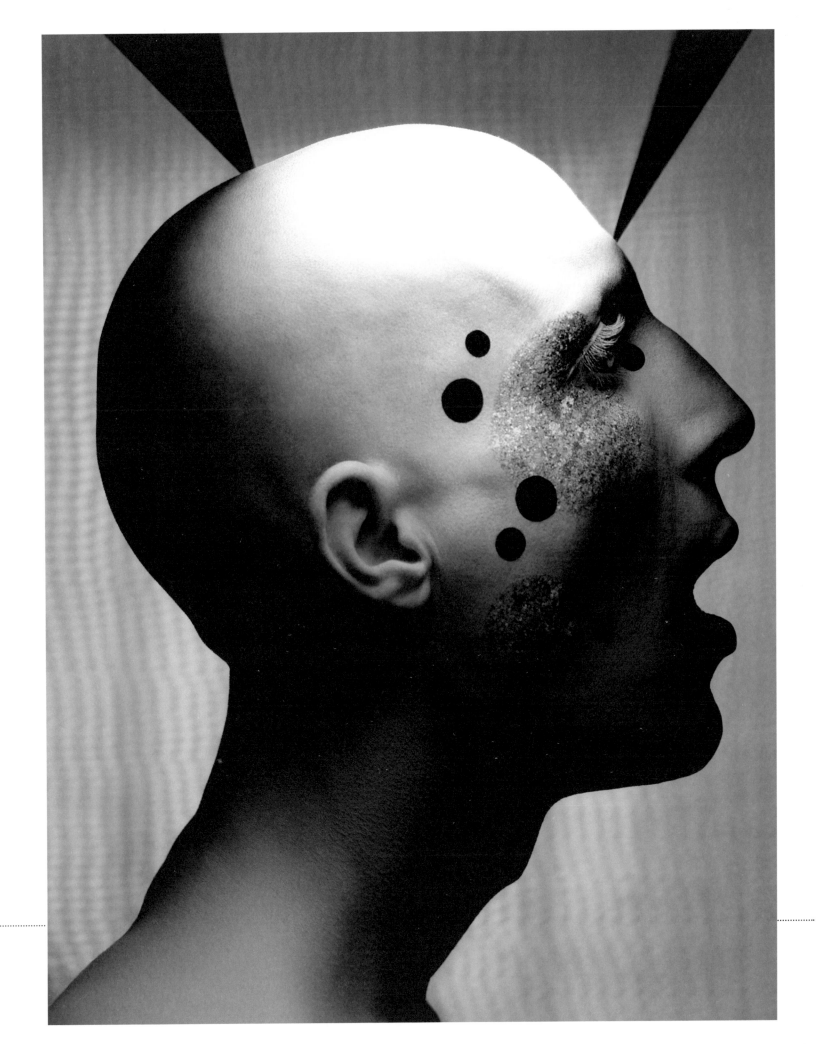

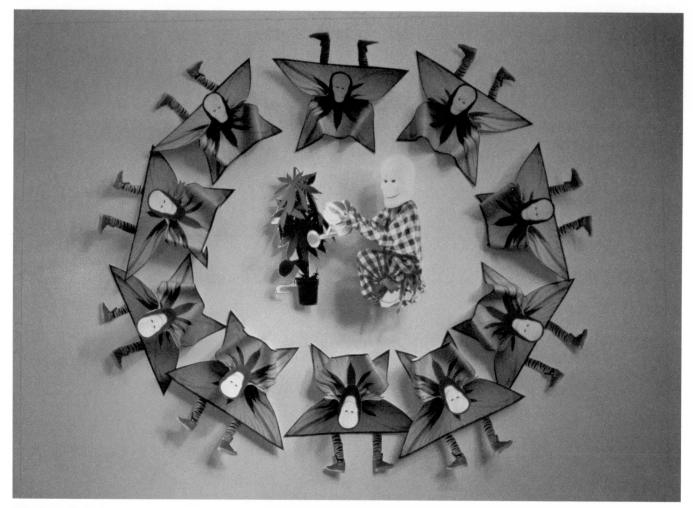

Styling: Damien Blottière
Mask: Caroline Melzig Thiel

FASHION DESIGNER: BERNHARD WILLHELM
TITLE: WOMEN COLLECTION AUTUMN/WINTER 2007/2008
COUNTRY: GERMANY

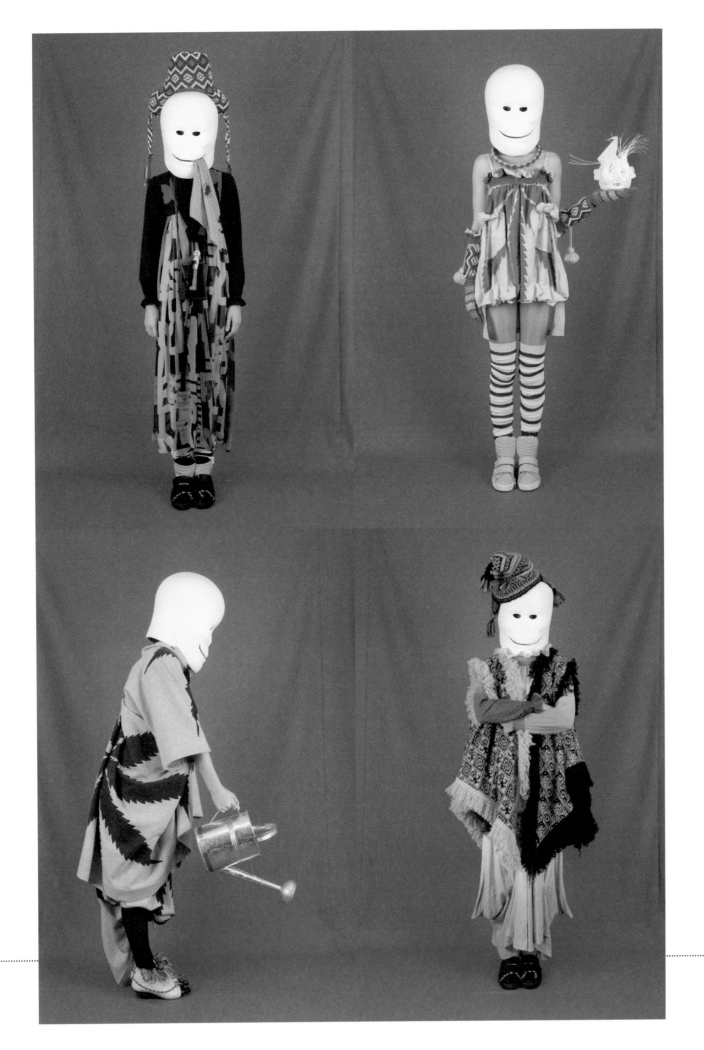

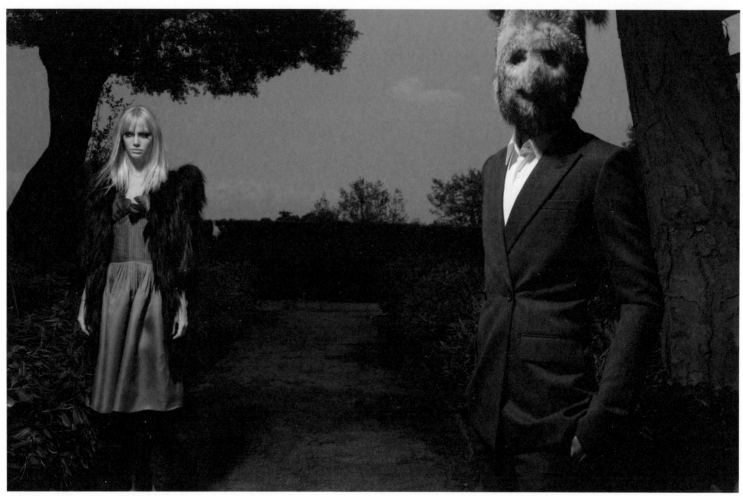

Masks: Lenfanterrible
Make up artist: Luna
Hair: Carol Guzmán
Photographer assistant: Marcel Batlle
Digital retouch : Natalia Falagán
Lights: J.M.
Models: Elisa Raats & Asa (Francina)

STYLIST: CARLOS DIEZ DIEZ
PHOTOGRAPHER: JM FERRATER
TITLE: LA NOCHE DE LOS CAZADORES PASIVOS
COUNTRY: SPAIN

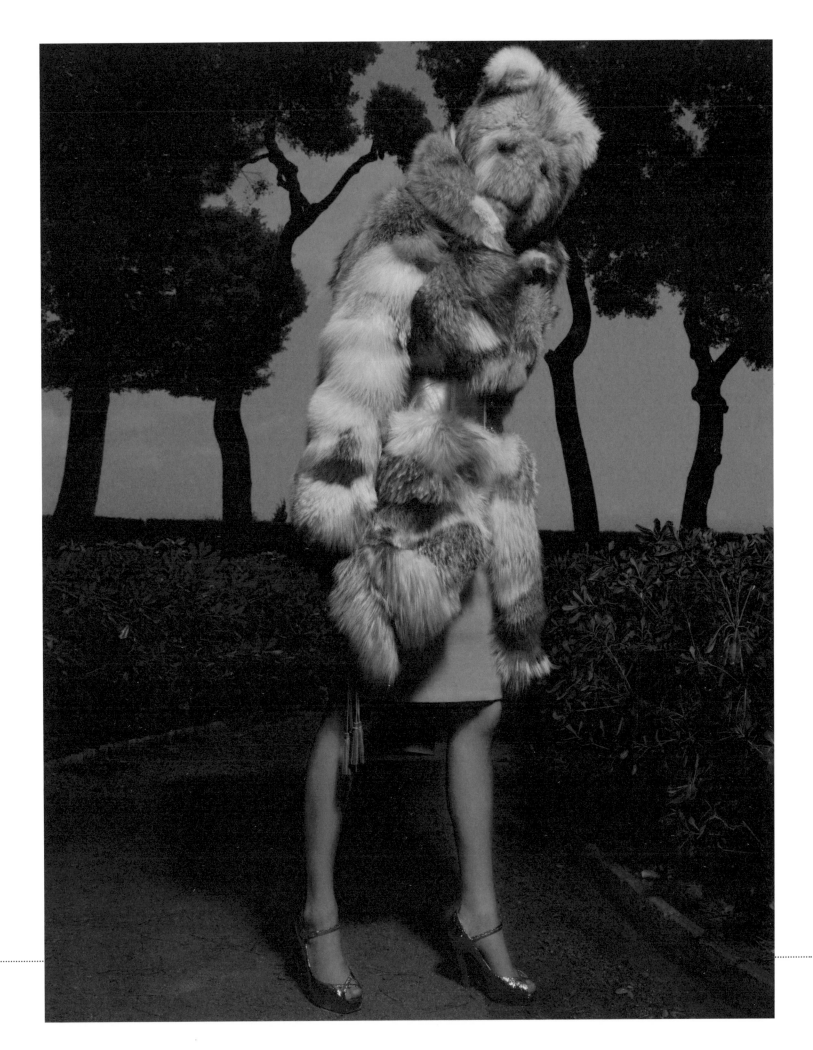

INDI
E

»WE MUST NEVER FORGET THAT WE HAVE ONLY BORROWED MOTHER EARTH FROM AL GORE AND NOW, AT THE ELEVENTH HOUR, HER CHILDREN ARE DESTROYING THEIR MOST PRECIOUS POSSESSION … OR SOMETHING LIKE THAT. IN OUR VIEW, THE ECOLOGY THEME OF SIDEWAYS OFFERS ARTISTS A WHOLE RANGE OF WAYS IN WHICH TO FORMULATE THEIR OWN PERSONAL COMMENTS, BEYOND THE USUAL CLICHÉS AND PLATITUDES, AND PRESENT THEM AS INDIVIDUAL STATEMENTS.«

Founded in 2003 by Editor-in-Chief Kira Stachowitsch and Publisher Clemens Steinmüller as the first international style magazine from Austria, INDIE has carved a niche for itself by bringing a dynamic, unorthodox and independent perspective to its editorial style. INDIE fuses the work of emerging artists from the fashion, music and cultural scenes with that of the established 'old guard' to create unconventional features issue after issue. This coupled with fashion editorials by internationally recognized photographers, stylists and make-up artists are all vital elements of INDIE magazine.

The stripped-down graphic style of INDIE is distinctive without overwhelming the magazine's powerful photographic images and embodies each editorial with a striking aesthetic.

Central to the magazine's vision has always been an understanding of the unbreakable bond between music and fashion. Each issue celebrates the connection between these two realms of the arts in fashion editorials featuring some of the most exciting up-and-coming musicians styled in designer pieces from haute couture to streetwear. It is an exploration of the interconnectedness of music and fashion, a ceaseless bond evident from the Teddy Boys and Girls of post-war London to the emaciated indie rock star looks on Dior Homme's catwalks.

In order to illustrate the personal perspectives and viewpoints of people working inside the fashion industry, INDIE features guest editors from significant names in the world of fashion who are given free rein to write about a topic of their choosing. Previous contributors have included fashion designers Stephan Schneider and Anne-Sofie Back as well as the photographer/publisher Rankin.

Each issue of INDIE includes an unconventional editorial 'Special' based around a chosen theme that is set apart from the areas of fashion and music. Beautiful, arresting illustrations created by contributing artists are presented as stand-alone pieces of artwork in the Special. Previous Special topics have included hotels, groupies and romance novels. Whilst the Special's subject areas differ greatly, they are connected in each issue by their inclusion of off-beat literature and accompanying visuals.

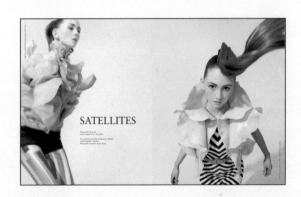

The 250 to 300-page magazine is published quarterly in English and German. With a total circulation of 55,000 INDIE is distributed in magazine and bookstores throughout the UK, France, Italy, Germany, Spain, Sweden, Austria, Switzerland, Belgium, The Netherlands, Luxembourg, Turkey, USA, Canada, Australia, Taiwan, Hong Kong and Japan.

INDIE is published by plastic media in Vienna, Austria, which is also the publishing house of material girl, a new, avant-garde, luxury magazine for girls of all ages.

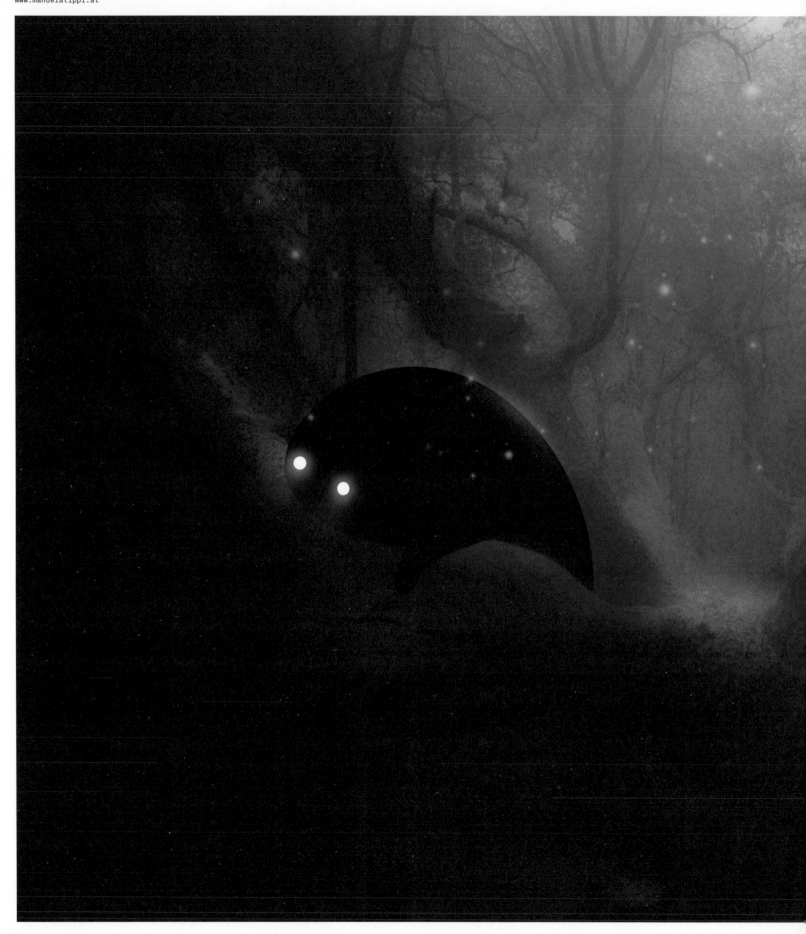

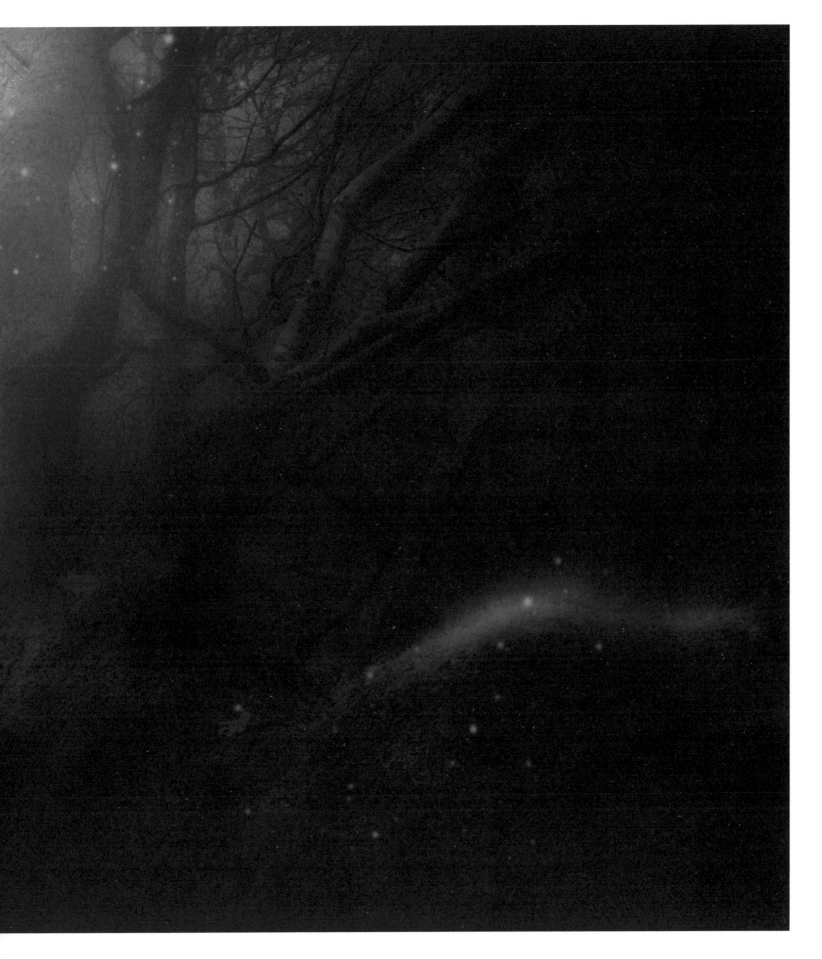

NETROPOLIS | DUBAI
Michael Najjar, Artist, Germany. 2006, 120 x 180 cm, Courtesy of the artist and bitforms gallery New York
www.michaelnajjar.com, www.bitforms.com

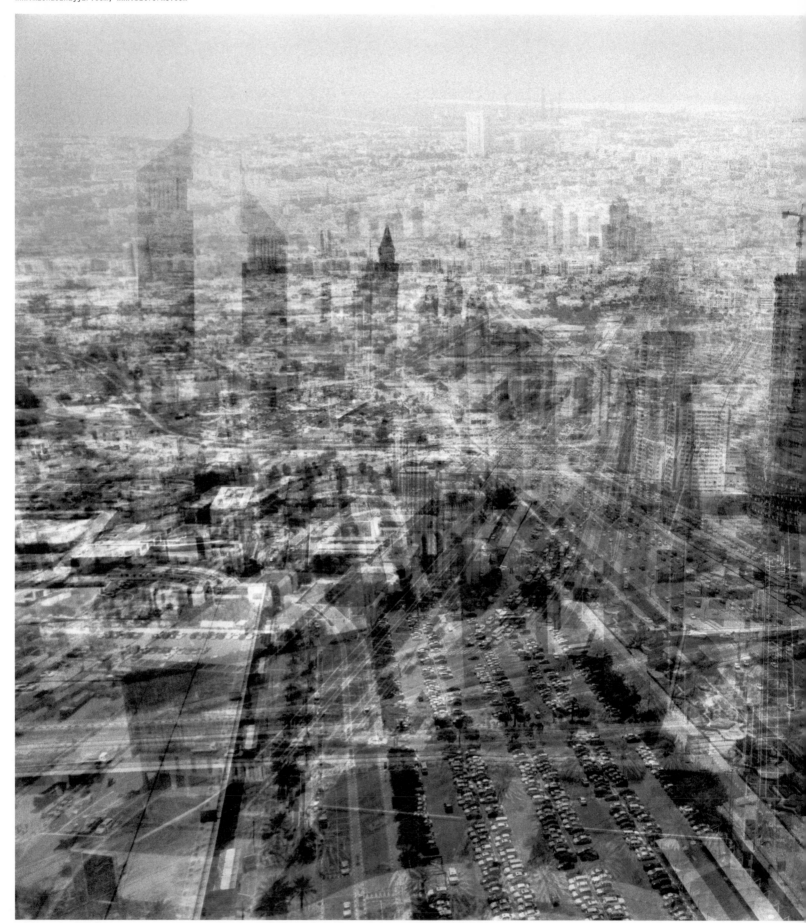

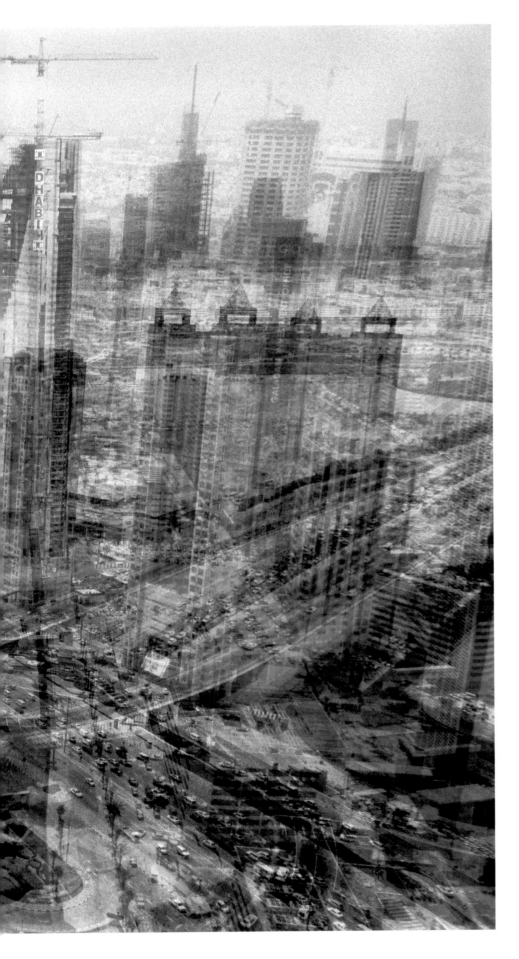

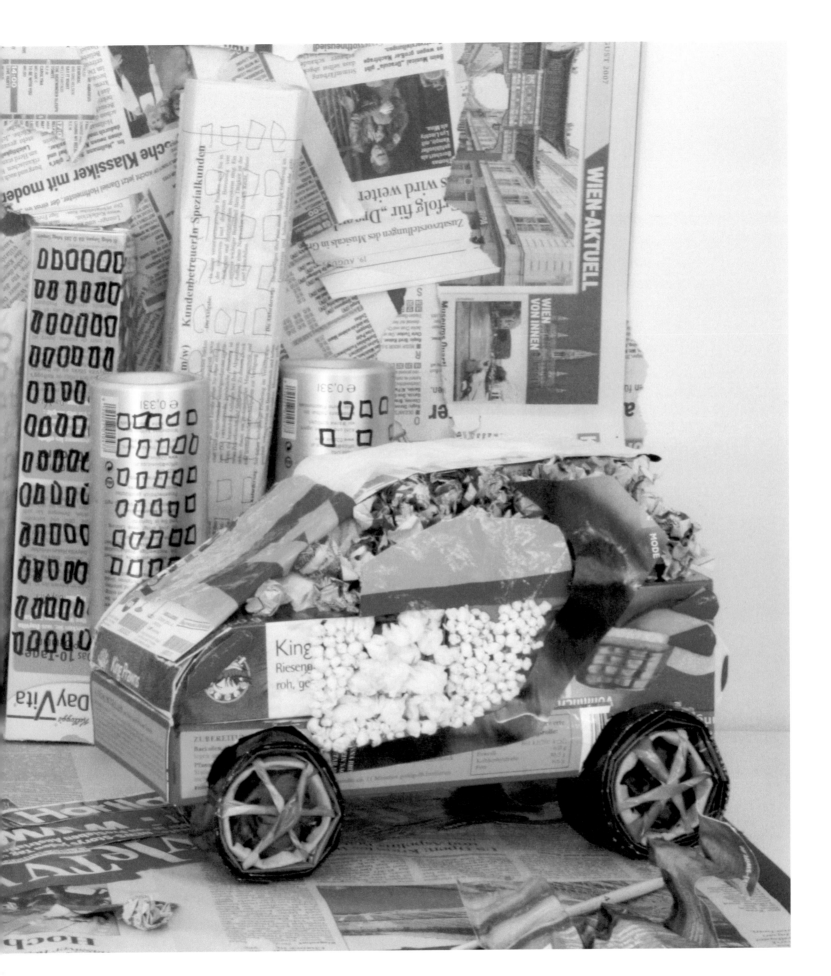

SPINNING AROUND
Kristina Feuchter, Artist, Austria
www.memyselfandi.at

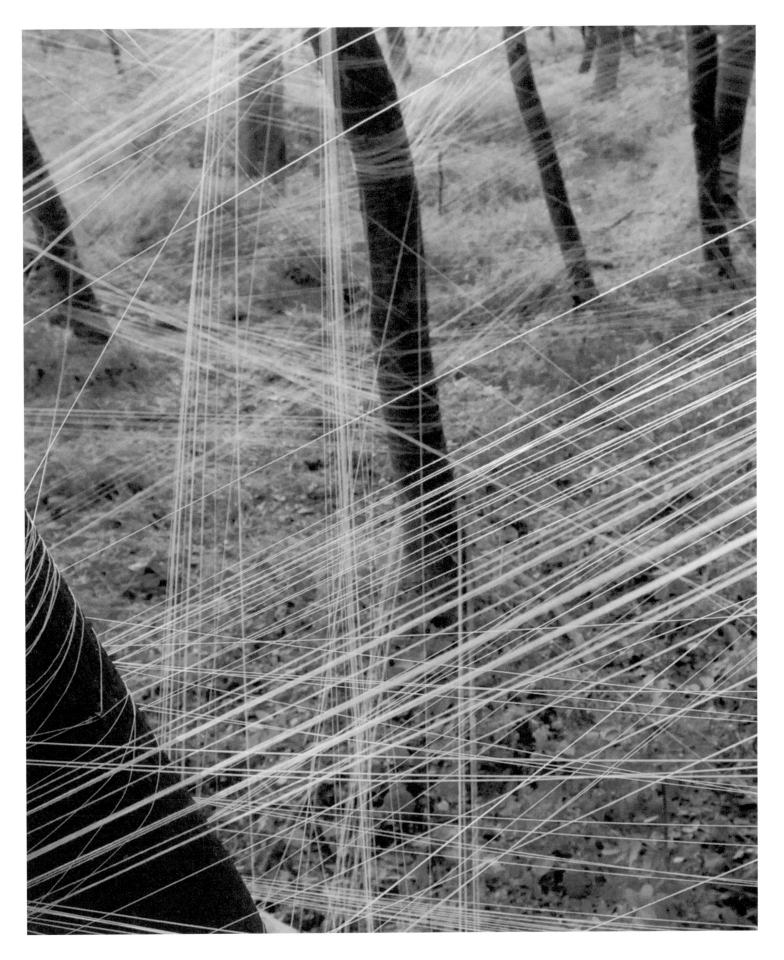

BLACK FISHLETS 3 & 4
Sylvie Proidl, Visual Artist, Austria. Topic: Rainforests and the culture of indigenous peoples
www.sylvie-proidl.com

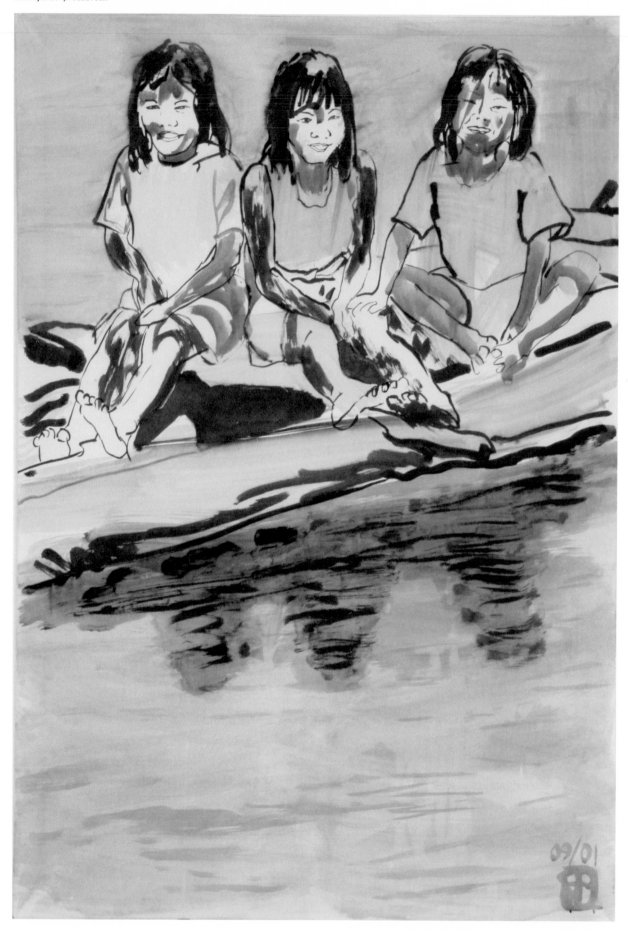

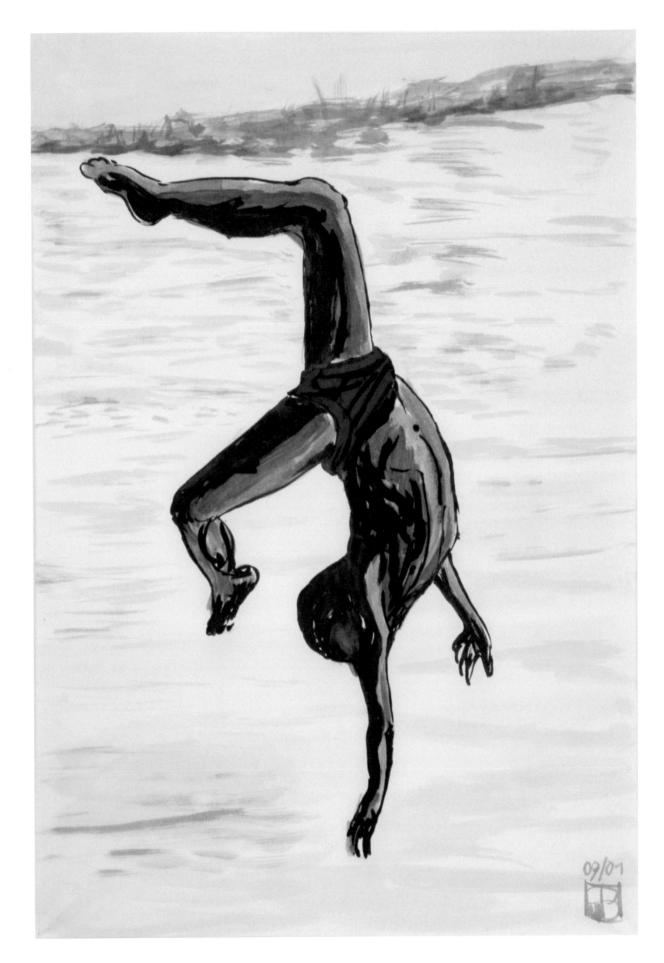

09/01

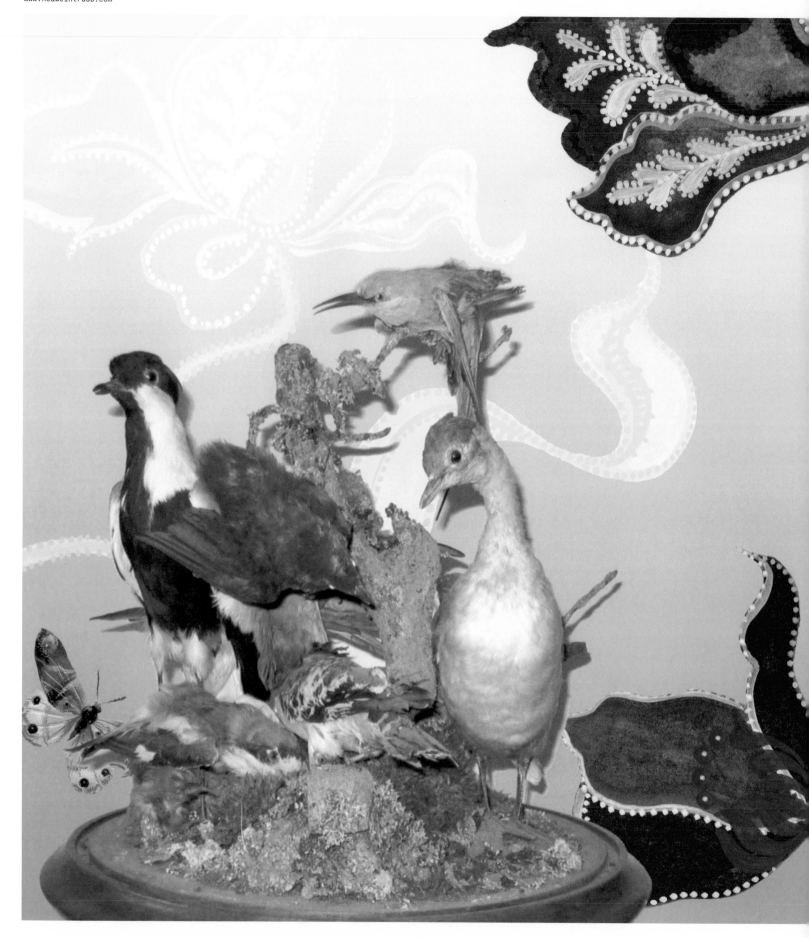

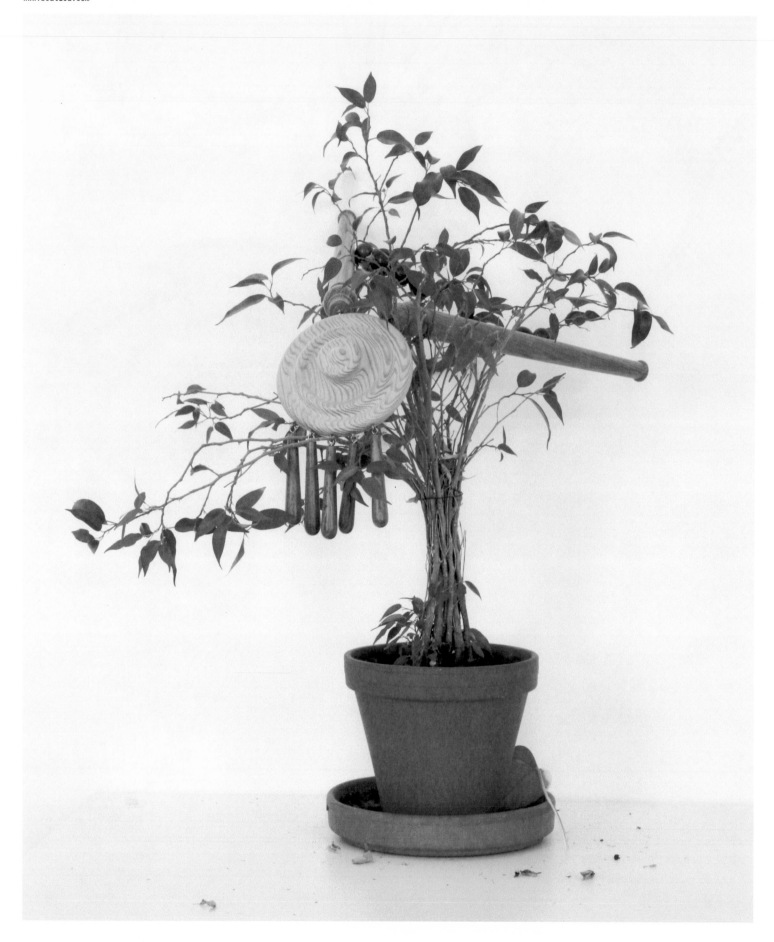

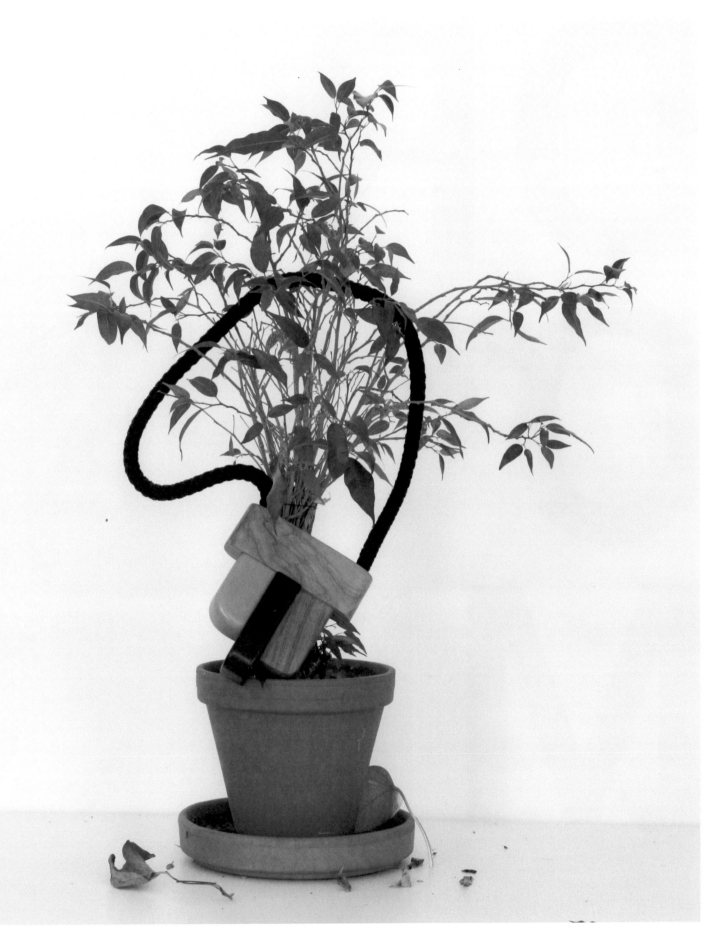

DR
O
ME

»IF CULTURE MEANS ACTIVATING THE MIND AND CREATING AND CIRCULATING THOUGHTS, THEN A FORWARD-LOOKING MAGAZINE WITH CERTAIN IDEALS, LIKE DROME, CANNOT IGNORE THE PROBLEM OF POLLUTION OR ECOLOGICAL CAMPAIGNS. IN FACT ART, AS WELL AS SCIENCE, ECONOMICS, POLITICS AND PHILOSOPHY, CAN AND MUST INTERPRET ITS OWN AGE, ACTING RESPONSIBLY TO SUSTAIN THE STRUGGLE TO ACHIEVE HARMONIOUS COHABITATION BETWEEN HUMAN BEINGS AND NATURE. THIS IS AN OBJECTIVE THAT CANNOT BE PUT OFF ANY LONGER. TO QUOTE MICHELANGELO PISTOLETTO, "SURVIVAL IS AESTHETICAL, ETHICAL AND PHYSICAL". THEREFORE WE ARE INTERESTED IN CREATIVE PROJECTS THAT ARE LINGUISTICALLY VERSATILE AND RELEVANT, AIMED AT ENCOURAGING SUSTAINABILITY. THE SPIRIT THAT GUIDED OUR CONTRIBUTION TO SIDEWAYS INVOLVED ESTABLISHING A CONNECTION BETWEEN LANGUAGES AND DIFFERENT PERSPECTIVES IN ORDER TO OBTAIN THE WIDEST POSSIBLE FRAMEWORK OF POSITIONS CONCERNING THE ENVIRONMENT AND SOCIAL RESPONSIBILITY.«

DROME magazine is an ongoing, cutting edge, quarterly magazine project and a leading name in the new generation of contemporary art magazines. It is engaging and crosscutting; independent and conscientious; elegant and tongue-in-cheek; glossy and alternative; poetic and bold. Its strong editorial content combines art, design, photography, literature, fashion, cinema, music, video, theatre, dance and architecture. Monothematic with multiple perspectives, each issue is dedicated to a timeless subject – such as Nomadism, Faith, Game, Food, Frontier, etc. – and contains in-depth features, a cross-section of articles plus experimental graphics and fashion shoots.

Based in Rome, DROME was launched in Italy in June 2004. It is bilingual (Italian/English) and distributed worldwide. The magazine was founded by the Italian journalist Rosanna Gangemi and the French-Austrian graphic designer Stefan Pollak. Together they set out to create an innovative magazine with a hip Italian perspective and twist, whose content stimulates the reader into discovering how and where the contemporary arts cross paths.

Celebrating creativity in all its forms, DROME is a meeting place for some of the most groundbreaking artistic experiences happening in the world today. It aims to be both a prestigious platform for artists and journalists, and a reliable medium through which art is accessible to everyone. In the short time since its launch it has grown to become a key reference source documenting the best of the contemporary arts scene, discovering new talents, investigating special themes and understanding the complexity of today's society through art.

Each issue is a unique combination of experiments, explorations and collaborations. Photo editorials showcase the hottest photographers of today and the best of what's coming tomorrow. Fashion is approached as an art form. Artwork is created by big name illustrators as well as emerging talents. Articles are written by established journalists and scholars, but also by promising young reporters. The magazine's many incisive and revealing interviews with some of the most renowned artists and maîtres à penser of our times are also one of DROME's trademarks.

DROME has recently begun to team up with various cultural organisations in a wider role as promoter or partner for an increasing number of events and projects. These include thematic parties, special publications, exhibitions, conferences and awards – all with an eclectic feel that reflect the multi-faceted nature of the magazine itself. The magazine is also present at the most important contemporary art, photography and fashion fairs worldwide.

DROME believes in spreading culture, that is why it is also the first Italian culture magazine to support the copyleft movement. DROME offers exclusively, copyleft articles, i.e. it allows entire texts or parts of them to be reproduced and distributed in any way, provided it is not for commercial gain and as long as the source and author are quoted.

DROME's international interest in the discovery and presentation of emerging artists as well as its support of more established personalities can also be seen in its selection for the Sideways project. The works presented here range from photography (Karin Andersen, Silvia Camporesi, casaluce-geiger, Christian Rainer), to graphic design (Rubens Lp), painting (Native & ZenTwo), stencil (Sten) and digital collage (Zaelia Bishop, Fernanda Veron).

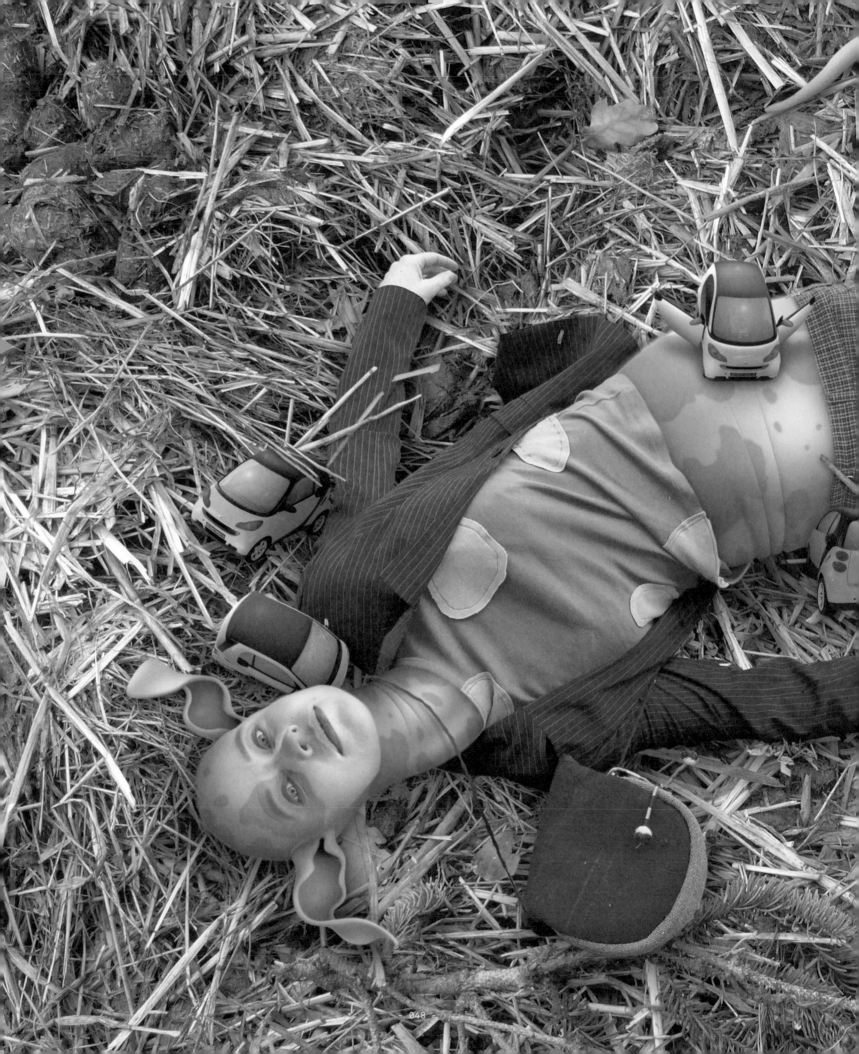

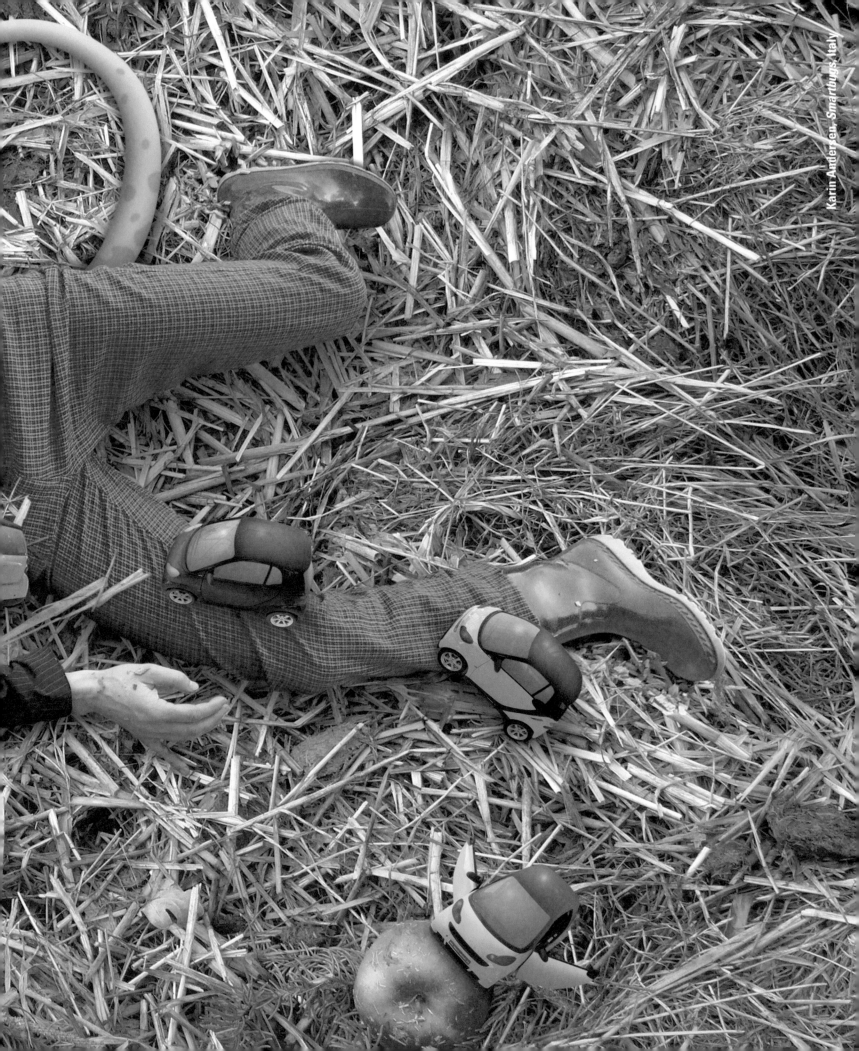

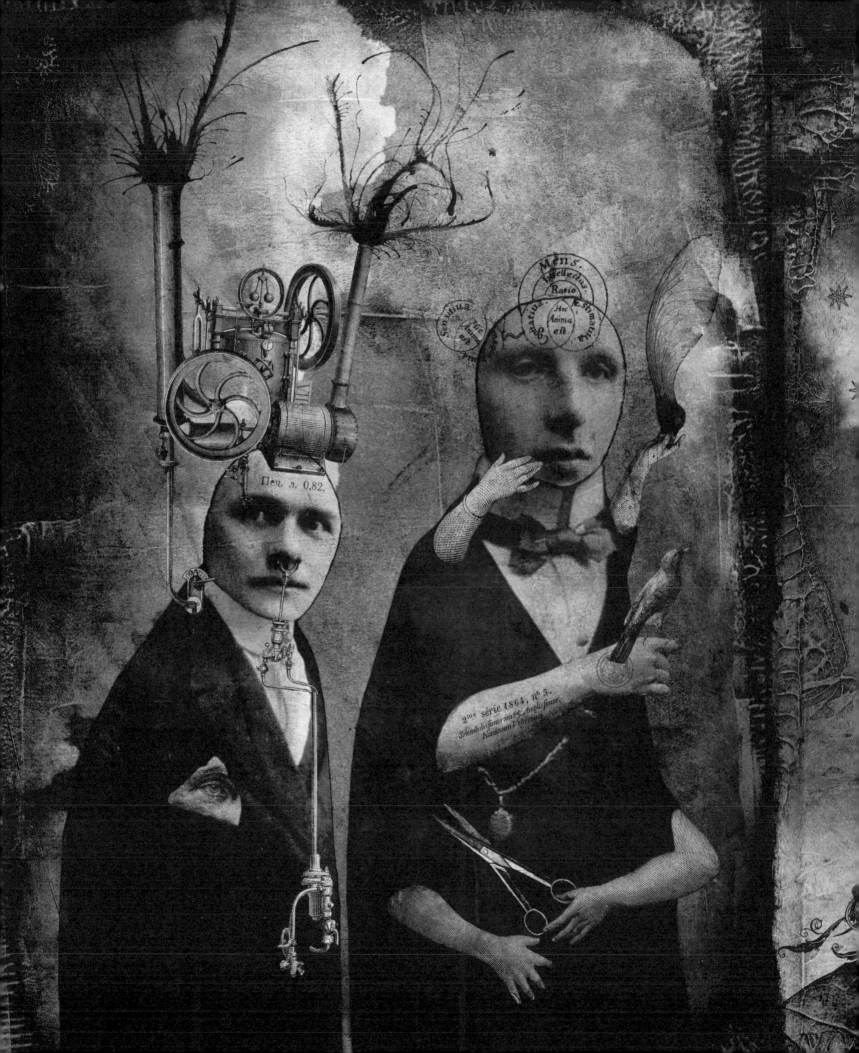

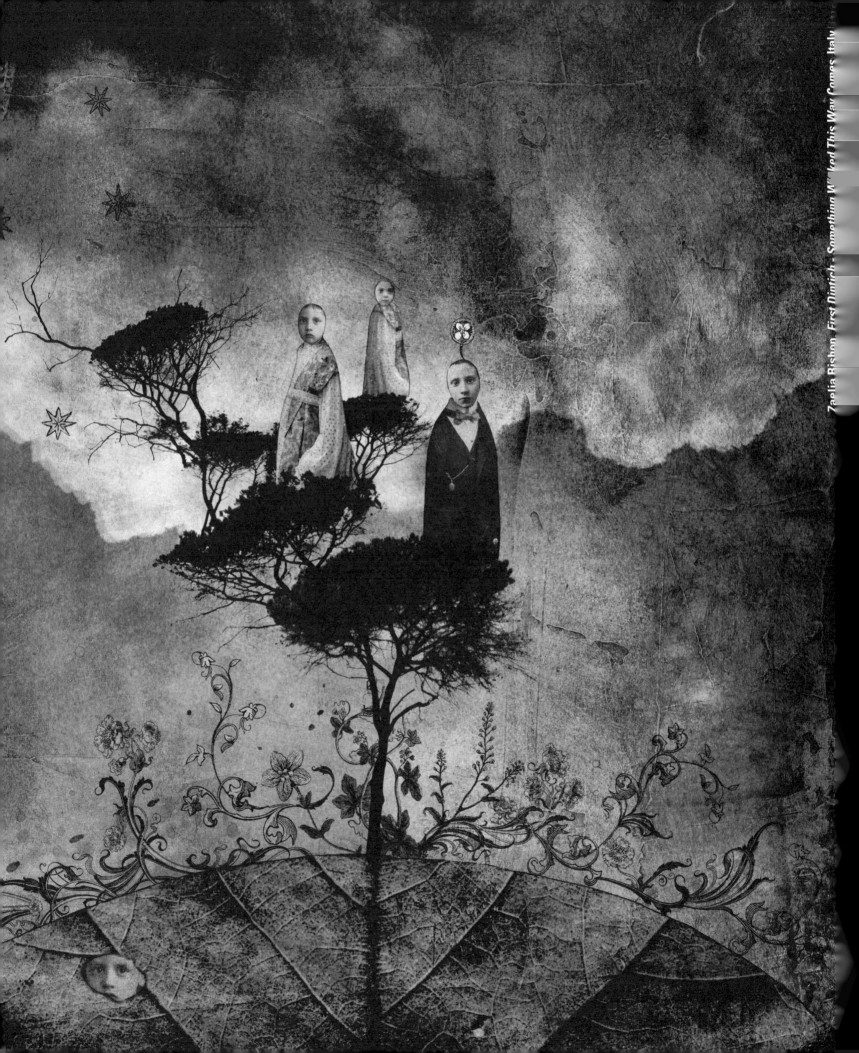

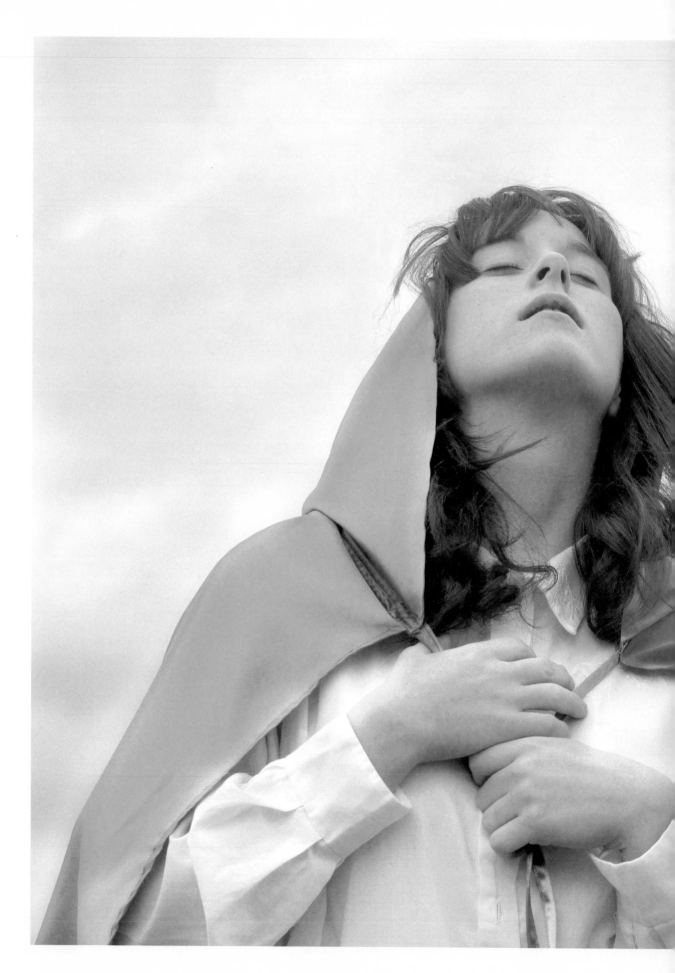

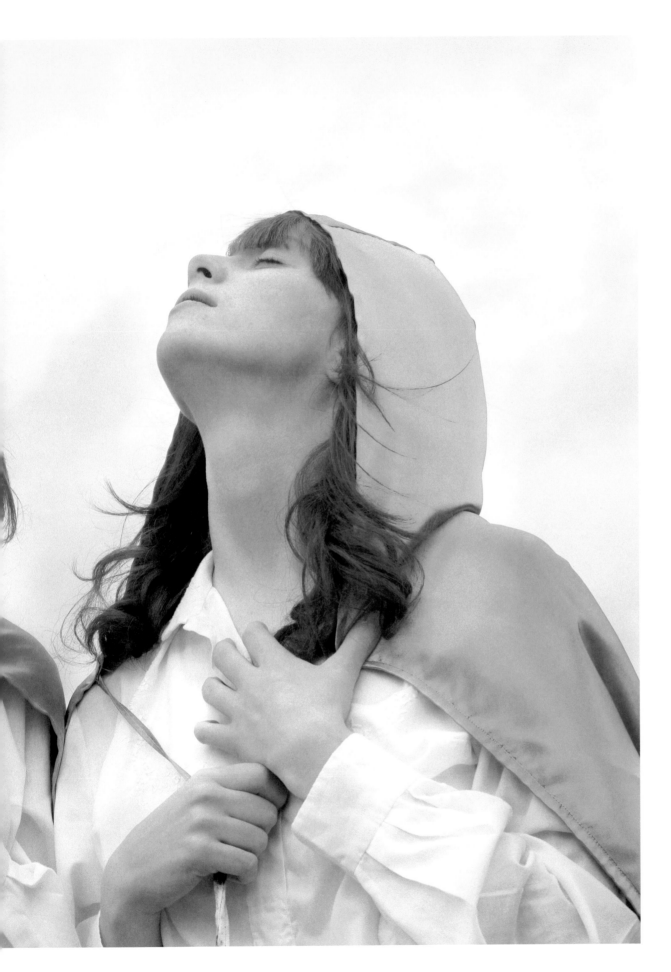

Silvia Camporesi, *il latte e la carne #5* - lambda print cm 70 x 100, Italy

-----BEGIN PGP MESSAGE-----
Version: GnuPG v1.2.1 (MingW32)

hQIOAz0wHyl3h4SsEAf8CHq7/7sZ+7tUDSr92teubWiy4sw4b4wvcAzs4LkZ4c3vhEuKa
Ws8tugdev1ZEM1I2C5EP25XM8VJFcxYepo0REk61BXKiYImbXZuRWGkXdXz3ITUQX
VY2iNjg+9BGO0JtYb9eFOsSRuH8/IwUW0QaMyAd7LQVbFdtfa1IVCleSCHcV57VzRQ
Zi17xQETKDXnL3KuMWtV0/kjVw8xpp9d3wugJCB76zMQKaz3tmEBrCDzvzKWMxCDt
3tPfNmQxHm4VhpFMXS3Tyspoqdnxqj+hNreuetev3U2GzYIeZ0eA1M1ej/szAKLb2vqY
6KABVMSGD0TYvtIdXBFjk1C4IC/NQf/a49IuaVQcGtO1JojPv8o5W+GwNeJCFeTKexR
L1ZPa74LE6gzjV5JpLjgjliTpAAis09ZjIcLA/meuCcwTE0WyPiBL2dzJL7R1y2rhRUuMIz
HO4xE405oSHdEjlvvWU+o6/je9DudPY4zzUPBi3gI+3n0YsqWZ2RWIuYKdobjVoV7is5
wZVEmpBQAh6/fKeEwcDOe355nPKfnnyZi1++sPrQj/mdRoqJohNGfe8t5L6AIHxxmG2
u2IuEq/hExrJ0yeA4p5bU70FP6CSQy7PIPFljh/yzy8XOSblfrV4+4rET+ZYI4SMZhmBwTr
ASIX4OxV0Xi/aFH6qg1NPDt1LYWxtJJARMbaBed2jqXQm/fXwYMWBNcPx3of8EnYSV
Q1YamoBBFxuw6WI36IzEqV9Hm0ip5am60A/omwHL3Q8zmbeaN5qRhOFO21N7C
==
=uBjL
-----END PGP MESSAGE-----

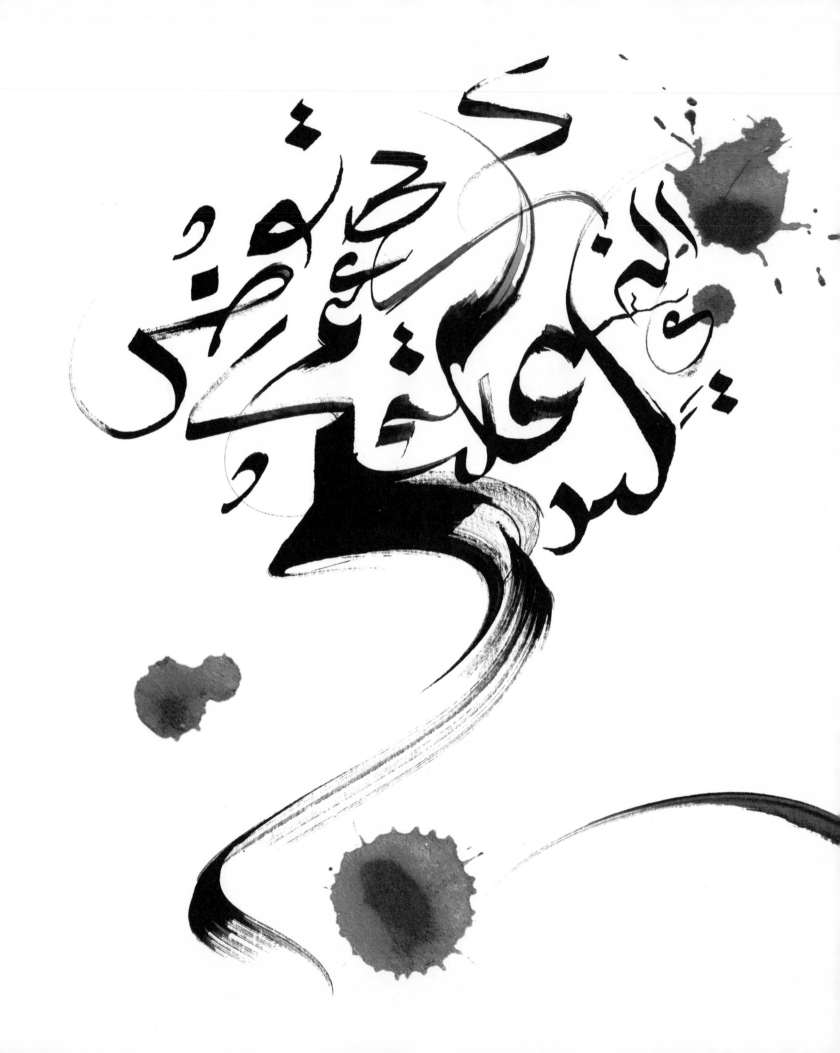

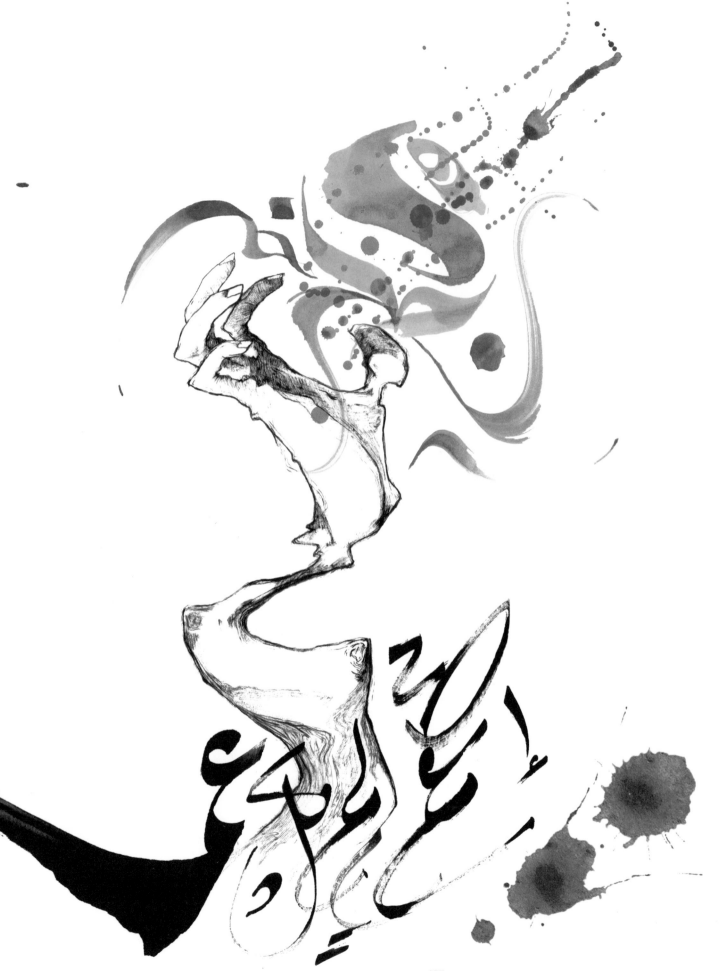

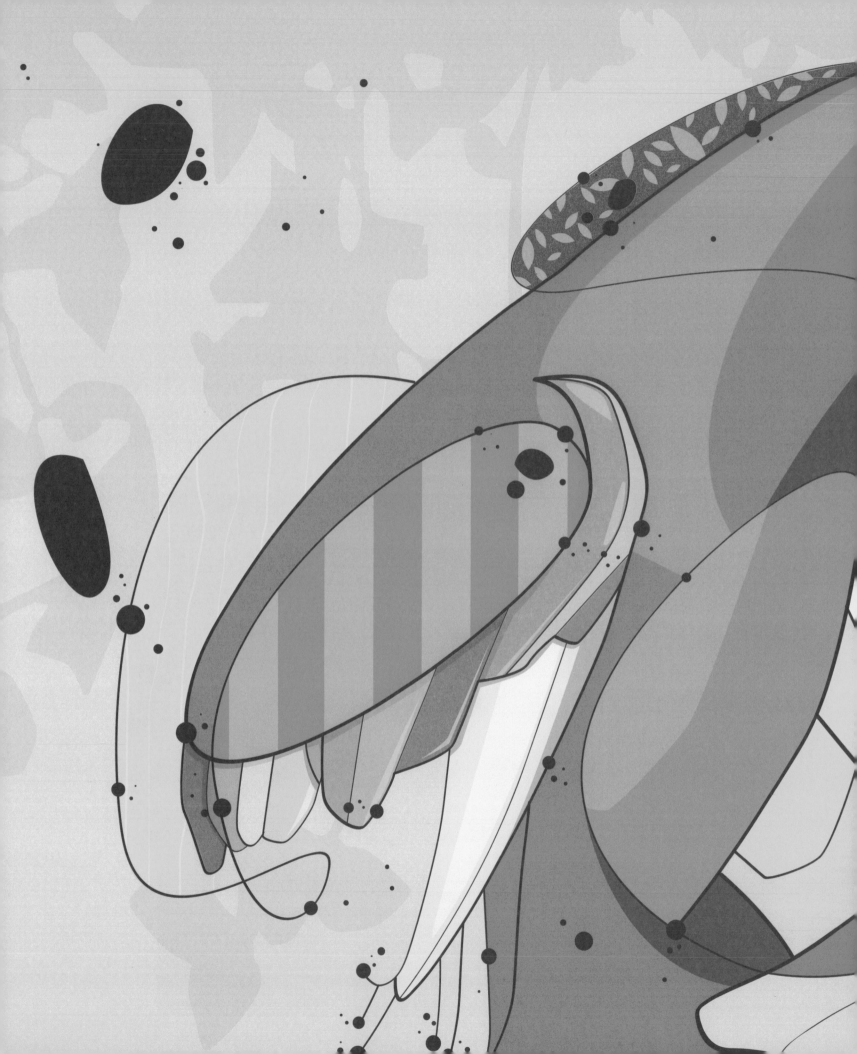

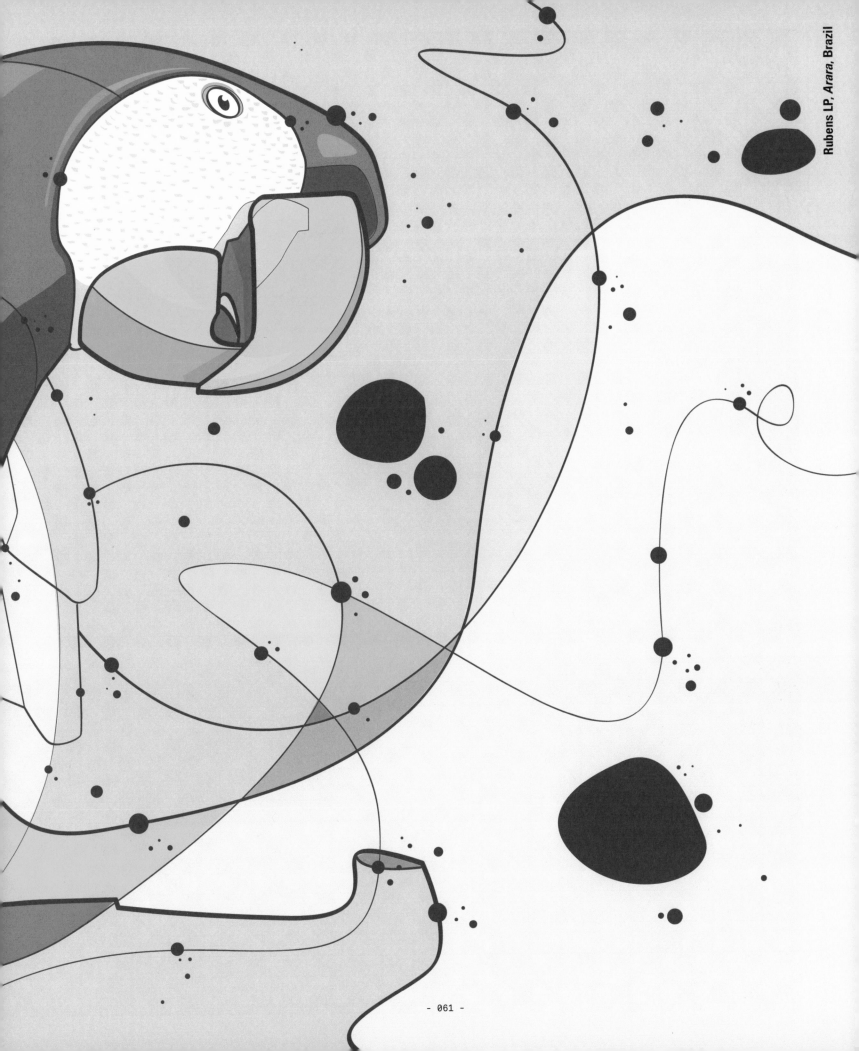

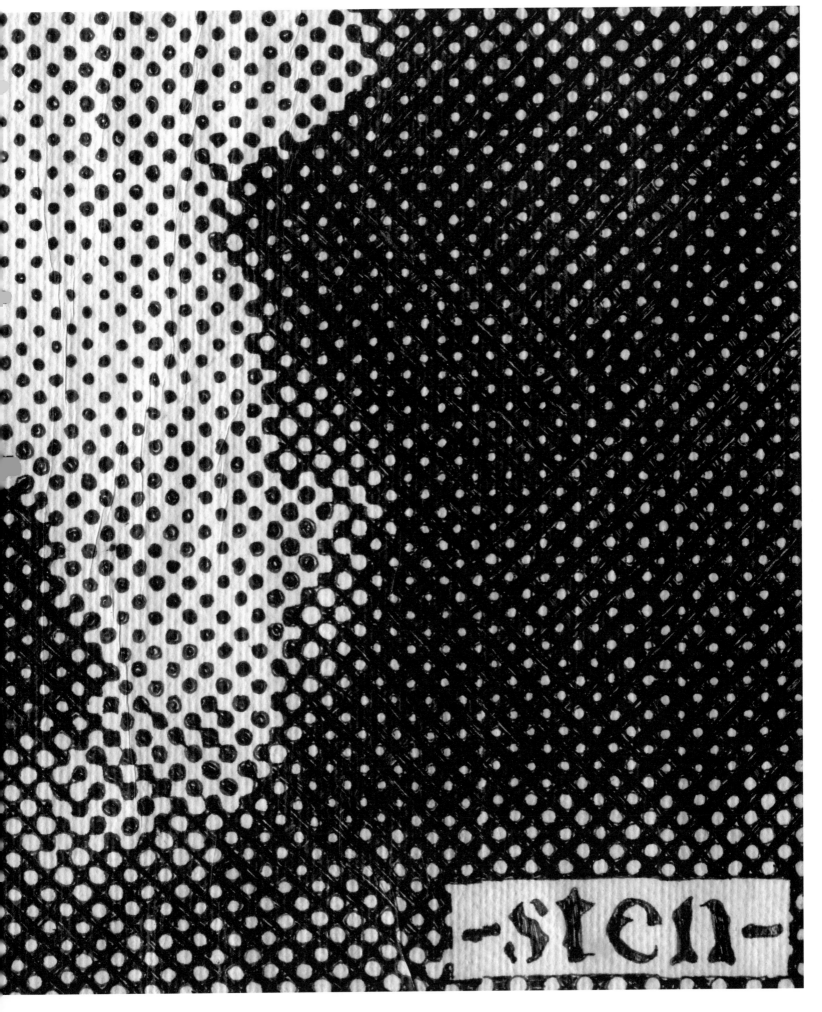

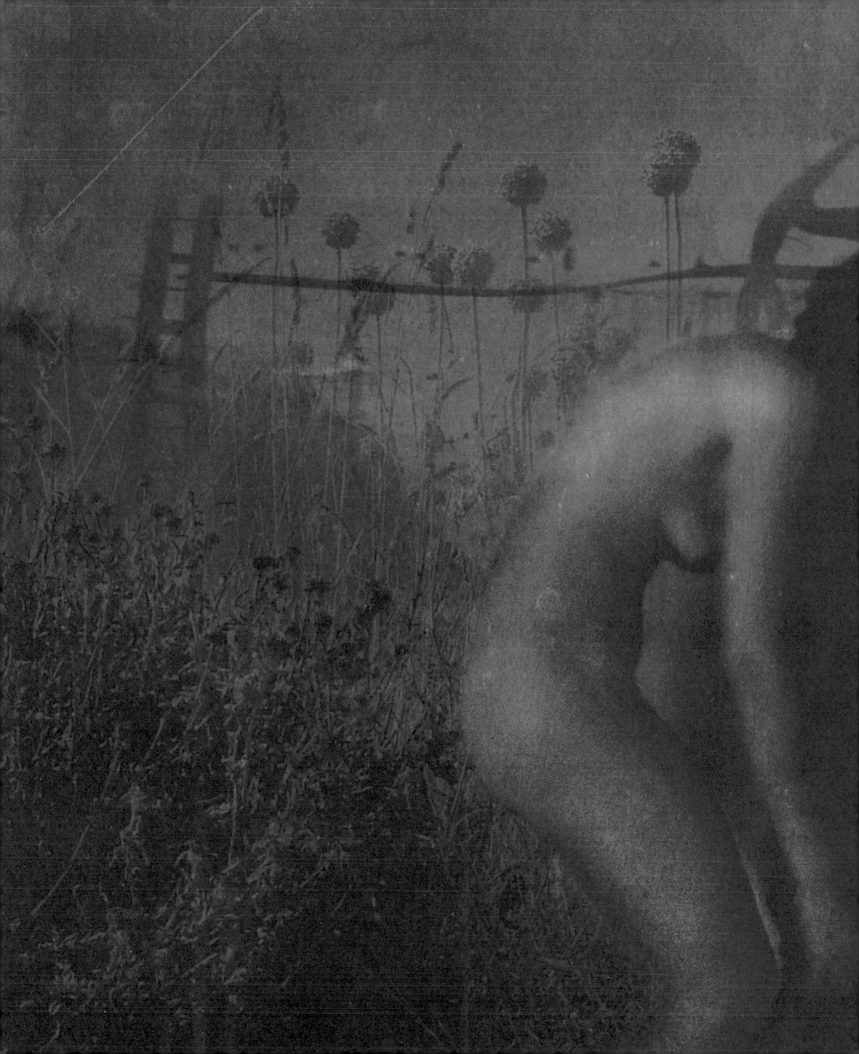

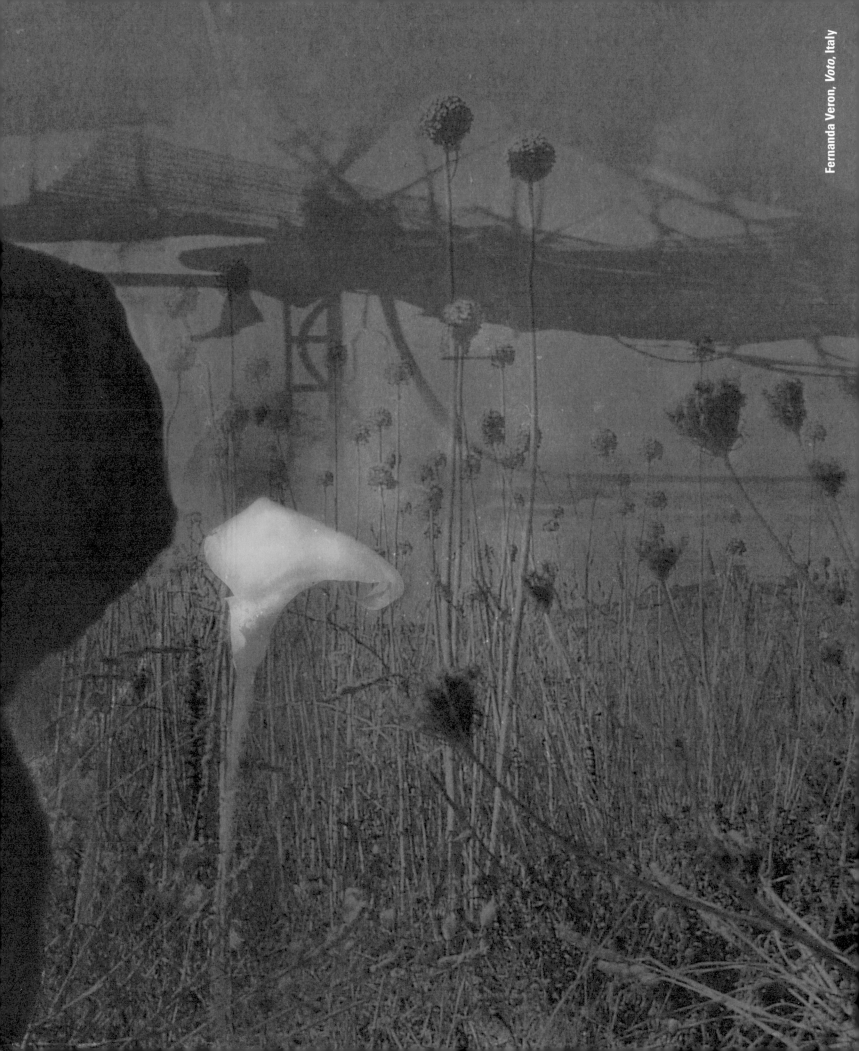

STYLE 100

»IF WE DON'T WANT OUR SOCIETY TO DESTROY ITSELF THROUGH CARELESSNESS, WE NEED TO APPLY CONCEPTS OF SUSTAINABILITY AND ECOLOGICAL RESPONSIBILITY AT ALL LEVELS OF LIFE. WE CANNOT JUST REMAIN CONSCIENCE-FREE HAPPY SHOPPERS, FOR EXAMPLE. MEDIA FOLK, AS AGENTS OF ATTITUDE AND OPINION-FORMERS, NEED TO TAKE PART IN THE SHIFT OF PARADIGM THAT WILL MARK THE BEGINNING OF THE 21ST CENTURY. PROJECTS LIKE SIDEWAYS PROVIDE A SORT OF PLAYGROUND WHERE FREESTYLE AND FREEFORM STATEMENTS ARE POSSIBLE, BEYOND THE BOUNDS OF THE PERIODICAL CONCEPT OF MAGAZINE PUBLISHING.«

When the founders of Style100 magazine (originally launched as Style & The Family Tunes) first set out to leave their mark on the map of Berlin's Mitte district in 1994, the area was still a real bohemian city quarter that had not yet evolved into a showground packed with myths and marketing ploys. Raw, undeveloped, post-Wall urban spaces combined with a unique moment of inspired creativity attracted a generation of colonising pioneers and enabled them to weave a creative network that later attracted a different kind of invaders with their own agenda of money-making schemes and real estate pricing politics. First there were the empty buildings and the neglected urban canvas of a sparsely populated, former East European city centre, then came the parties, galleries and conceptual projects followed by flagship stores, more galleries and the full focus of the lifestyle media establishment, who only began to really pick up on this new European creative centre when things were already in full swing. Growing up within this background, the independently published magazine "Style" (as it is usually nicknamed) became a pioneering source of inspiration and a creative publishing benchmark for a whole set of new magazines, book editors and web designers who later emerged from the Mitte media melting pot.

Style100 is, and always has been, a magazine about fashion, music and culture. Together, founding editors Cathy Boom (dedicated fashionista and photography expert), Christian Tjaben (writer, former music promoter and DJ) and creative director Jaybo a.k.a. Monk (artist, fashion and graphic designer) have created a monthly bulletin of possibilities; a printed Friday-night-plus-Saturday-afternoon-and-Sunday-morning; a coffee table accessory of (pop-)cultural independence and hipsterdom.

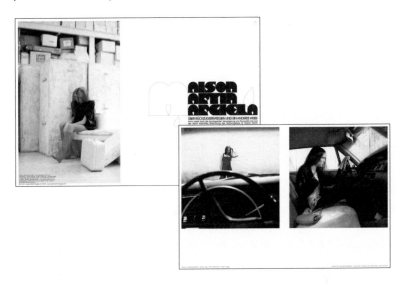

Style is a relaxed island in the hectic sea of trend spotting: playful and unorthodox, it uses a palette of colours, signs and symbols that are as unique as the creative folk and their creations that it features. Originally set in a hip-hop context, the magazine's mandate soon broadened over time. In particular, the creation of a highly influential fashion editorial set standards for the post-rave fashion and designer scenes — when couture was mixed with street, high end with low riders and haute with hot.

Genre bending, award-winning layouts and some of the best photography around combined with a select mix of interviews, features and reviews constitute a magazine for magazine lovers that manages to stand up to the task of reinventing itself on a monthly basis through constant change and fresh recombinations. New hybrids in design and music have emerged, the web bubble has burst and contemporary art has become ever-so-fashionable, but Style remains true to itself.

Like Berlin, its hometown, it is at home all over the cultural map: Eastern or Western, Northern or Southern, Asian-Pacific or Transatlantic, Continental European or Outer-national — all split into myriads of micro-societies. The city is an ideal hothouse and platform for innovative and taste-defining ideas: If it sticks here, chances are it'll stick as really fresh anywhere. Despite all the upheaval and change, Style100 has continued to be a point of reference in the midst of a decade of fast-track cultural evolution. In a way, the magazine and the people who make it represent sustainability within the ecology of cool.

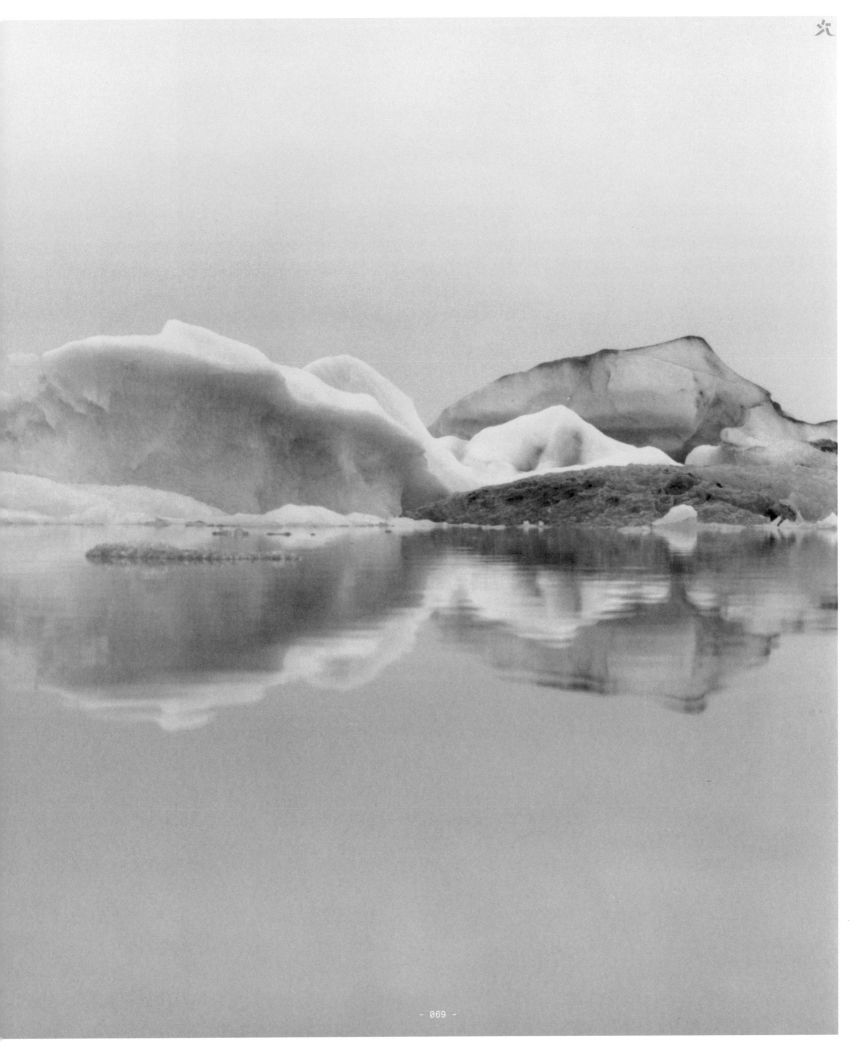

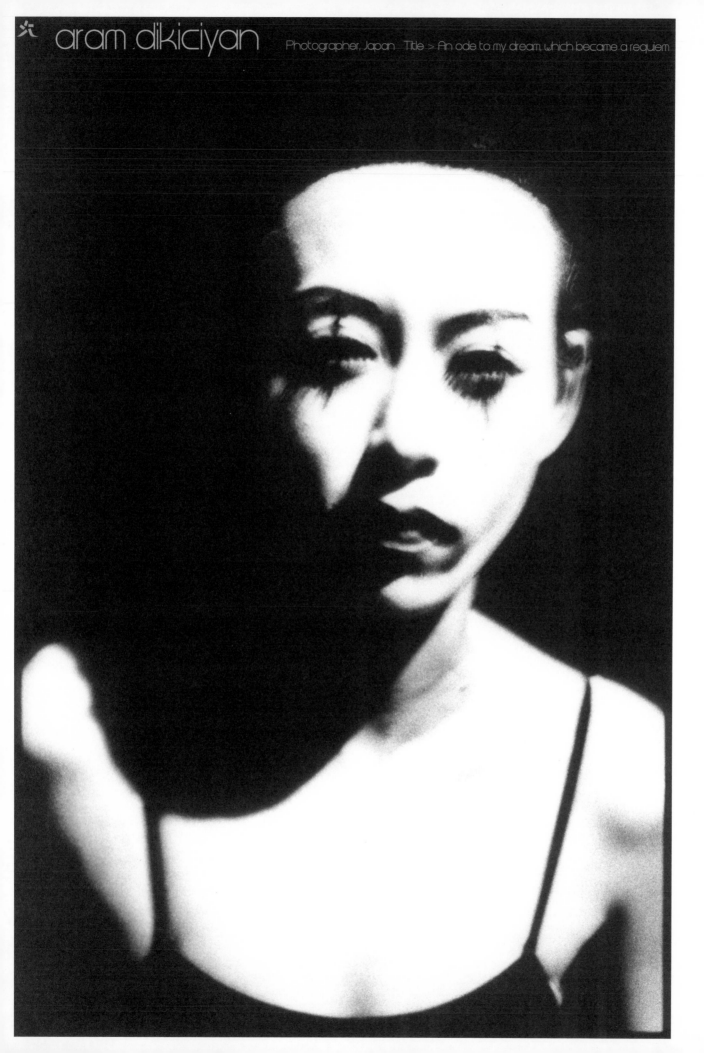

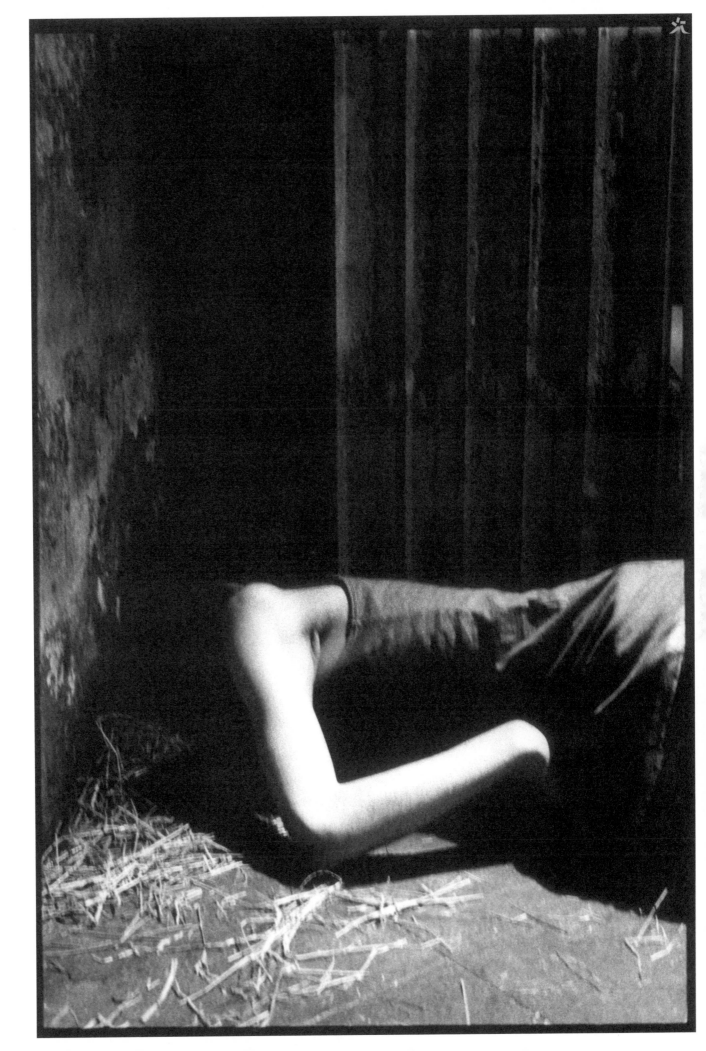

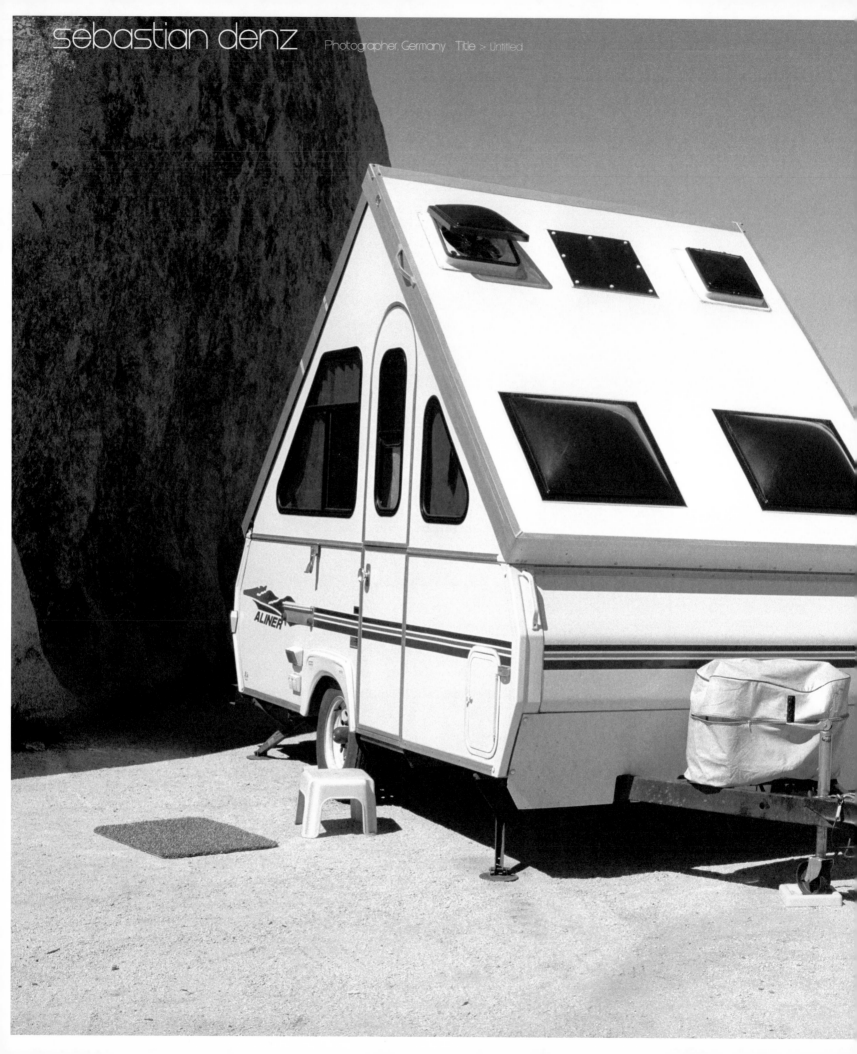

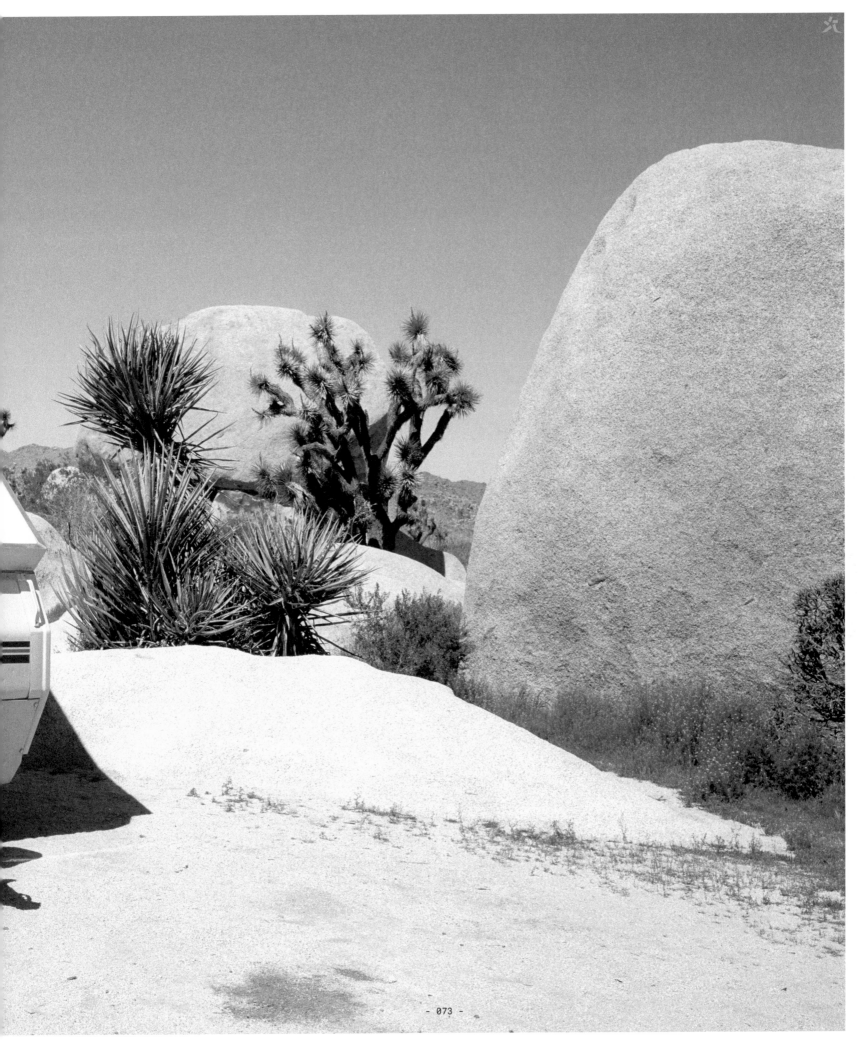

Presse Parrot

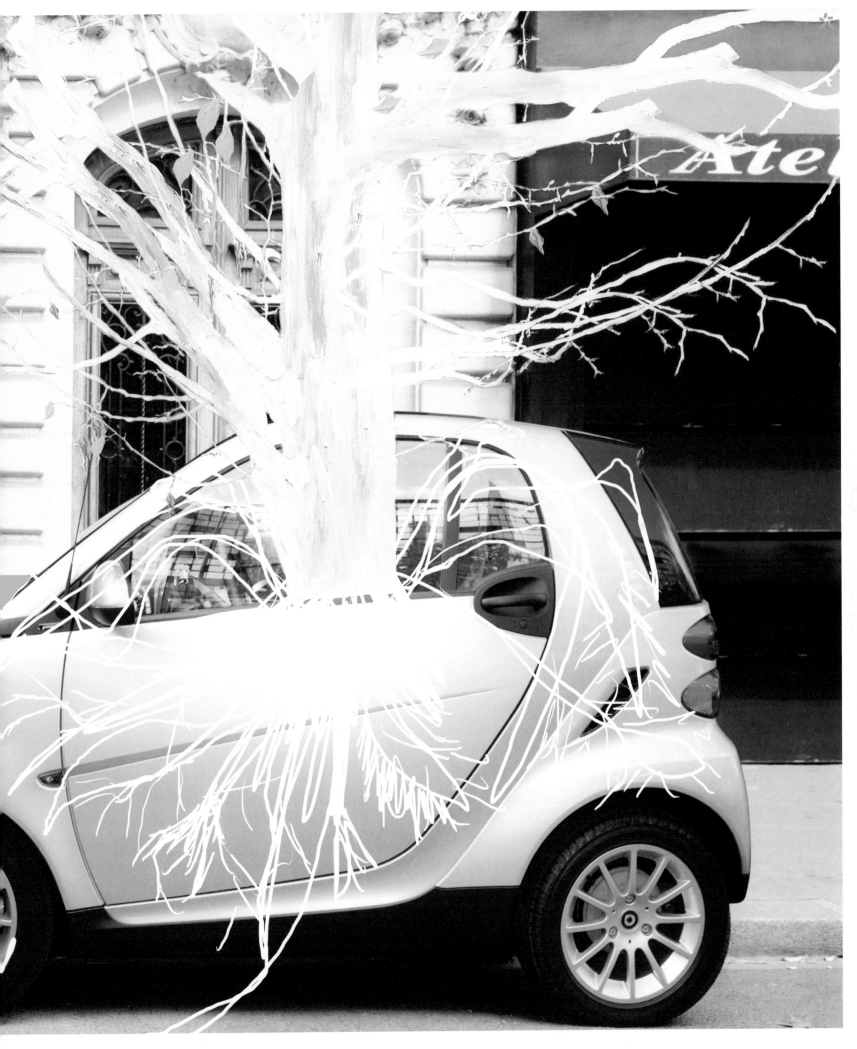

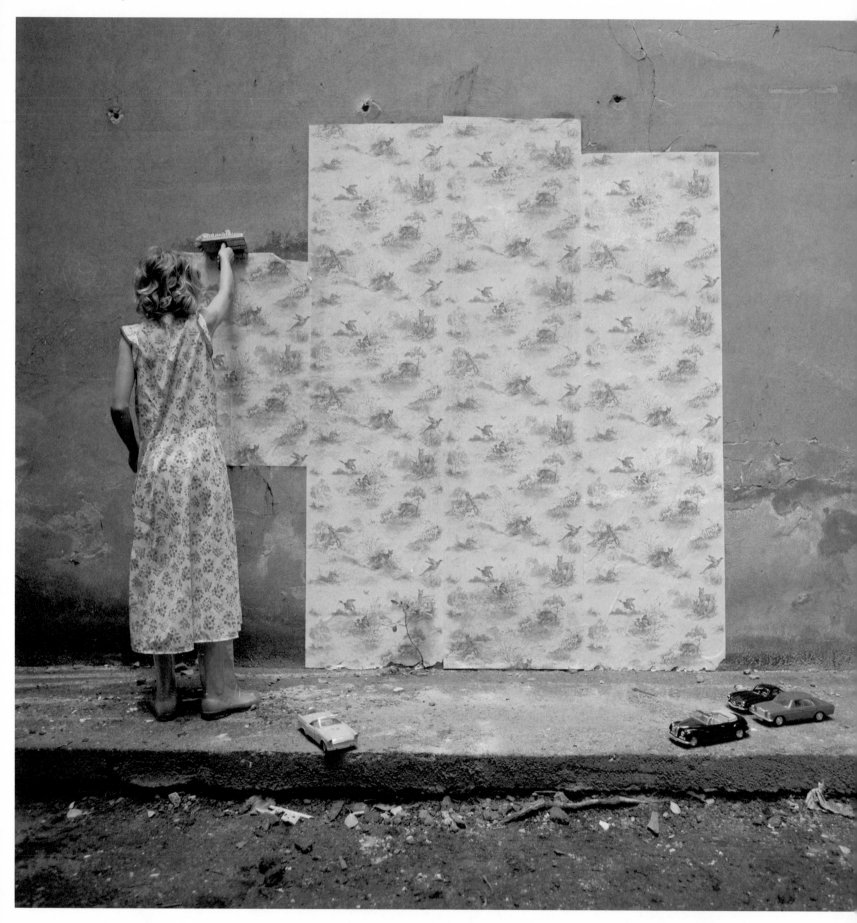

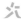

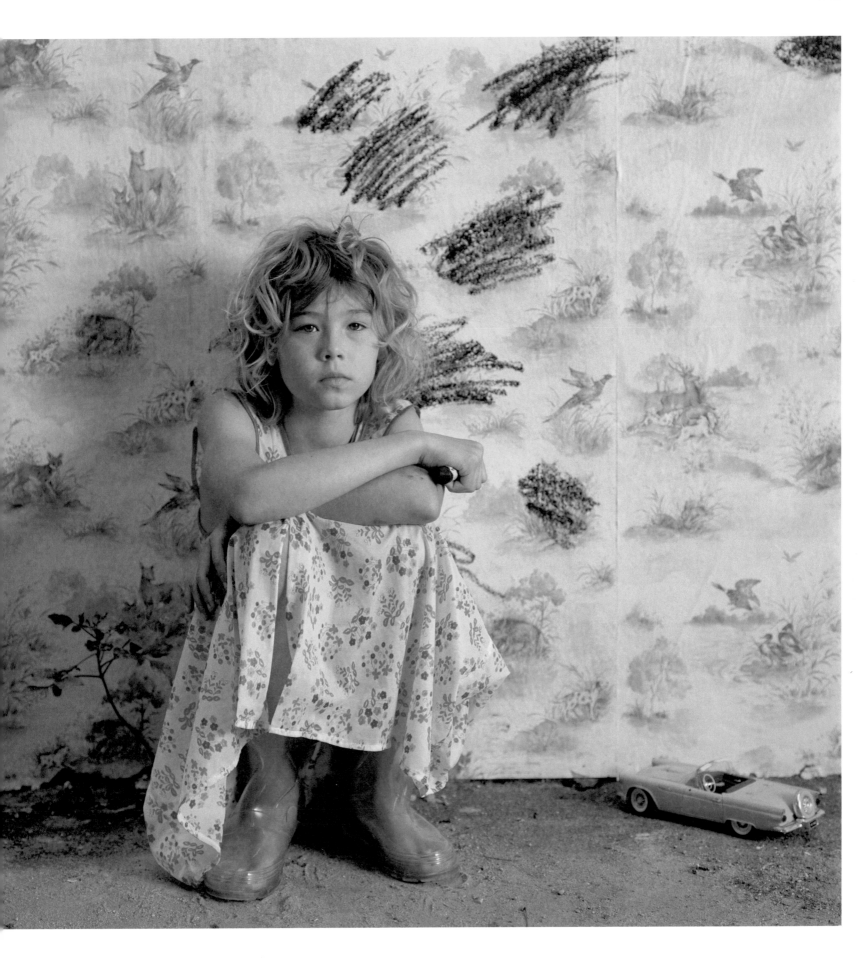

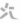

wolfgang stahr

Photographer, Germany Title > Water Towers, Kuwait-City

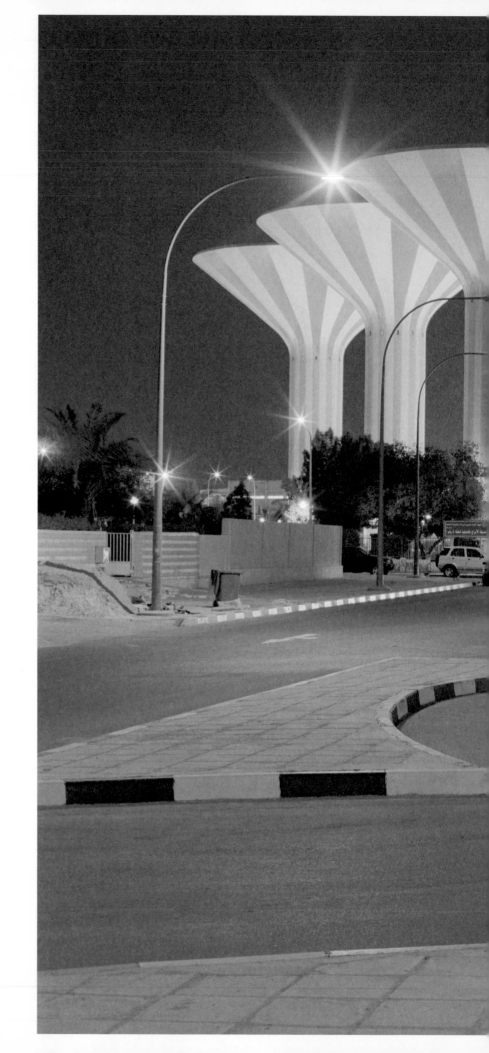

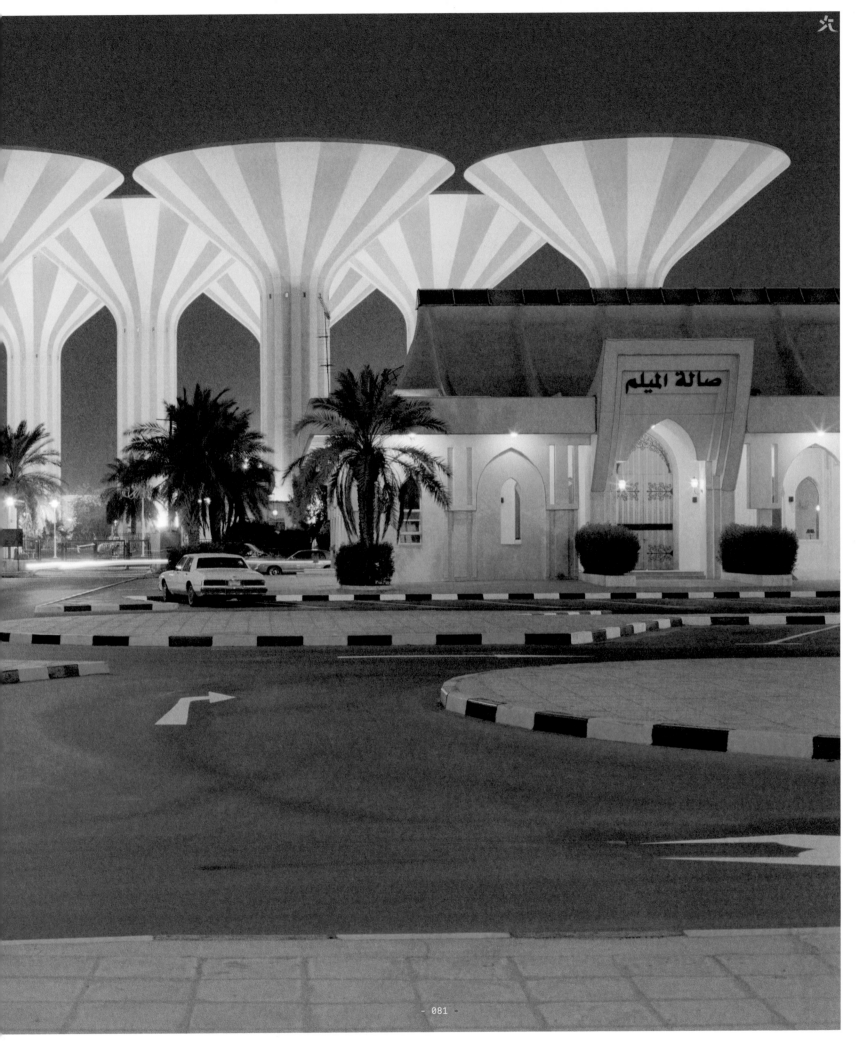

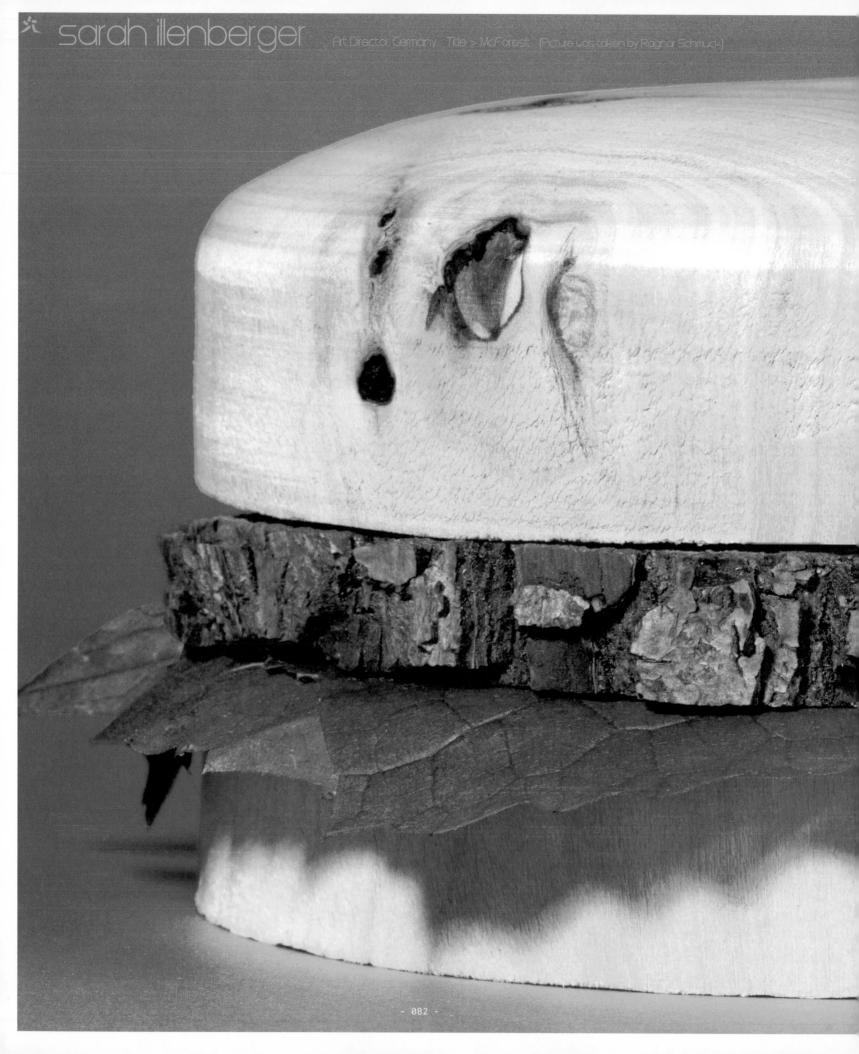

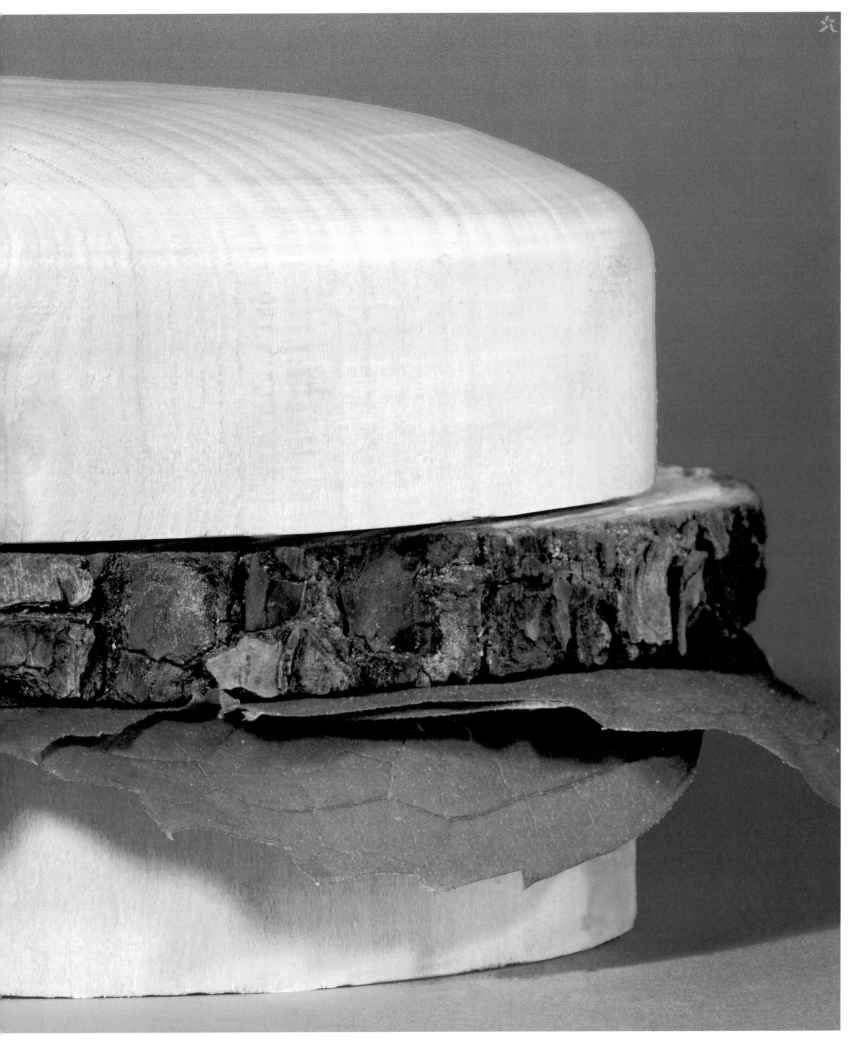

michael danner

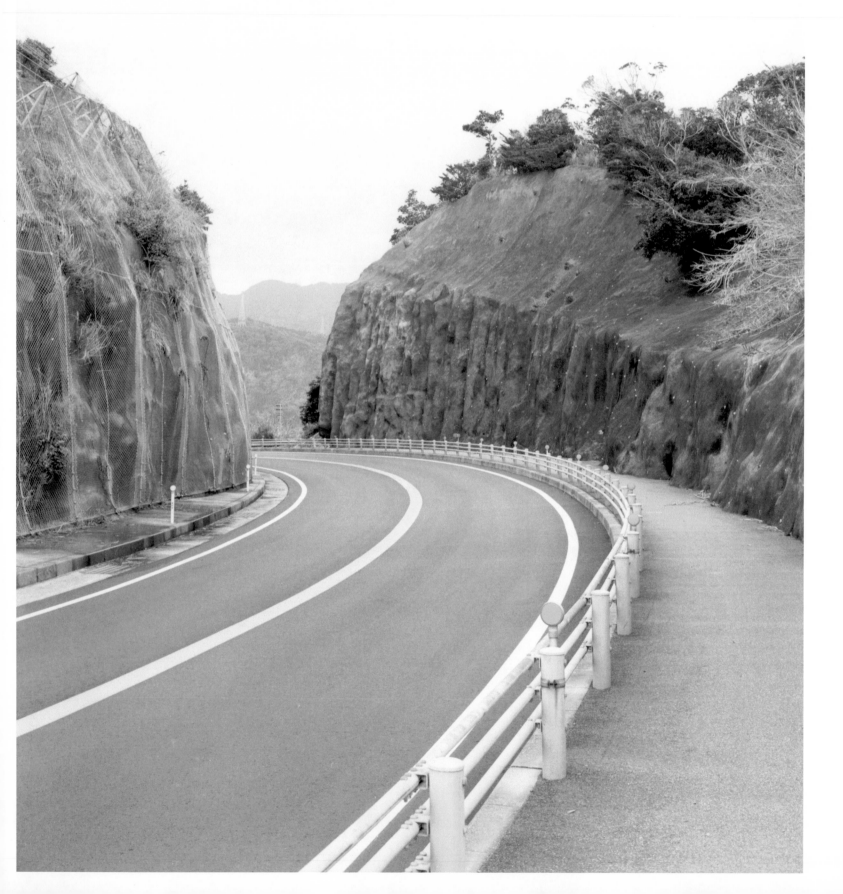

Photographer, Germany Title > Turn, Japan / Nichinan (left) and Bamboo, Japan / Kyoto (right)

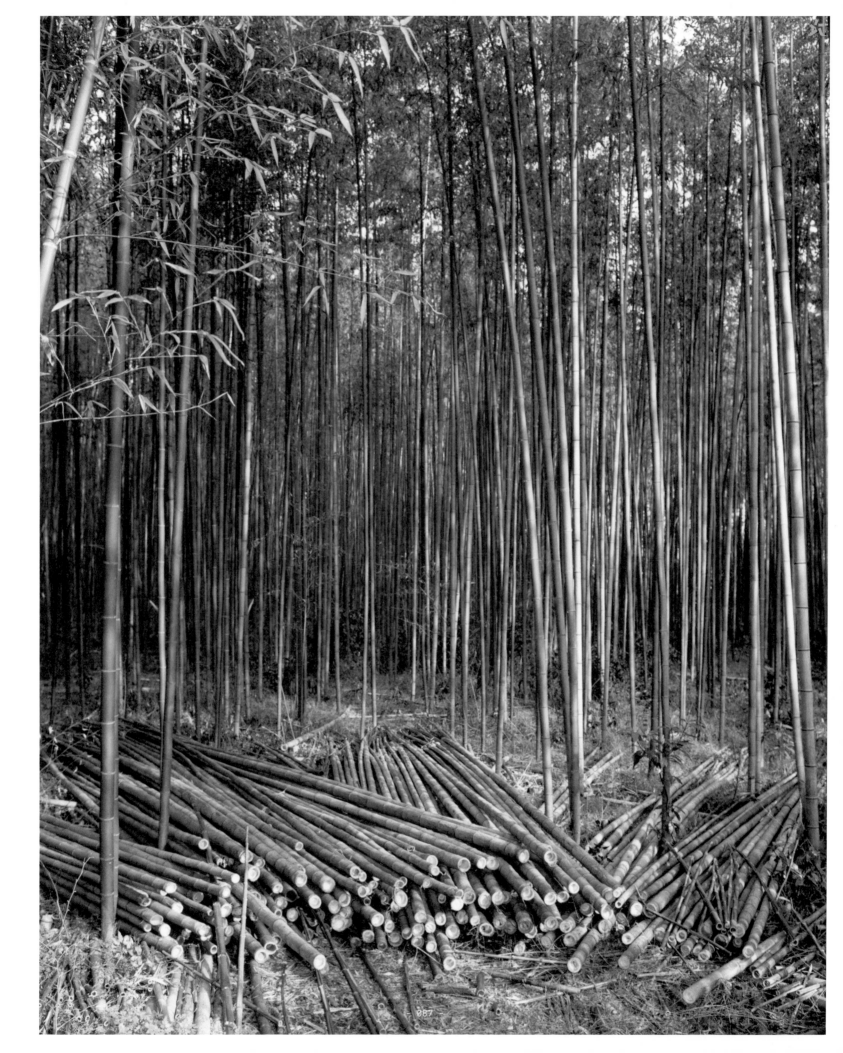

TOK
ION

»AS A MEMBER OF THE MEDIA, TOKION IS INVESTED WITH THE TASK OF RAISING AWARENESS ABOUT ENVIRONMENTALLY CONSCIOUS PROJECTS IN FASHION AND THE ARTS. THE ARTISTS' WORK WE HAVE SELECTED REFLECTS A GROWING CONCERN, BOTH SOCIALLY AND ARTISTICALLY, WITH THE NEGATIVE IMPACT THAT HUMANS ARE HAVING ON THE ENVIRONMENT. THE OPPORTUNITY TO PARTICIPATE IN SIDEWAYS HAS GIVEN TOKION AN IDEAL PLATFORM ON WHICH TO PRESENT WHAT WE BELIEVE ARE IMPORTANT IDEAS ON THE SUBJECT OF ECOLOGY, WHILE AT THE SAME TIME SUPPORTING THE ARTISTS, PHOTOGRAPHERS, DESIGNERS AND ARCHITECTS WHO ARE CREATING THE MOST EXCITING AND THOUGHT-PROVOKING WORK OF OUR GENERATION. HELPING THE ENVIRONMENT IS EVERYONE'S PROBLEM. IN ADVOCATING CHANGE AND AWARENESS, WE HOPE TO BE PART OF THE SOLUTION.«

The Americans brought Tokion back home with them, establishing offices in downtown New York City, where it has continued to flourish as a leading platform for this international network of cool kids. Throughout the past eleven years of its existence, Tokion has featured both established and emerging artists such as Ed Ruscha, James Brown, Brian Eno, Ryan McGinley, Peter Saville, Matthew Barney, Lou Reed, Alexander McQueen, Gus Van Sant, Michel Gondry, Harmony Korine, Richard Prince, William Eggleston, Julie Verhoeven, Proenza Schouler, Kim Jones, Stephen Shore, Chris Johanson, Cory Arcangel, Christian Marclay, Jarvis Cocker, Terence Koh, Ennio Morricone, Calvin Johnson, Doug Aitken, Daido Moriyama, Jason Lee and Chloë Sevigny, among others.

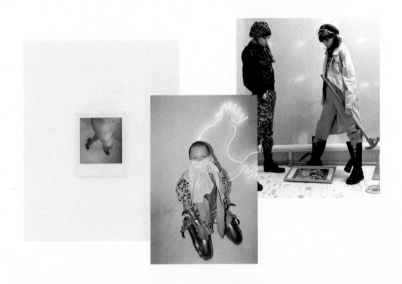

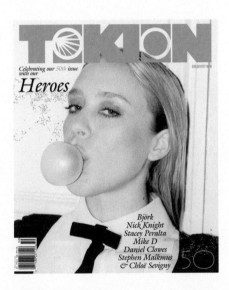

The past decade has seen Tokion emerge on the market as New York's culture and style magazine of note, having grown up significantly from its roots as a "street" mag. Tokion's unique combination of fine art, fashion and culture features has germinated a new breed of publication: the stylish art magazine. Targeted toward a less stuffy audience (no offence to the stuffy), Tokion links the best in visual cultural with an appropriate balance of substance and pop. As always it's a reflection of now, both in print and online.

Tokion magazine was created 11 years ago by two Americans living in Tokyo and taking the same language class. They invented the word "Tokion" and claimed it translated as "the sound of now" – which is almost believable. They were excited about a bourgeoning generation of fashion-forward, gallery-hopping, indie music-obsessed and technically savvy kids coming from all corners of the globe, connected by a loose network of magazines and this thing called "the Internet". Tastemakers in Tokyo, London, Copenhagen, Johannesburg, Sao Paolo, Paris and New York City were privy to the same information, listening the same underground bands, wearing clothes by the same obscure designers and loitering around a similar crop of boutiques, bars and clubs. It wasn't about different scenes anymore; "the sound of now" had become ubiquitous.

In 2003, Tokion founded the influential conference known as Creativity Now. Held annually in New York City and Tokyo, the conference brings together formidable names in art, design, music, film, fashion, journalism and photography to speak about their work and respective industries and discuss the state of the arts before an audience of up to 2,000. The international scope and diversity of the conference has made it a unique and important gathering for young individuals whose culture and interests span the globe. It has also given members of the international creative community including industry professionals, students and pop culture enthusiasts the opportunity to listen and pose questions to the definitive creative talents of this generation. The conference has since been imitated worldwide, setting a new precedent for inter-disciplinary dialogue about creativity.

Clockwise from top left
Solutions VIII: Waterworks, The Netherlands
Drought and Fires XVIII: Gansu Province, China
Solutions XXV: Solar Energy; NingXia Autonomous Zone, China

Canary Project: Susannah Sayler and Edward Morris | Photographers | USA

HYDRA I
HYDRA II

Ari Marcopoulos | Photographer | USA

Lobster Trap

Ben Durrell | Designer | USA

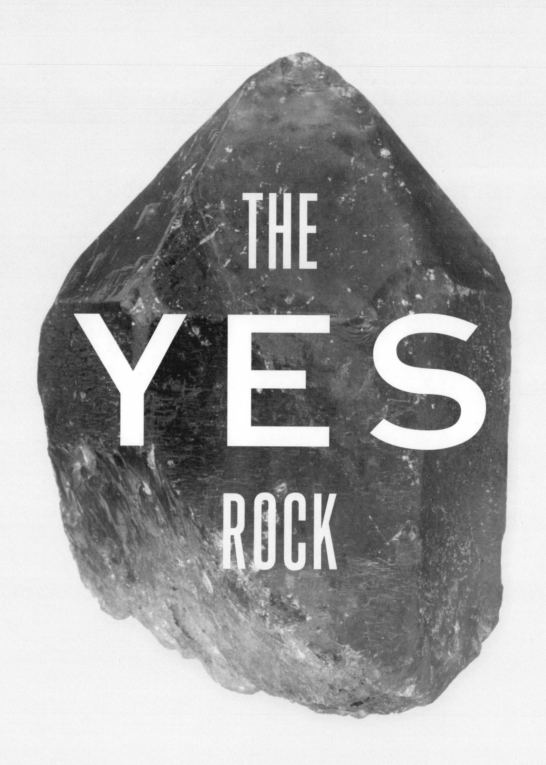

THE YES ROCK

"Yes Rock, No Rock" from The New College Beat

Ryan Waller | Designer | USA

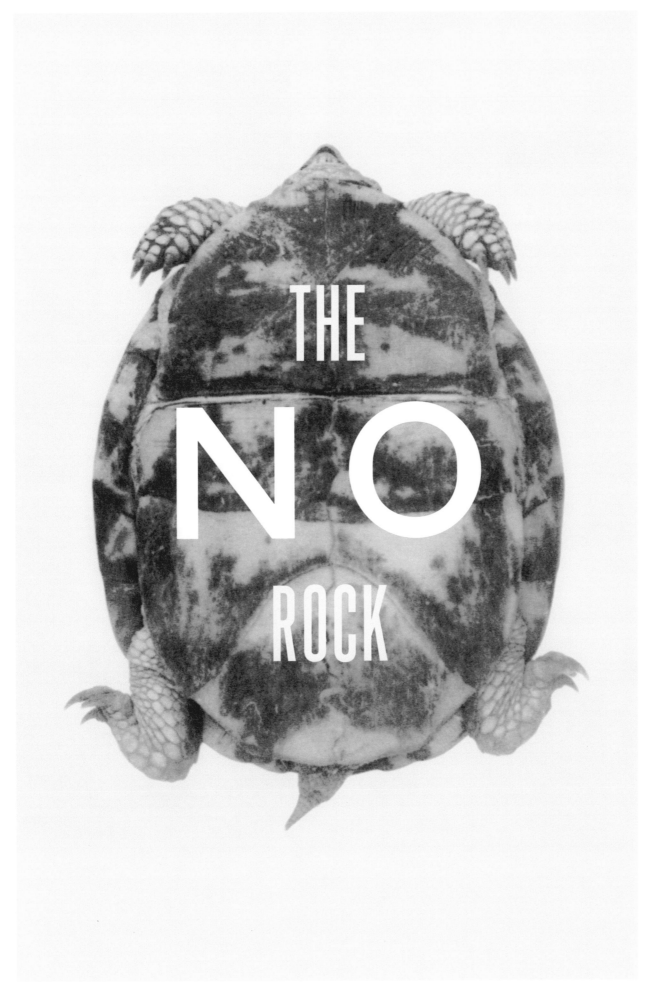

THE NO ROCK

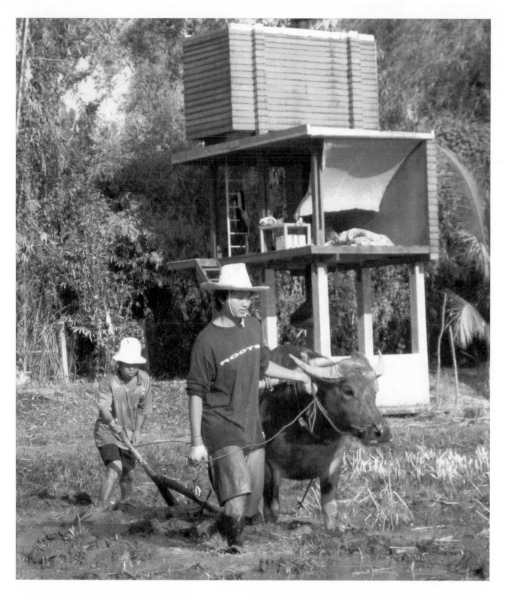

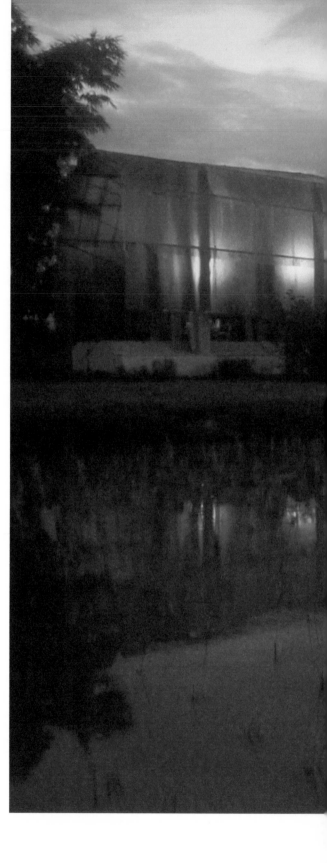

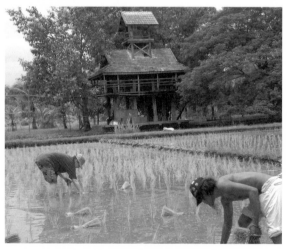

Clockwise from top left
Plowing, in the background Rirkrit Tiravanija's house, February 2005
Battery house by Philippe Parreno and Francois Roch, during shooting of the film The Boys From Mars. *June 2003*
Rice planting, in the background the Kitchen collaborative design by Rirkrit Tiravanija, Kamin Lertchaiprasert, Tobias Rehberger and Superflex, July 2007
Supergas by Superflex, February 2005

Rirkrit Tiravanija | Artist | USA

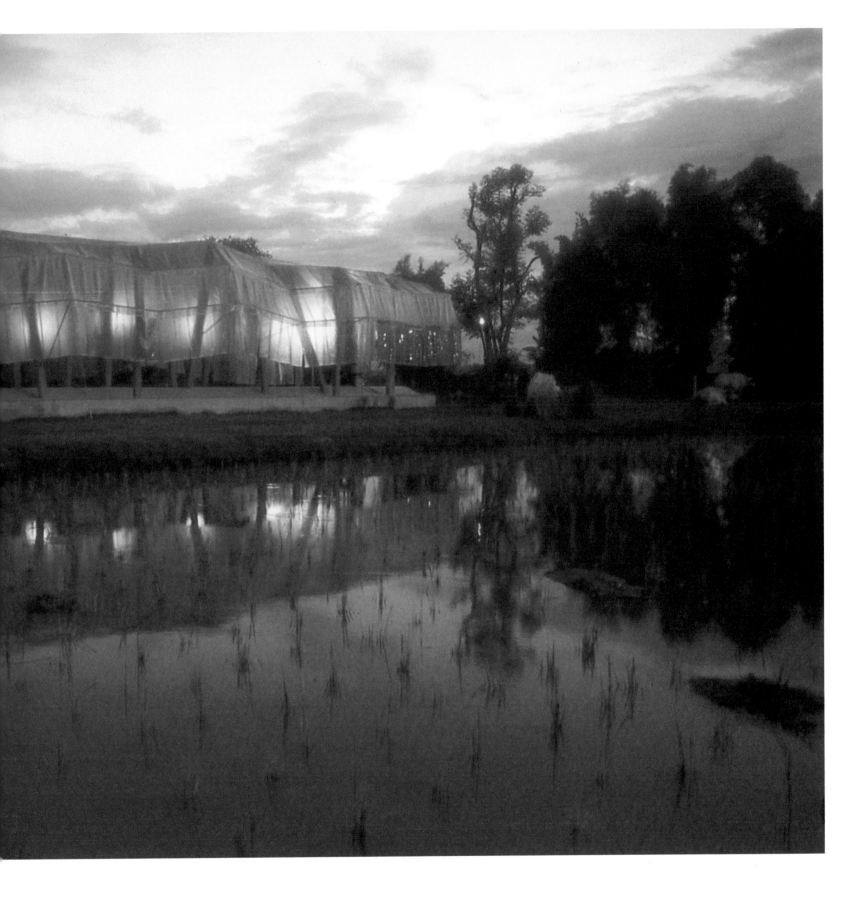

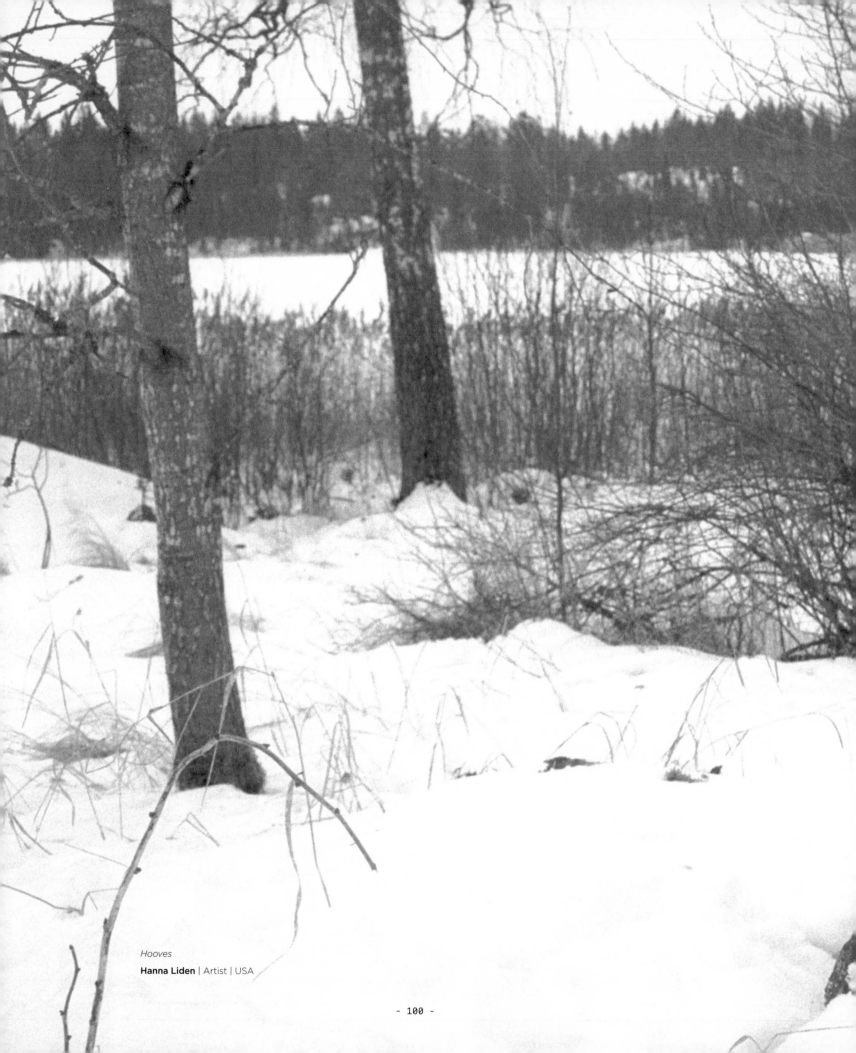

Hooves

Hanna Liden | Artist | USA

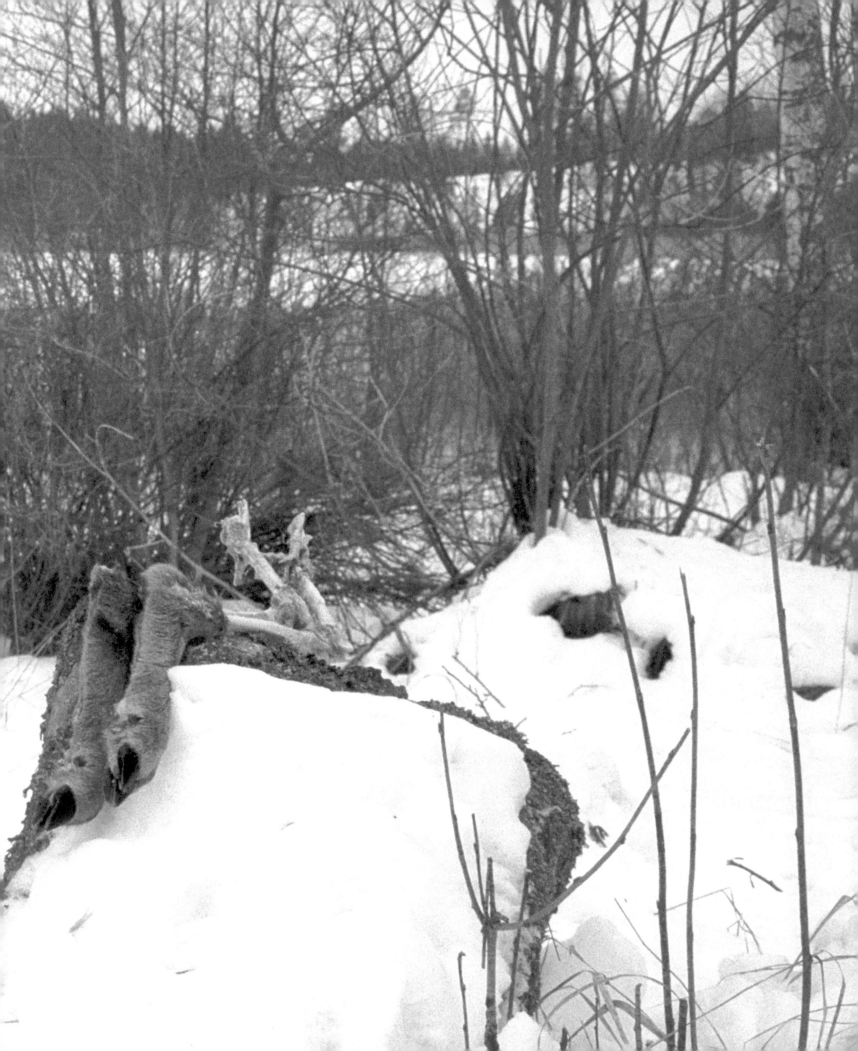

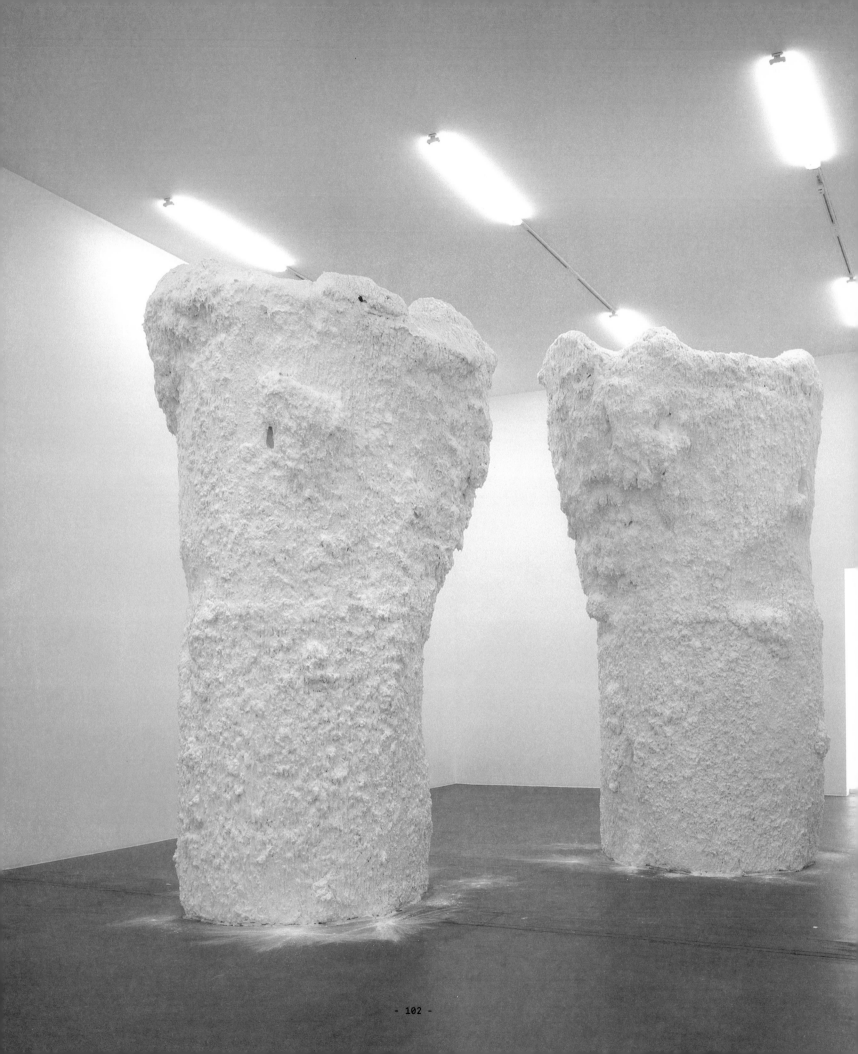

Untitled (Chocolate Mountains)
Crackhead

Terence Koh | Artist | USA

SMARTER

Sandra Kang | Designer | Canada
Sarah Lester | Photographer | Australia

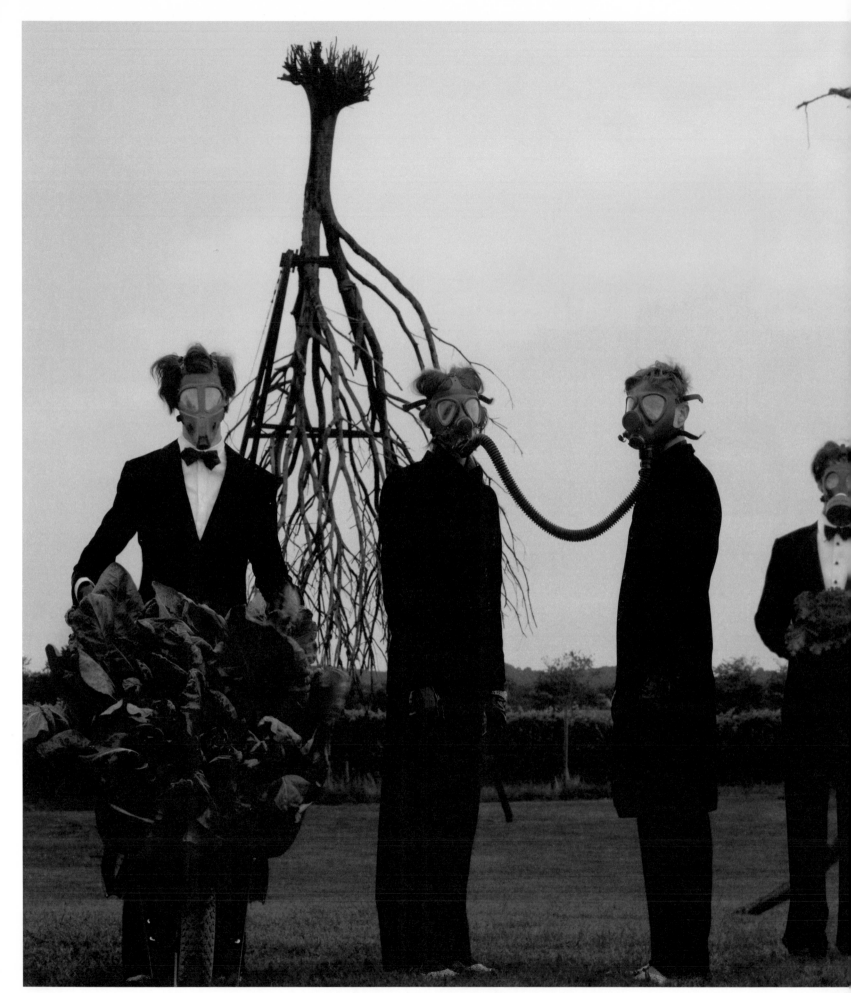

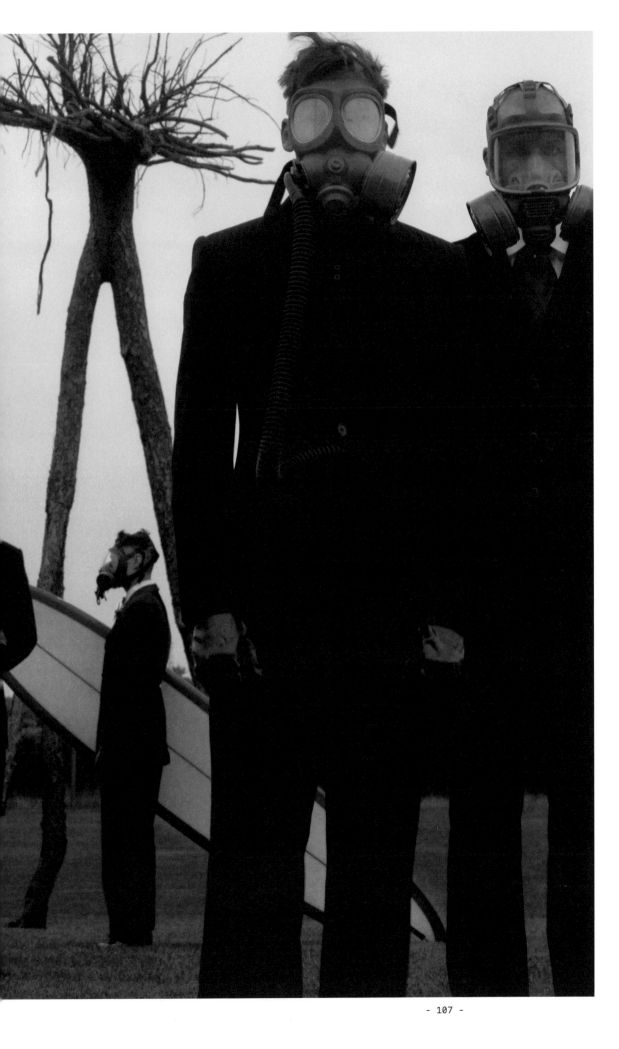

Steven Klein | Photographer | USA
Patti Wilson | Stylist | USA

»THE TREND IN CREATIVITY IS CHANGING. HUMAN BEINGS ARE FACING MANY ISSUES SUCH AS DESTRUCTION OF THE OZONE LAYER, AN EXPLOSIVE INCREASE IN THE WORLD POPULATION, FOOD SCARES, AND ENERGY CRISES. HUMAN EXISTENCE IS NOT SUSTAINABLE IN THIS SITUATION. NATURALLY, CREATORS ARE ONLY A SMALL GROUP OF THE HUMAN BEINGS, BUT, "WHAT IS CREATIVITY FOR SUSTAINABLE SOCIETY?" IS THE MAIN ISSUE THAT FACES THEM TODAY. CREATIVE WORK HAS THE POWER TO MAKE THE WORLD BETTER. LET'S CHANNEL OUR CREATIVITY INTO ACTIONS THAT MAKE THE WORLD A BETTER PLACE. NOTHING CAN BE MORE BEAUTIFUL OR IMPRESSIVE THAN THAT.«

+81 is the international dialling code for Japan. Together the number 81 and the inherently positive plus sign form an internationally recognizable visual image that can be read and understood the world over. +81 is a design culture magazine that introduces readers to a broad variety of exciting creative scenes. Although the magazine focuses primarily on graphic design, each issue has a special theme often extending to fashion, music, film, photography, and beyond.

With diverse points of view and a cutting edge feel, +81 presents design art of the highest quality combined with distinctive insights directly from the creators themselves. With its unique content generated from featured themes, selected artist profiles and distinctive page-by-page editorial design, +81 has earned considerable critical praise on an international scale.

The magazine was founded in Tokyo in 1997 by Satoru Yamashita as a new international business project for his graphic design company DD WAVE that primarily serves the music and film industries. His intention with +81 was to reach and inspire an international audience with a wealth of fascinating creative publishing work from a Japanese perspective that goes beyond the boundaries of plain graphic design. In this respect the bilingual Japanese/English +81 has been a resounding success and it now has a loyal following of a multitude of readers from around the world. The readership demographic varies slightly according to each issue's featured theme, yet the majority consistently stem from the design and creative fields. They are not just graphic designers, but people who have a passionate interest in fashion, music, and lifestyles as well.

The magazine's editorial design is one of +81's most respected features. Many designers and creatives the world over use the look and feel of the magazine as a source for ideas and its issues inhabit the shelves of many a design office worldwide. Part of the reason for this popularity is that the magazine's editors are highly discerning in their choice of featured artists: only the most fascinating works and creators are covered by +81. As a result, since the magazine's launch, the profiles and works of some 800 very special and individual artists from all disciplines have graced the pages of +81 including the likes of Stefan Sagmeister, Hideki Nakajima, Hedi Slimane, Hussein Chalayan, Jürgen Teller, Jun Takahashi, Vincent Gallo and Dave Myers.

After the golden age of LIFE and other pictorial magazines in the 1940s, the spread of television into homes across the world began to displace the authority of the magazine and there was speculation for the first time that print-based media would become obsolete. But with the late 1960s came a resurgence of the printed page and it found its place alongside the TV screen as one of the primary media that represents our culture – even today. This pattern, says Satoru Yamashita, is a similar situation to what is now happening between the print media and the Internet: "From here on out I think digital and paper will segregate into their respective territories and we will witness another resurgence of the paper-based media". And this is Yamashita's mission with +81: "The paper media must continue to explore the fascinating appeal of printed matter because paper still has unlimited potential. +81 will continue to confront these and other new challenges far into future".

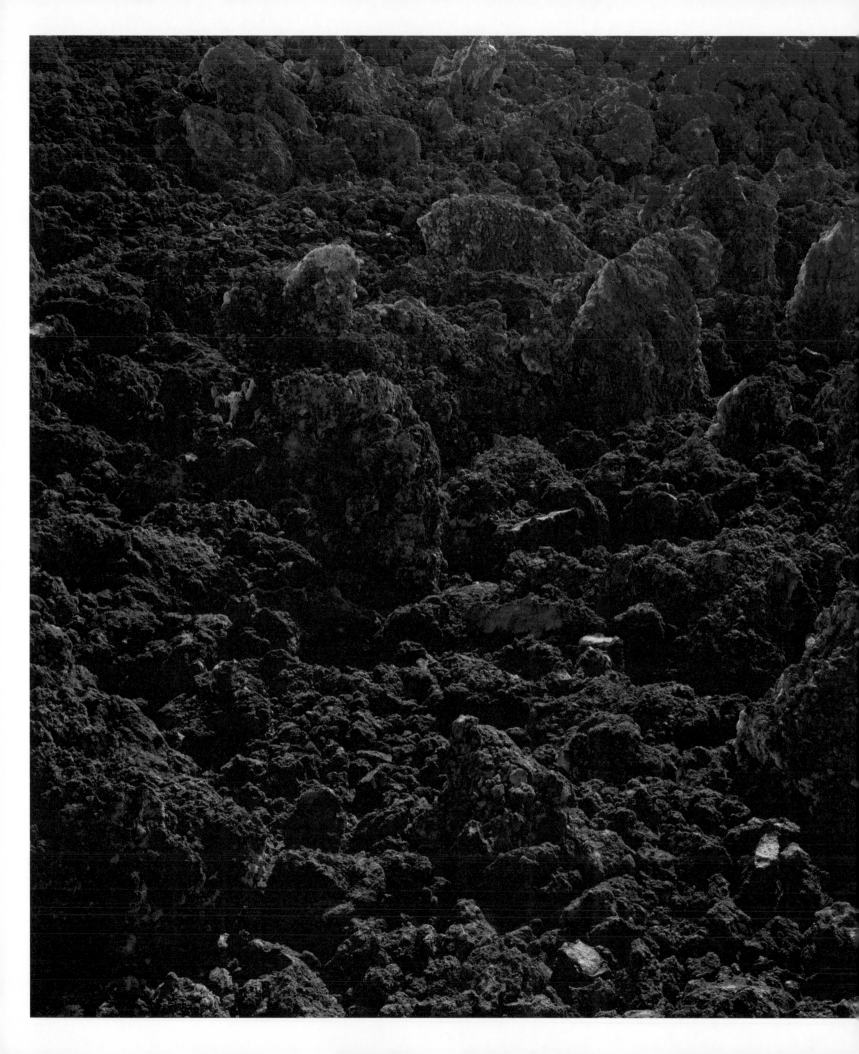

TITLE: KINTAMANI
Artist: Mikiya Takimoto
Profession: Photographer
Country of origin: Japan

TITLE: ANTARCTICA
Artist: Mikiya Takimoto
Profession: Photographer
Country of origin: Japan

TITLE: BLUEGROUND
Artist: Taisuke Koyama
Profession: Photographer
Country of origin: Japan

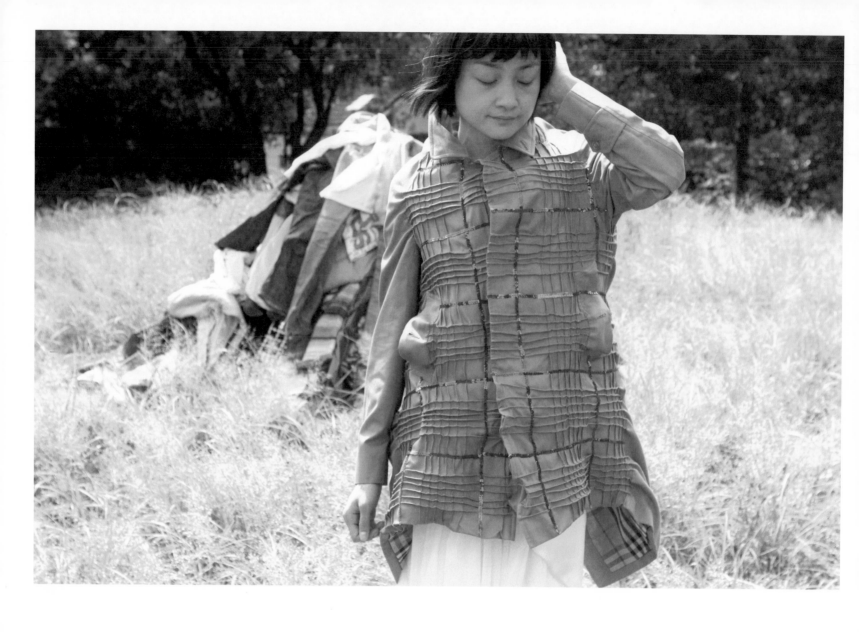

TITLE: BETTER LATE THAN NEVER.
Artist: TOKYO RIPPER
Designer: Hideaki Sato / Director: Shin-ichiro Kose / Photographer: Tomoki Hirokawa
Country of origin: Japan

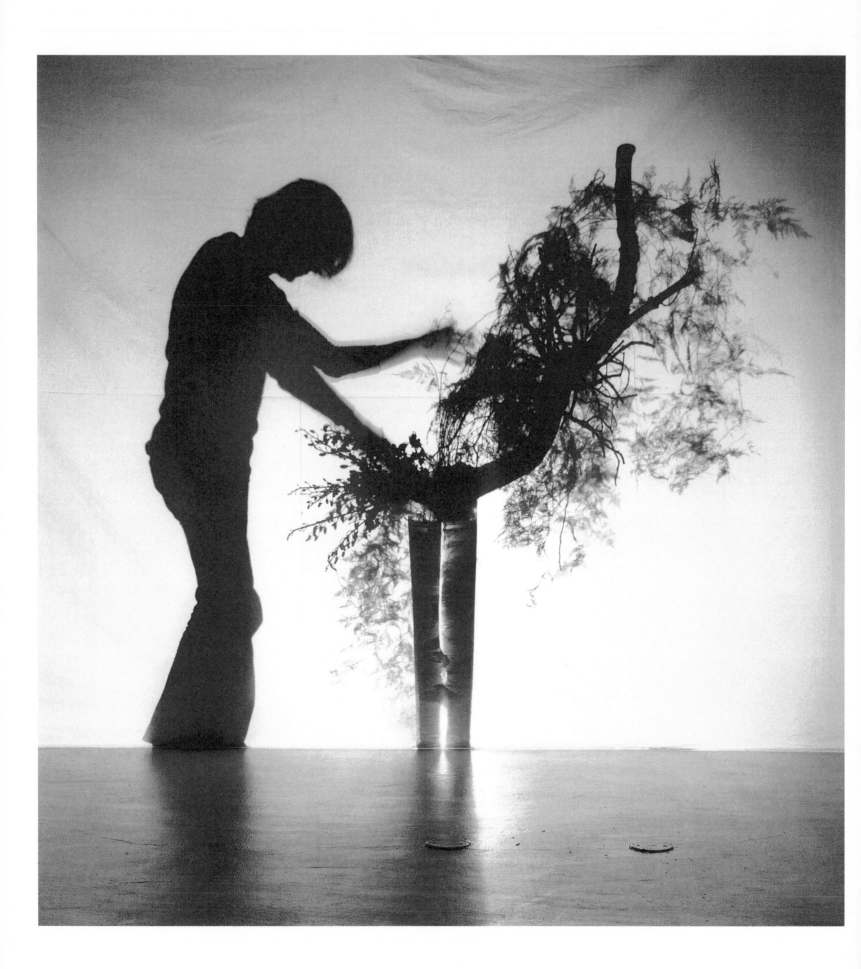

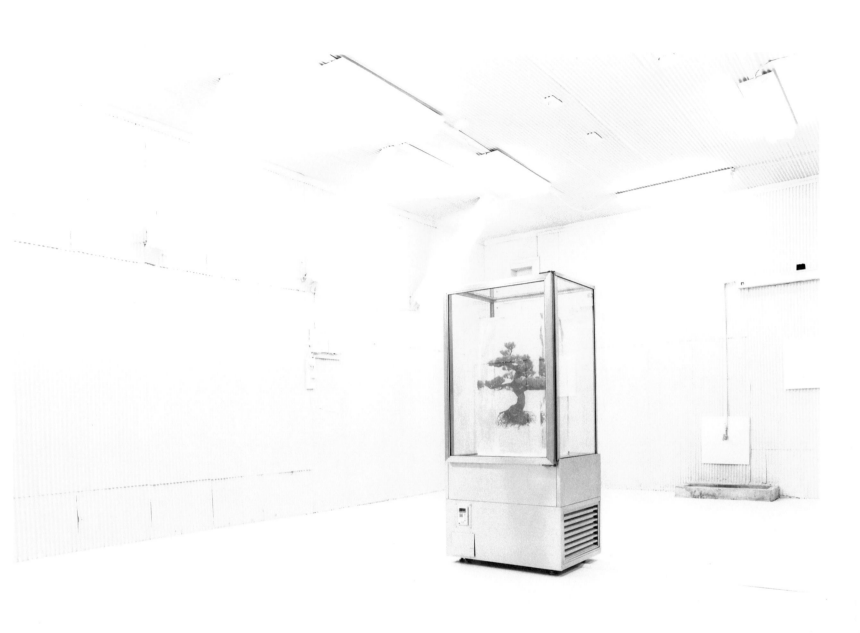

Page 118
<u>TITLE: KEHAI</u>
Artist: Makoto Azuma
Profession: Artist
Country of origin: Japan

Page 119
<u>TITLE: SHIKI 2</u>
Artist: Makoto Azuma
Profession: Artist
Country of origin: Japan

TITLE: DAMNED IKEBANA
Artist: Makoto Azuma
Profession: Artist
Country of origin: Japan

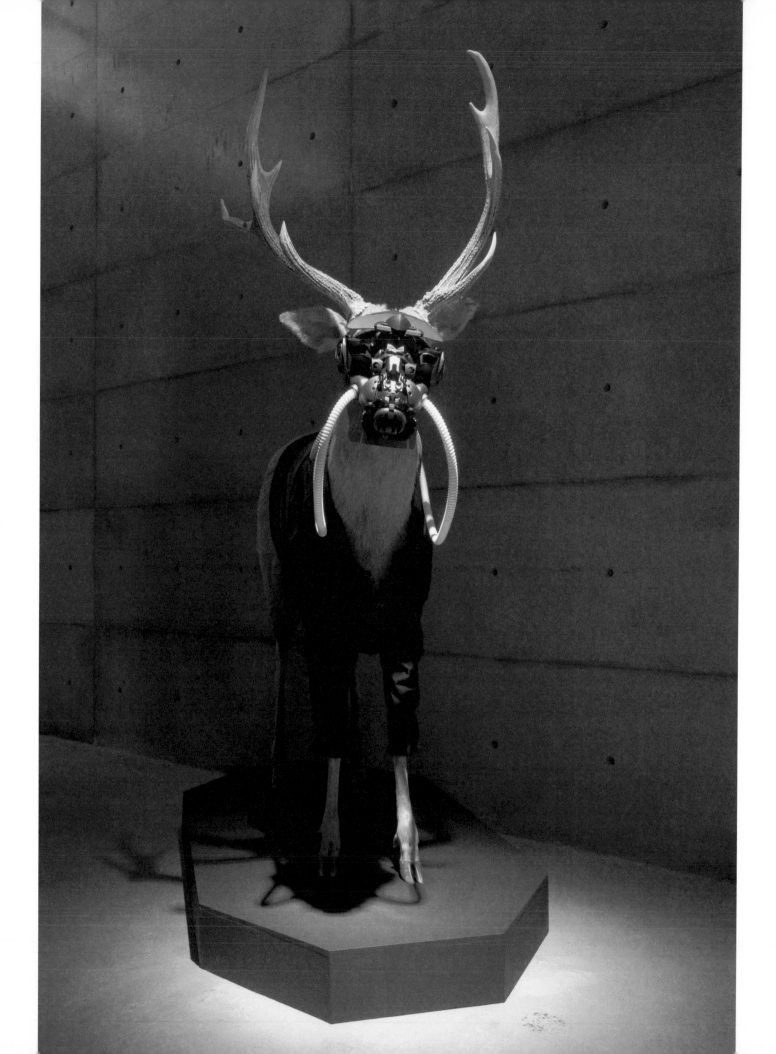

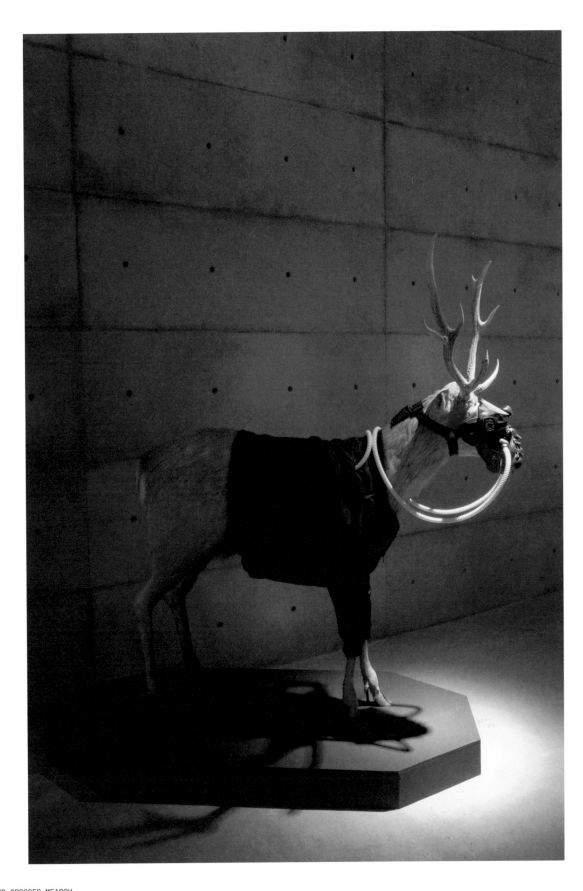

TITLE: BLACK WIND CROSSES MEADOW
Artist: Hiroki Tsukuda
Profession: Artist
Country of origin: Japan
Photographed at DIESEL DENIM GALLERY AOYAMA

smart
as
vase

松　　　桜　　　梅　　　芒
MATSU　　SAKURA　　UME　　SUSUKI

TITLE: SMART AS VASE
Artist: Shun Kawakami
Illustrator: Tadashi Ura
Photographer: Taisuke Koyama
Country of origin: Japan

TITLE: ALEX
Artist: Risa Fukui
Profession: Artist
Country of origin: Japan

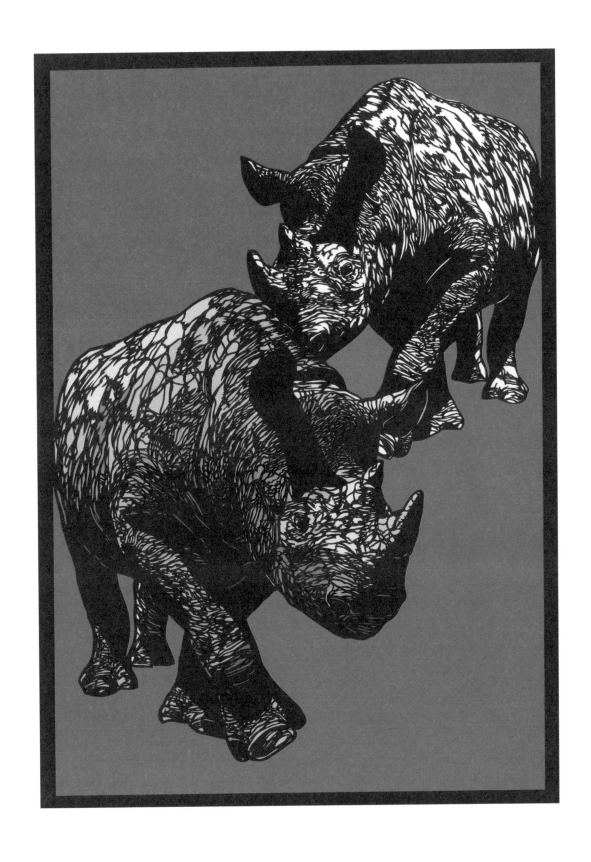

TITLE: RHINO
Artist: Risa Fukui
Profession: Artist
Country of origin: Japan

TITLE: HARU
Artist: Koji Nishida
Category: Interactive Graphic
Profession: Art Director
Country of origin: Japan

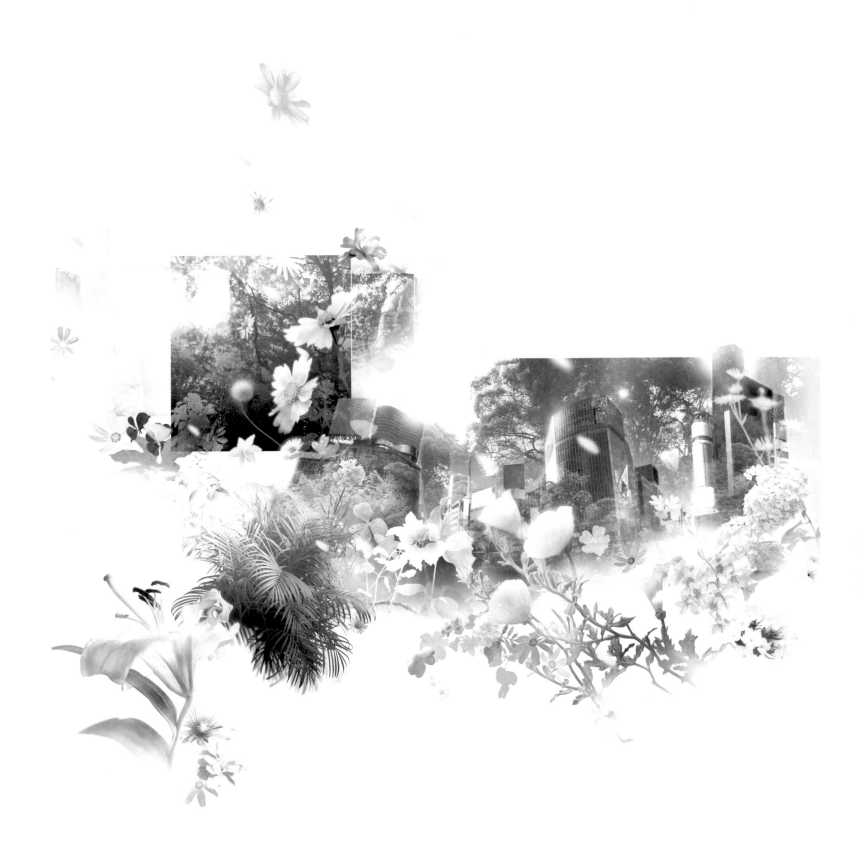

TITLE: SHIBUYA - SHE WRAPS HER ARMS AROUND THEM.
Artist: Koji Nishida
Category: Interactive Graphic
Profession: Art Director
Country of origin: Japan

NOM
AGAZ
INE

NO Magazine is an independent, unisex, high profile, lifestyle magazine that was launched in 2004 by Sven Erik Dahl (Editor-in-Chief), Anne Lena Buraas (Sales and Marketing Director), Rita Frydnes Nordberg (Public Relations) and the renowned Norwegian photographer Marcel Leliënhof (Editor of Photography). Their the goal was to produce Norway's leading lifestyle magazine for both men and women.

NO Magazine underwent big changes in 2006/2007 with the engagement of two new editors – Signe Prøis (Main Editor) and Margrethe Gilboe (Fashion Editor) plus a complete redesign by the new AD team comprising leading Norwegian graphic designer Halvor Bodin and his partner Claudia C. Sandor (former Editor of Contemporary Art for Fjords Magazine). The magazine also expanded from four to eight issues a year, two of these being international, English-language editions that bring NO Magazine out to a broader audience. NO International was released for the first time in New York in June 2007.

NO Magazine is special in a Norwegian context in that it brings all sorts of topics together onto the same platform, but not at the expense of innovation and quality. An elite magazine for the masses? Perhaps. The magazine is dedicated to a diversity of topics such as product, graphic and fashion design, lifestyle, contemporary art, music, entertainment, sports, beauty, travel, and social issues. These are grouped into the magazine's three main departments: culture, social issues and fashion/trends. NO Magazine is particularly dedicated to creativity, presenting a plethora of both Norwegian and international figures who are impor-

tant in their field – be it cultural, social or trend-based. The magazine has a small staff at its core augmented by brilliant contributors from Norway and other countries. This loose structure brings a varied and vibrant aspect to the magazine and helps keep it fresh and alive.

We believe that the mix of top-notch photography, the constantly evolving design and the diversity of topics work together to create a magazine that reflects Norwegian culture in an international context. The aesthetic is less traditionally Scandinavian than what one would expect from this type of magazine. International magazines emerging from Scandinavia tend to be more one-dimensional based on fashion with strict and clean composition and downsized typography. We strive to make a magazine that has a challenging graphic aesthetic but that doesn't distance itself from its more mainstream readers. Typographic experimentation with custom-made fonts is an important part of every issue's design. Fashion editorials tend to be quite unpredictable whereas an article about, for example, an art-collecting real estate magnate is more relaxed. But there are no rules, we want to challenge the traditional slickness in the world of magazine design and bring a bold and intuitive aesthetic to our audience.

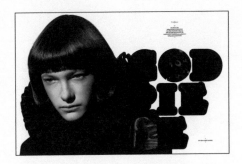

Since its redesign in August 2006 the magazine has received several graphic design awards. It was a runner-up in editorial design at the ED/European Design Awards in Athens in May 2007.

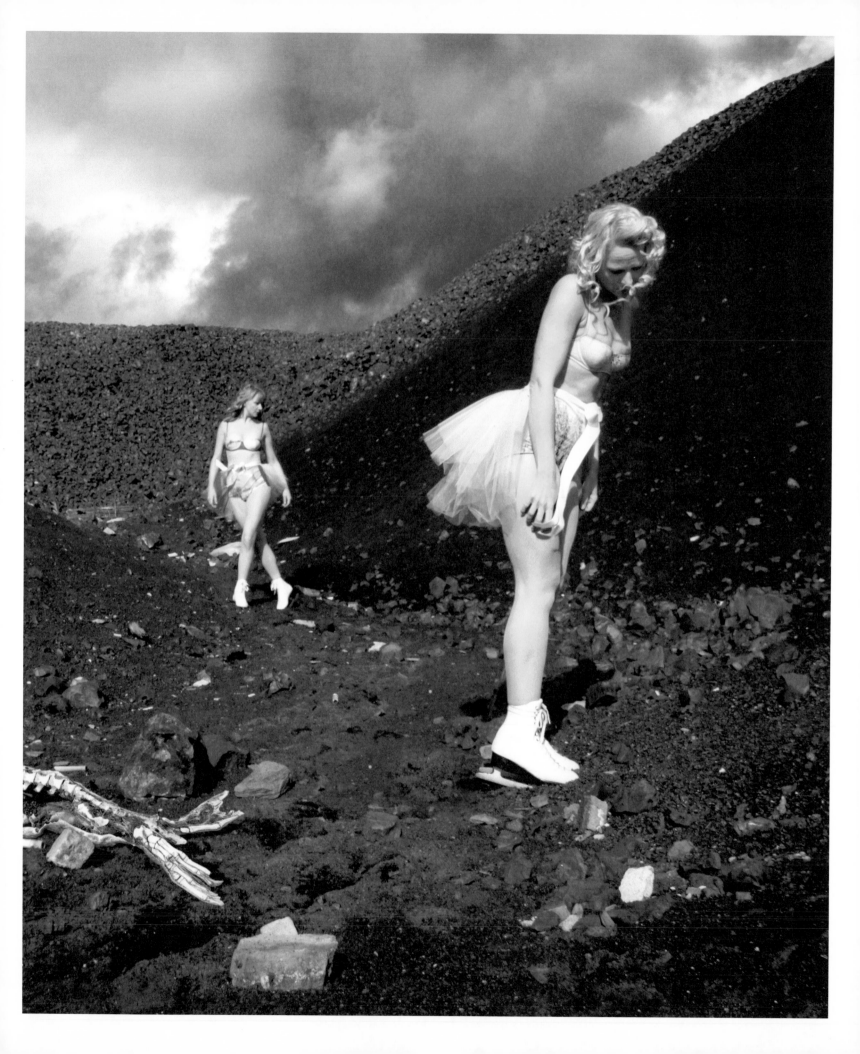

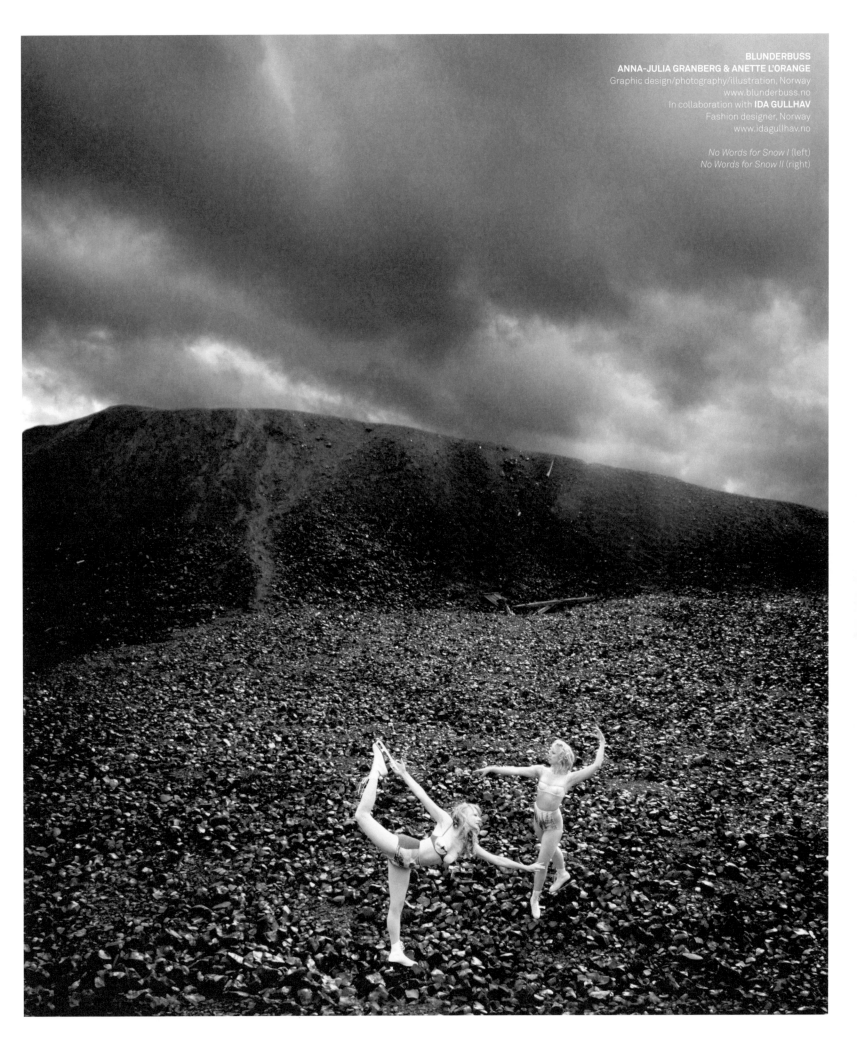

BLUNDERBUSS
ANNA-JULIA GRANBERG & ANETTE L'ORANGE
Graphic design/photography/illustration, Norway
www.blunderbuss.no
In collaboration with **IDA GULLHAV**
Fashion designer, Norway
www.idagullhav.no

No Words for Snow I (left)
No Words for Snow II (right)

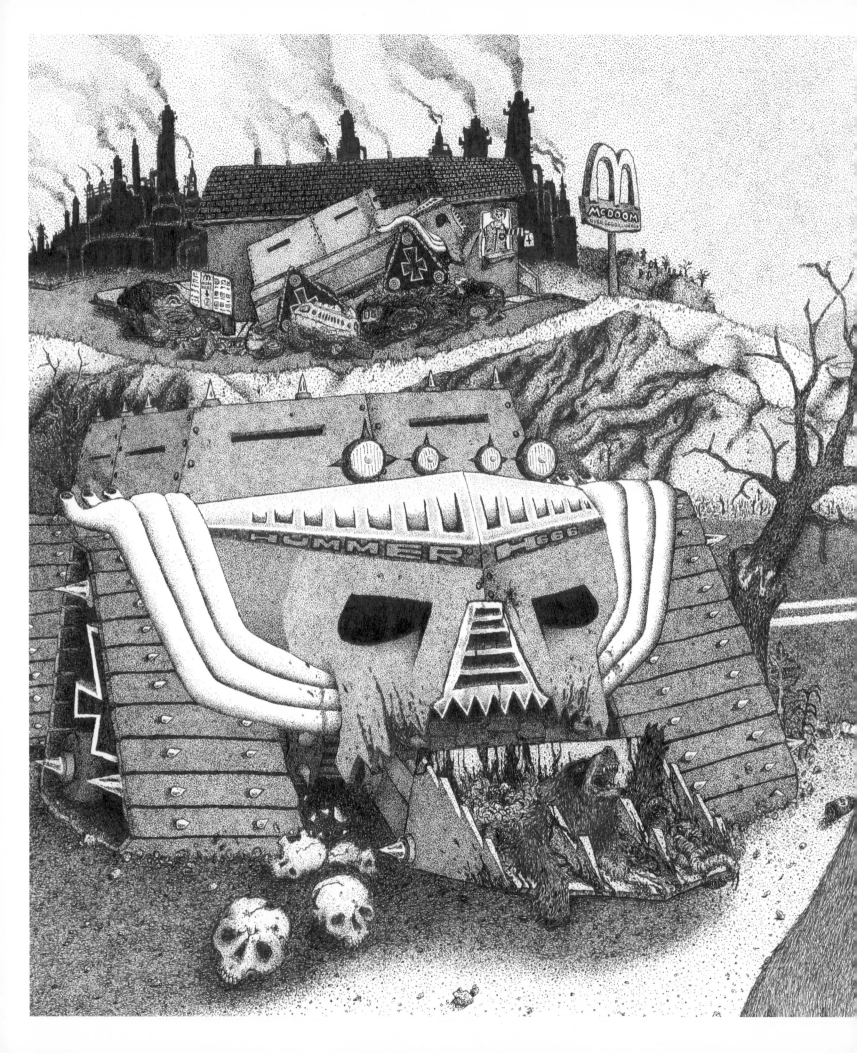

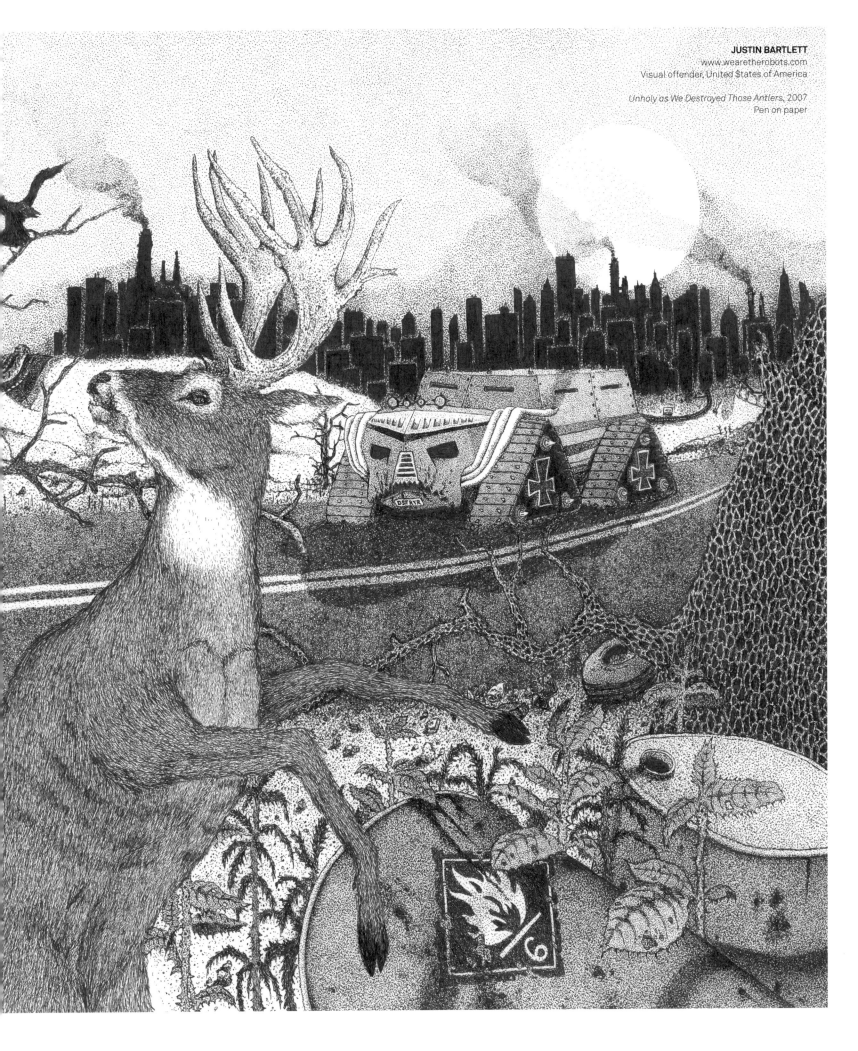

JUSTIN BARTLETT
www.wearetherobots.com
Visual offender, United States of America

Unholy as We Destroyed Those Antlers, 2007
Pen on paper

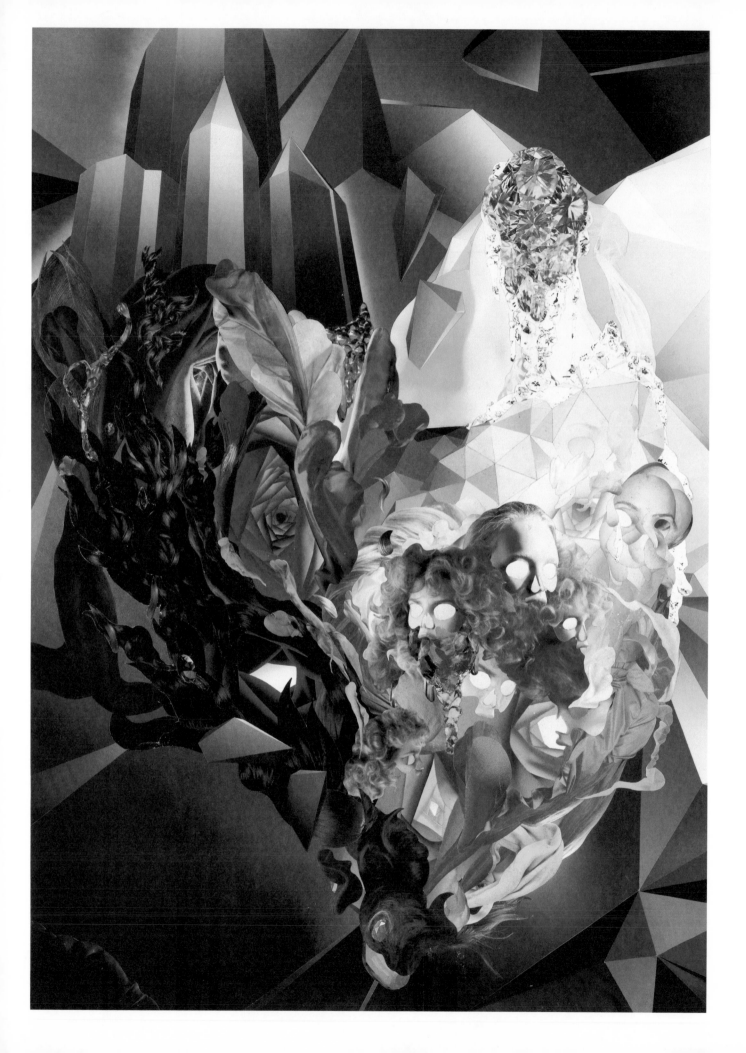

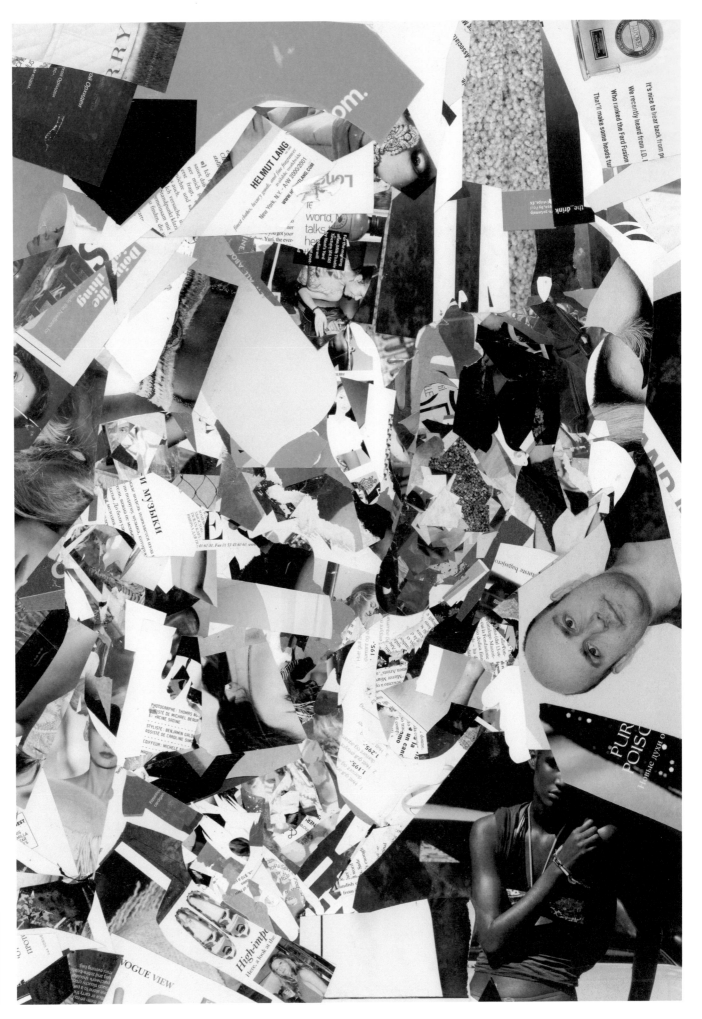

ARE MOKKELBOST
Artist, Norway
www.b-o-r-g.org

ION – 2ND LEVEL, OMNI, NO. 01, paper collage, 2006
Backside view on right is normally hidden
Courtesy of Standard (Oslo)
www.standardoslo.no

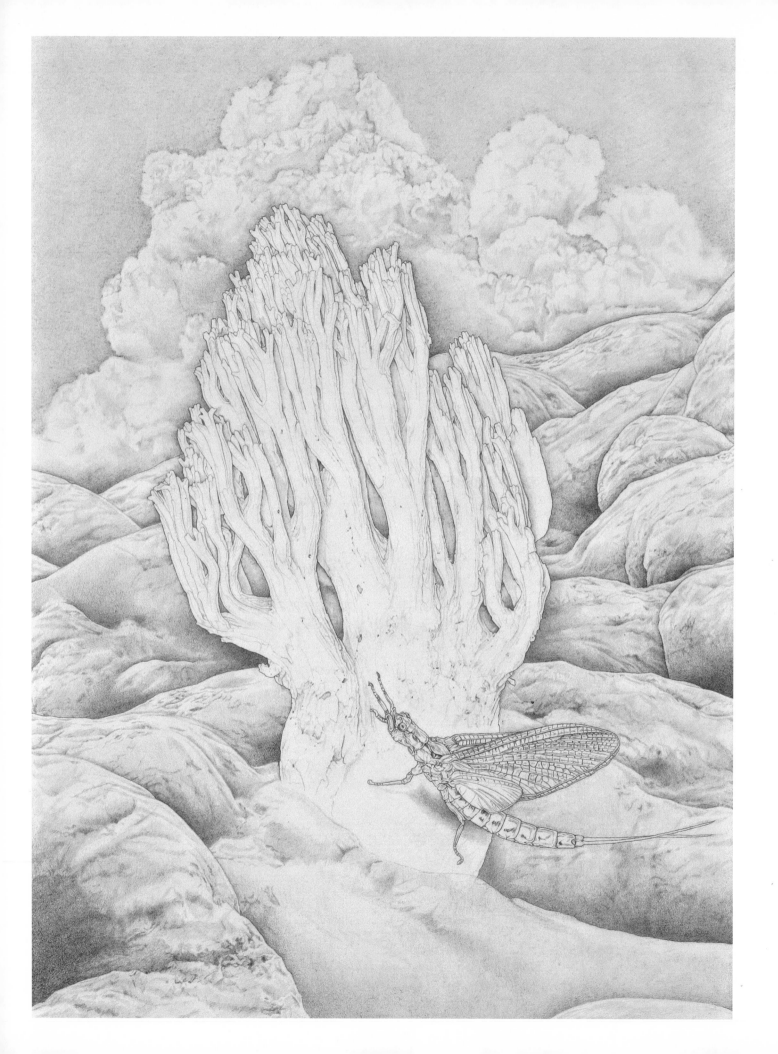

ANE GRAFF
Artist, Norway

Coral Fungus with Mayfly (left)
Copper/Rocks (right), both 2006
Graphite on paper
Courtesy of Standard (Oslo)
www.standardoslo.no

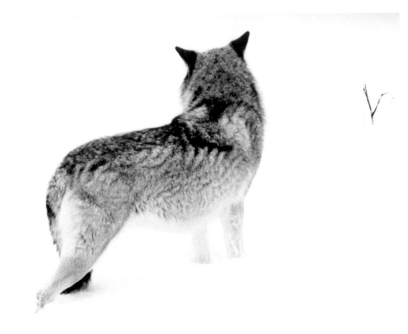

BENJAMIN ALEXANDER HUSEBY
Artist and photographer, Norway

From the series *Natur & Ungdom*, 2006
C-type print (left), silver gelatin print (right)

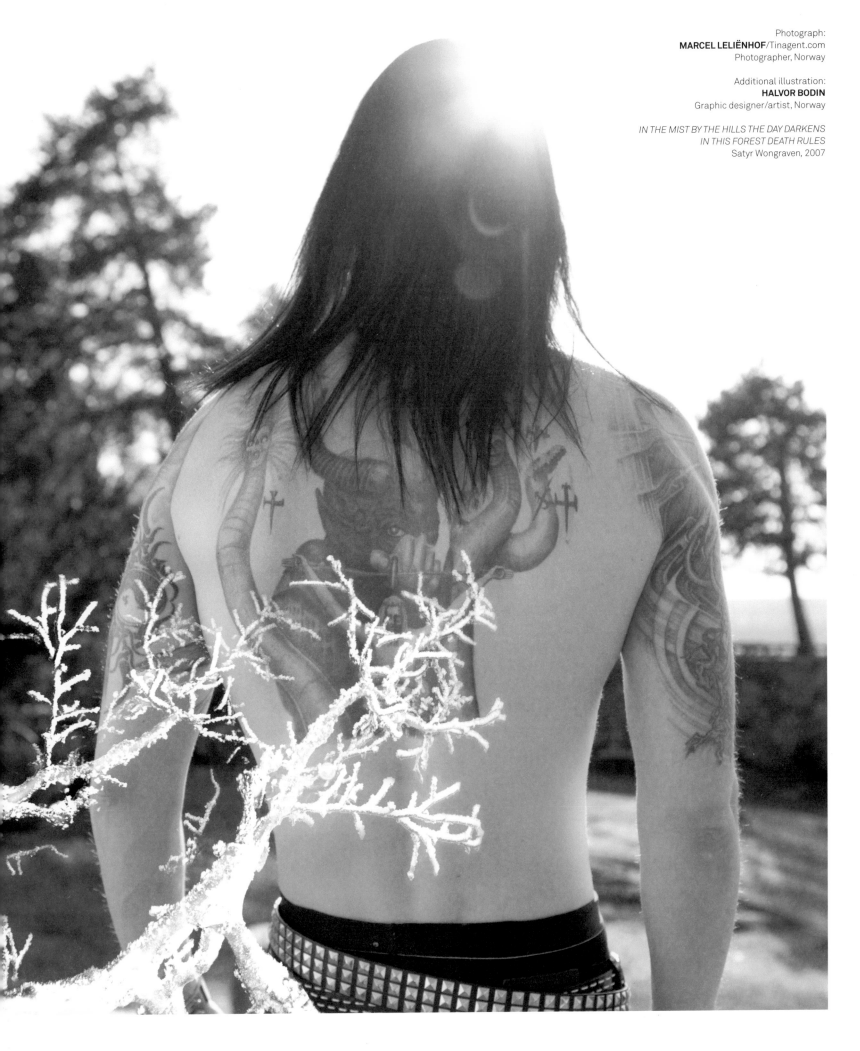

Photograph:
MARCEL LELIËNHOF/Tinagent.com
Photographer, Norway

Additional illustration:
HALVOR BODIN
Graphic designer/artist, Norway

IN THE MIST BY THE HILLS THE DAY DARKENS
IN THIS FOREST DEATH RULES
Satyr Wongraven, 2007

BIPOLAR HORIZON

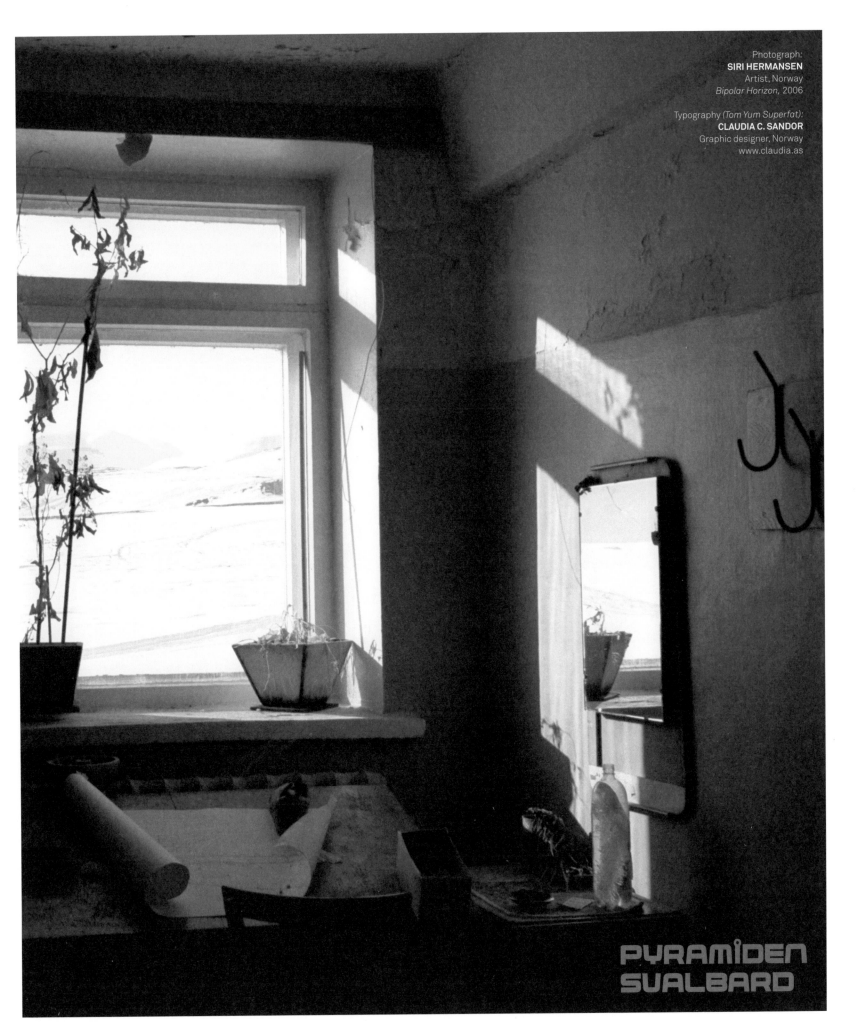

PYRAMIDEN
SVALBARD

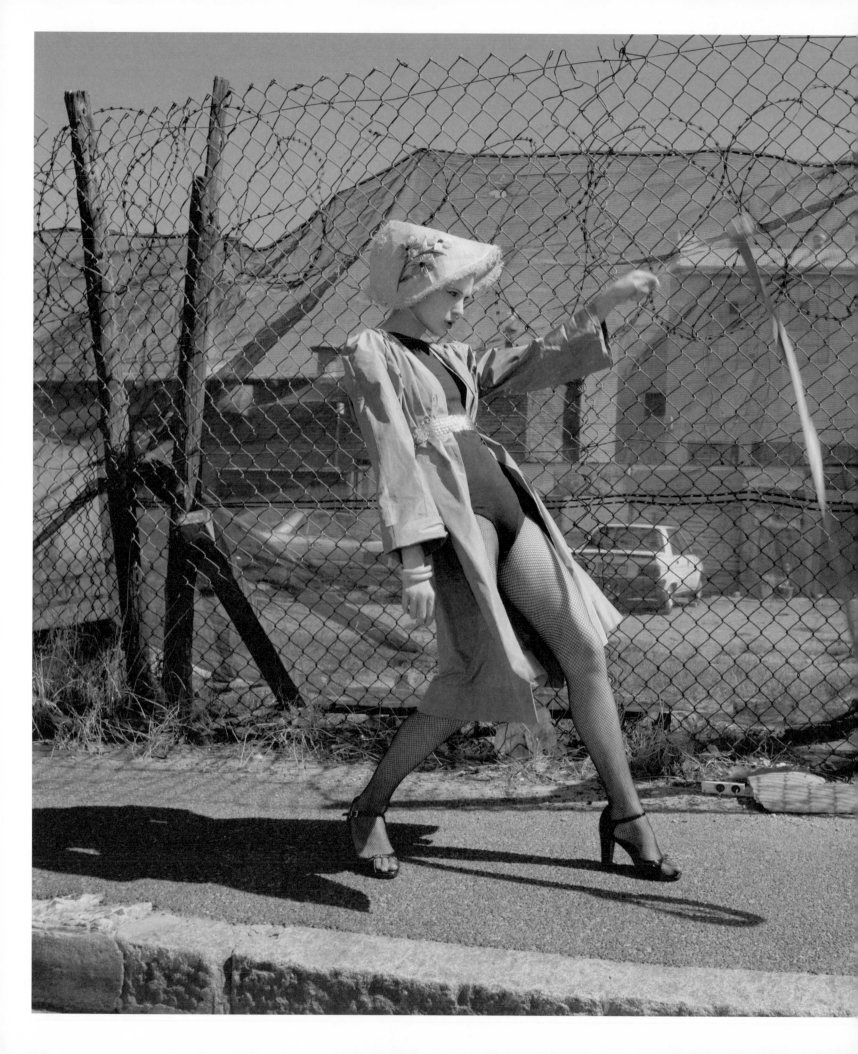

SIREN LAUVDAL
Photographer, Norway
www.siren.no

Urban Geisha, 2006

Model: Julieta Olszewska
Stylist: Jenny Vågån
Hair and make-up: Nicola Weideman
Location: Cape Town, South Africa

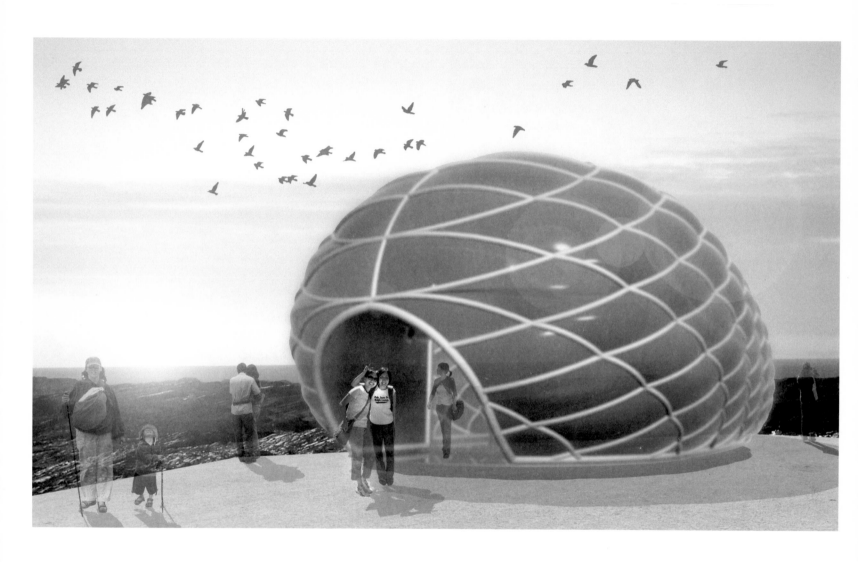

MOBILE CULTURE VESSEL
The Mobile Culture Vessel is designed to provide and develop culture in the regions of Norway.
The vessel consists of two containers, surrounded by an inflatable structure.
It will contain an info centre for activities regarding cultural heritage in the area,
art exhibitions in addition to art and theatre workshops.

mmw architects of norway
Architects, Norway
www.mmw.no

Mobile culture vessel, 2007 for Sund, Fjell and Øygarden, outside Bergen
Renderings: Joakim Skajaa

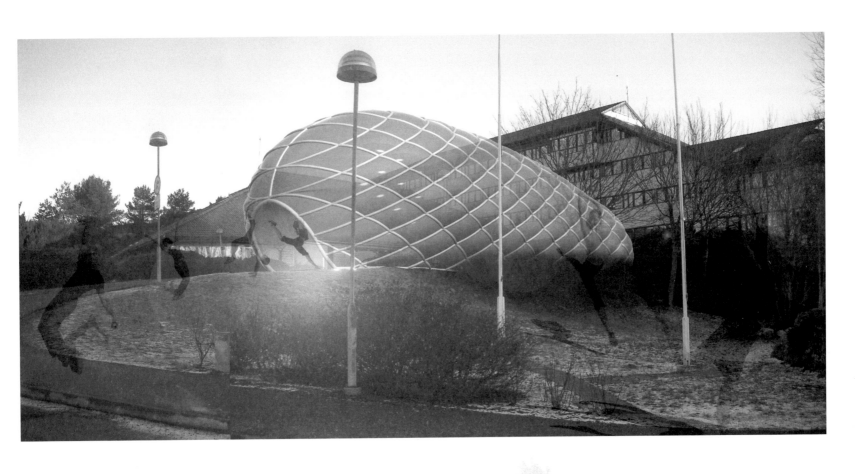

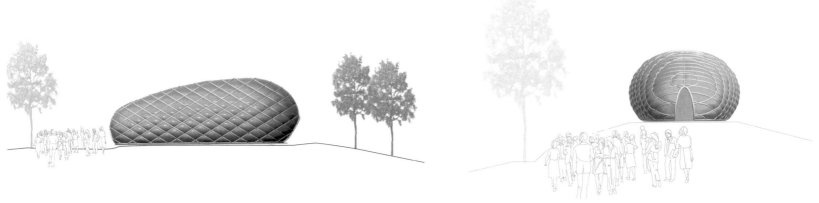

DAZ
ED & C
ONF
USED

»SINCE ITS BEGINNINGS IN THE EARLY '90S, DAZED & CONFUSED HAS HELD A STRONG COMMITMENT TO SOCIAL AND ECOLOGICAL CAUSES. SPECIAL ISSUE THEMES IN THE PAST HAVE INCLUDED ENVIRONMENTAL ISSUES, SOUTH AFRICA AND THE PROBLEM OF AIDS AND HUMAN RIGHTS. RECENT FEATURES HAVE ALSO INCLUDED AN INVESTIGATION INTO THE YOUTH RESISTANCE MOVEMENT IN BELARUS, "EUROPE'S LAST DICTATORSHIP", AND AN INTERVIEW WITH NAOMI KLEIN ABOUT THE IDEAS IN HER CONTROVERSIAL NEW BOOK THE SHOCK DOCTRINE. ALONGSIDE ITS CORE REMIT OF CUTTING-EDGE FASHION AND CULTURE, DAZED CONTINUES TO SEE ENVIRONMENTAL AND SOCIAL ISSUES AS A KEY PART OF ITS MAKE-UP. AS DAZED HAS ALWAYS SUPPORTED YOUNG TALENT, WHEN WE WERE ASKED TO JOIN THE SIDEWAYS PROJECT, IT MADE SENSE AS AN OPPORTUNITY TO GIVE EXPOSURE TO SOME OF THE YOUNG ARTISTS IN OUR RISE ONLINE CREATIVE COMMUNITY, AS WELL AS BEING INVOLVED IN A PROJECT THAT IS HELPING THE ENVIRONMENT.«

With its new online platform, Dazed Digital, the magazine has now extended its cutting-edge and groundbreaking ethos to the web. As an ideas sharing network, Dazed Digital posts exclusive video interviews, live footage of tomorrow's music stars, behind-the-scenes fashion reportage, and exclusive features above and beyond what is in the magazine, alongside daily blogs and submissions from its extended global network of writers, photographers, artists, and activists. Dazed has also taken its long-established tradition of nurturing and supporting new talent to the next level in the Rise section of Dazed Digital, where new talent in music, illustration, fashion and photography is profiled by Dazed's in-house creatives, with a special guest judge each month.

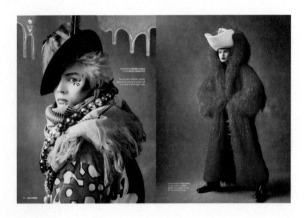

Founded by prodigious photographer Rankin and writer and cultural enthusiast Jefferson Hack, and taking its name (and freewheeling spirit) from the classic Led Zeppelin song, Dazed & Confused started life as a limited-run, foldout poster in 1992. Cover stars in those early days included PJ Harvey, Damien Hirst, Richard Ashcroft, Chloe Sevigny, Pulp's Jarvis Cocker, Robert Carlyle, Kate Moss and Milla Jovovich. It was during this time that D&C cemented its growing international reputation for daring to extend its editorial remit beyond fashion, music and film, not just to include art and literature, but to tackle local and international social and political themes.

Outspokenly independent, Dazed & Confused prides itself on its agenda-setting editorial, world-beating fashion, superb photography and illustration, great music and film coverage and headline-grabbing events. Now distributed in over 40 countries, and with admirers and imitators across the globe, Dazed & Confused has come a long way since its first steps in the early '90s.

With its fashion, photography and art content long established as being right at the forefront of contemporary magazine culture, in recent years Dazed has brought its music and film editorial up to similarly rarefied standards with a long list of UK and world firsts, including covers featuring the likes of Eminem, The Libertines, Pharrell Williams, and Alicia Keys. Under its current editors Nicki Bidder and Rod Stanley, recent cover exclusives have included The White Stripes, Maggie Gyllenhaal, Bloc Party, Zooey Deschanel, Sofia Coppola, Justin Timberlake, the Yeah Yeah Yeahs, and Selma Blair.

The magazine's strong music association has also seen the Dazed & Confused brand extended to high-profile live concerts, such as the 2007 War Child benefit at Koko in London, which featured upcoming stars The Noisettes, Metronomy, Friendly Fires, and Late of the Pier. Dazed also recently launched its own club night DZD, featuring live music and DJs, footage from which is posted on Dazed Digital.

Today, still 100 per cent independent in ownership and in spirit, Dazed & Confused is one of the most influential monthly magazines in the world. Far from resting on its reputation, the Dazed Digital format is now pushing its taste and influence into new areas to engage a new generation of switched-on, intelligent, aware and influential individuals.

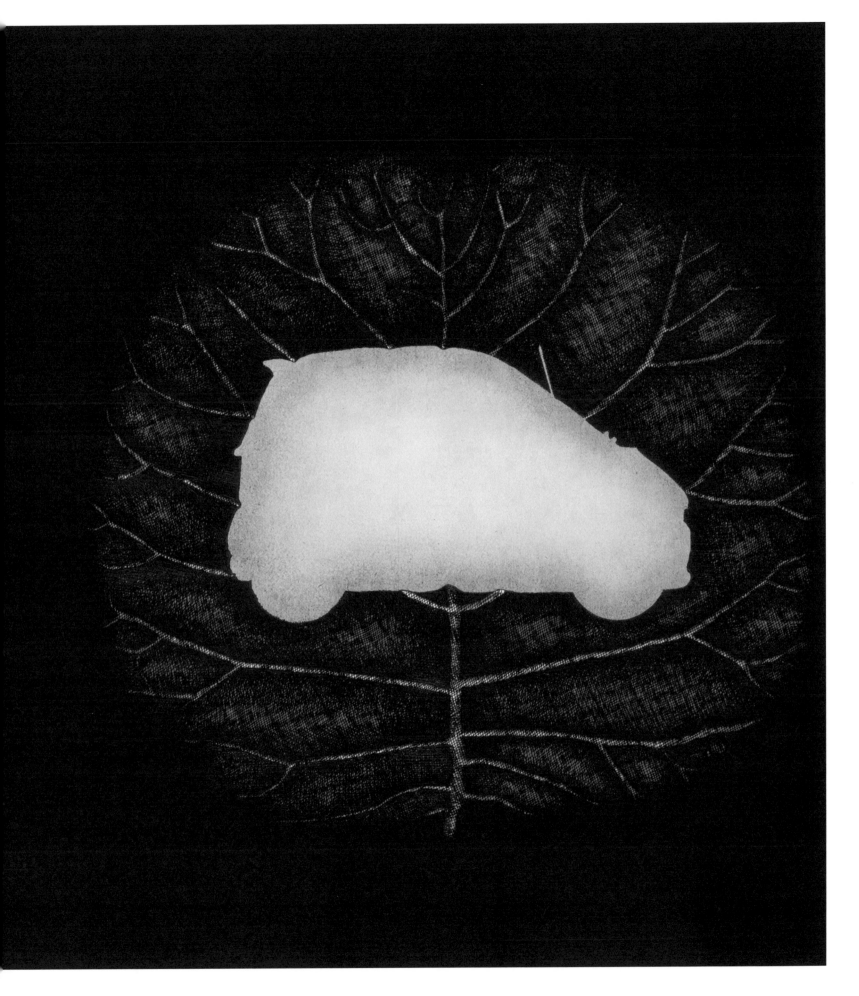

MATTHEW BARNES
http://thebattle.co.uk/

SHUN MATSUZAKA
www.illustrashun.com

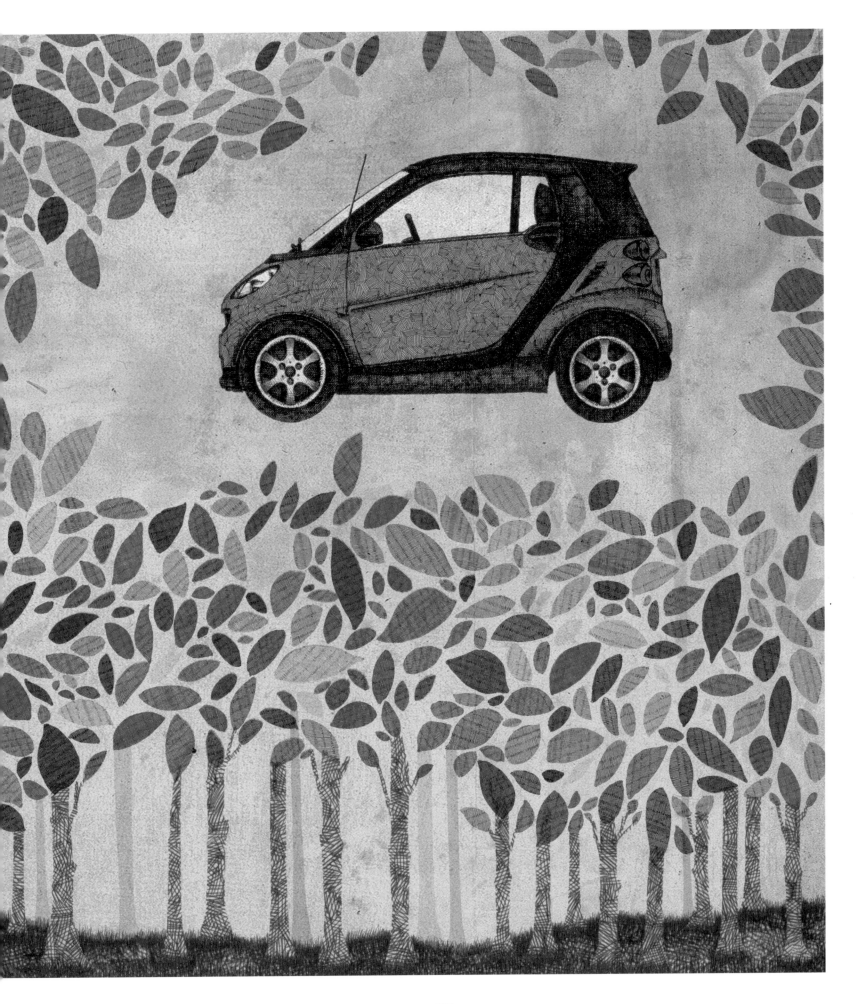

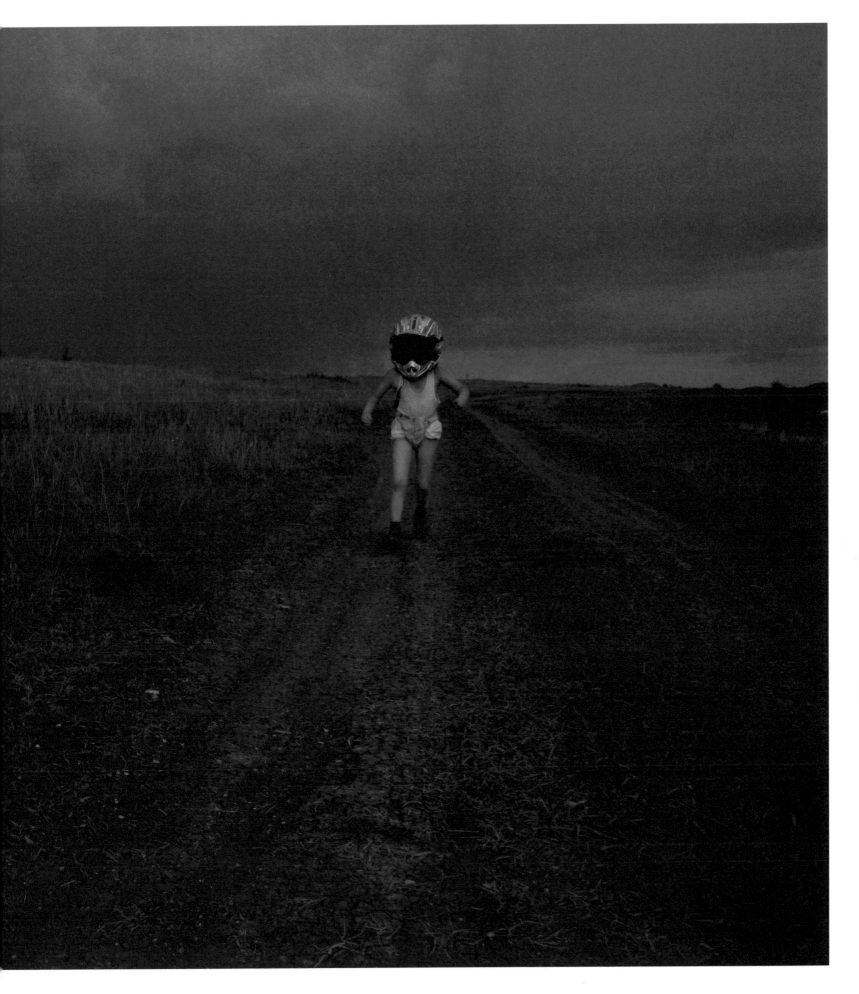

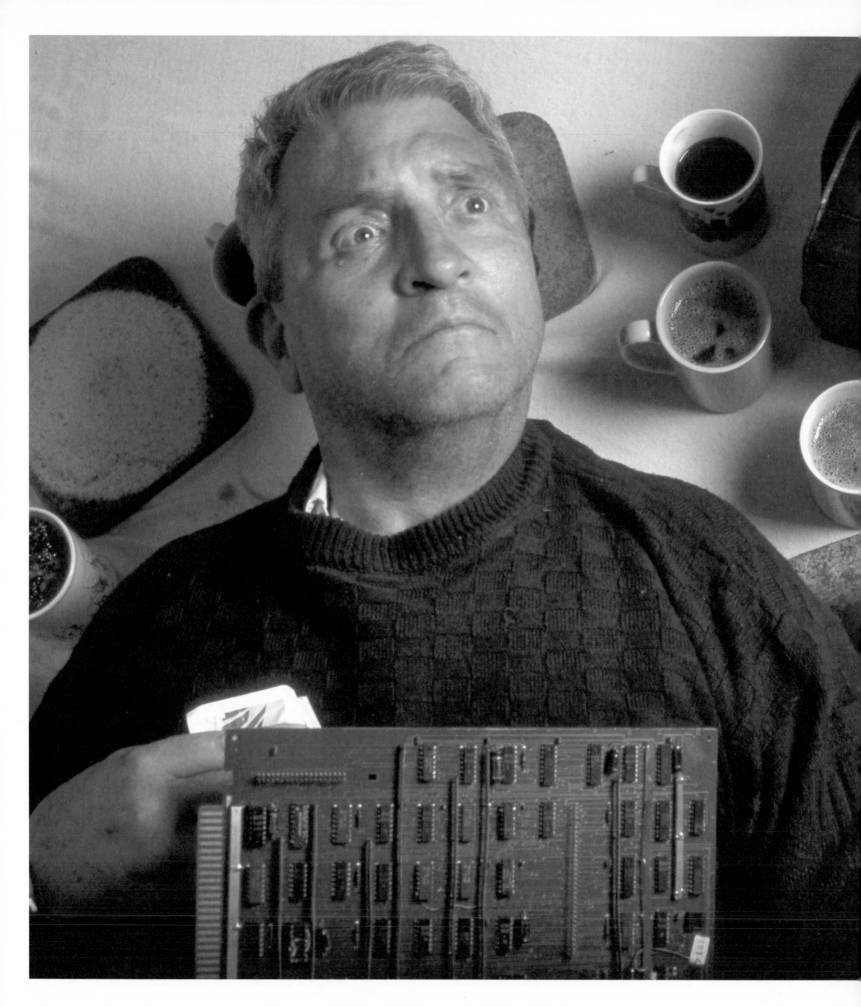

RACHEL DE JOODE
www.racheldejoode.com

Ecology - a study of the interrelationships of living organisms and
their environment.
Death of a Salesman - Coffee-, a Tableaux Vivant of a human body & it's
personal belongings. 2007

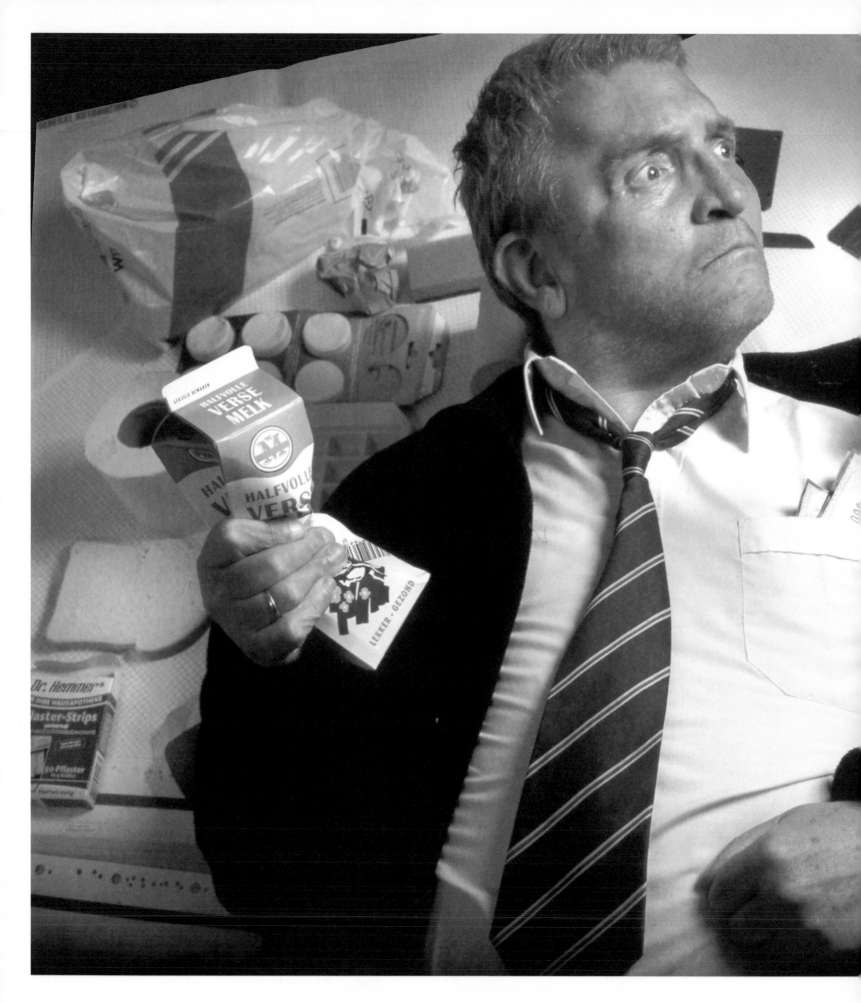

RACHEL DE JOODE
www.racheldejoode.com

Ecology - a study of the interrelationships of living organisms and
their environment.
Death of a Salesman - Milk-, a Tableaux Vivant of a human body & it's
personal belongings. 2007

BAB
YBA
BYB
ABY

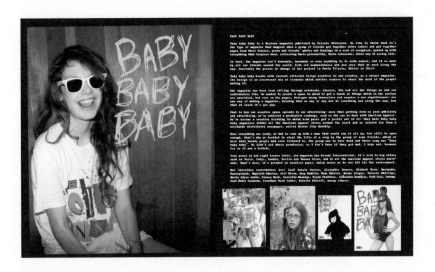

Baby baby baby is a Mexican magazine published by Celeste Editorial. We like to think that it's the type of magazine that would happen when a group of friends got together after school and combined pages from their diaries, poems and friends' photos and drawings in a sort of scrapbook, pasted full with everything that inspires them, reflecting their personality, their innocence and their way of seeing life.

Baby baby baby isn't homemade or handmade either, and doesn't even have anything to do with school, but it is made by all our friends around the world, from old acquaintances to new ones that we meet along the way. The person currently in charge of this project is Paola Viloria, Editor-in-Chief.

Baby baby baby is a unique magazine in that it breaks with current editorial design practice in our country. Its design is an irreverent mix of elements, which invites readers to share the mood of the people making it.

The magazine was born from rifling through notebooks, diaries, CDs and all the things we and our contributors like. We wanted to create a space in which to put together a bunch of things, that may seem unrelated on the surface but, once on the page, create a dialogue and thus acquire new significance. It is our own way of making a magazine, we know that we may or may not be doing something new along the way, but at least it's our way.

This is also how our creative space spreads to our advertising: more than being just a publicity and advertising vehicle, we've achieved a productive exchange with our clients. With American Apparel, for example, we've achieved a creative blending from which both parties profit: they display Baby baby baby magazines in all the American Apparel stores around the world and we have created a new worldwide distributed newspaper for them called Mexico City Monthly.

Once the concept was in place, we had to come up with a name for our magazine that would sum it all up, but still be open enough. That's why we decided to steal the title of a song by a group of some friends, which no more than twenty people had ever listened to. The group is called the La Live Band and the song was entitled "Baby baby baby". We didn't ask their permission, so we don't know if they got mad. We hope not, because for us it was intended as a tribute.

Four years on and eight issues later, our magazine has gone international. It is sold in big cities such as Paris, Tokyo, London, Berlin and Buenos Aires and, of course, in all the American Apparel stores worldwide. What's more, it's printed on wood-free paper, which means we do our bit for the environment.

Our favourite contributors are: José García Torres, Alejandro Romero, Richard Kern, Martynka, Wawrzyiniak, Napoleón Habeica, Jeff Olson, Lucy Hamblin, Vava Ribeiro, Nacho Alegre, Valerie Phillips, Mario López Landa, Stacey Mark, Carlotta Manaigo, Bryan Rindfuss, Señoritas González, Todd Cole, Catsup, José Pedro Casanova, Jonathan Beck Leder, Roberta Ridolfi, amongst many others.

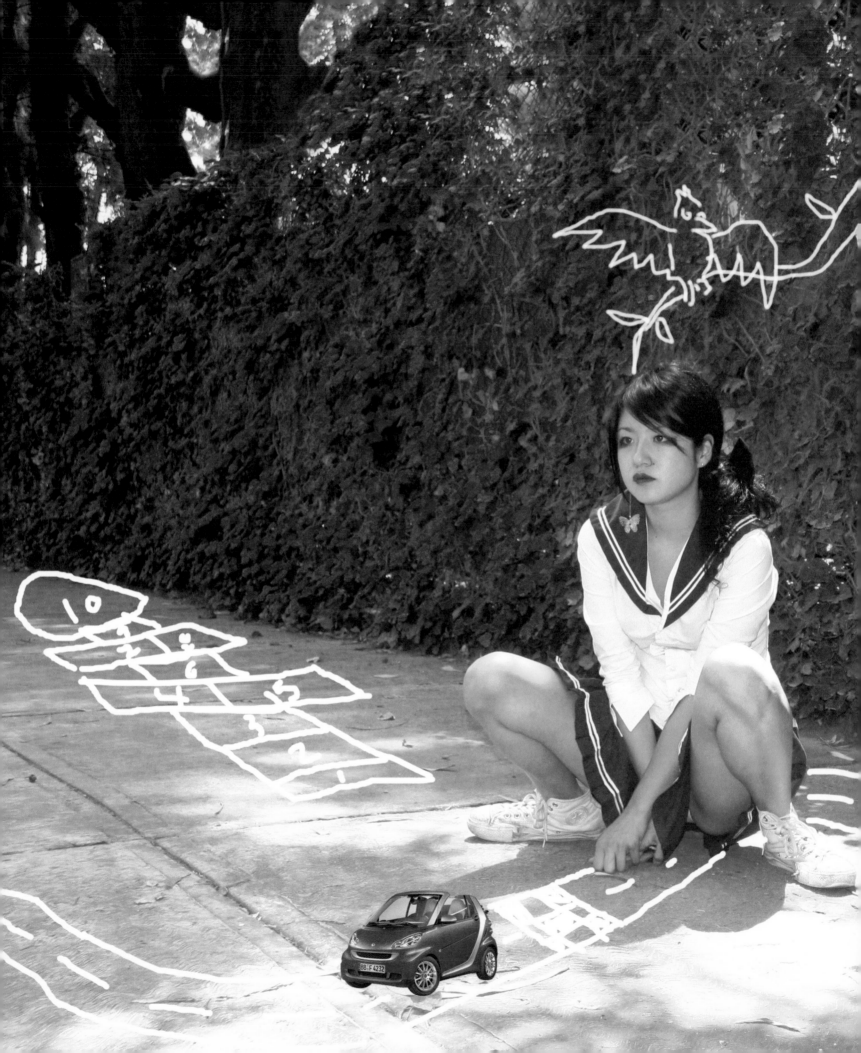

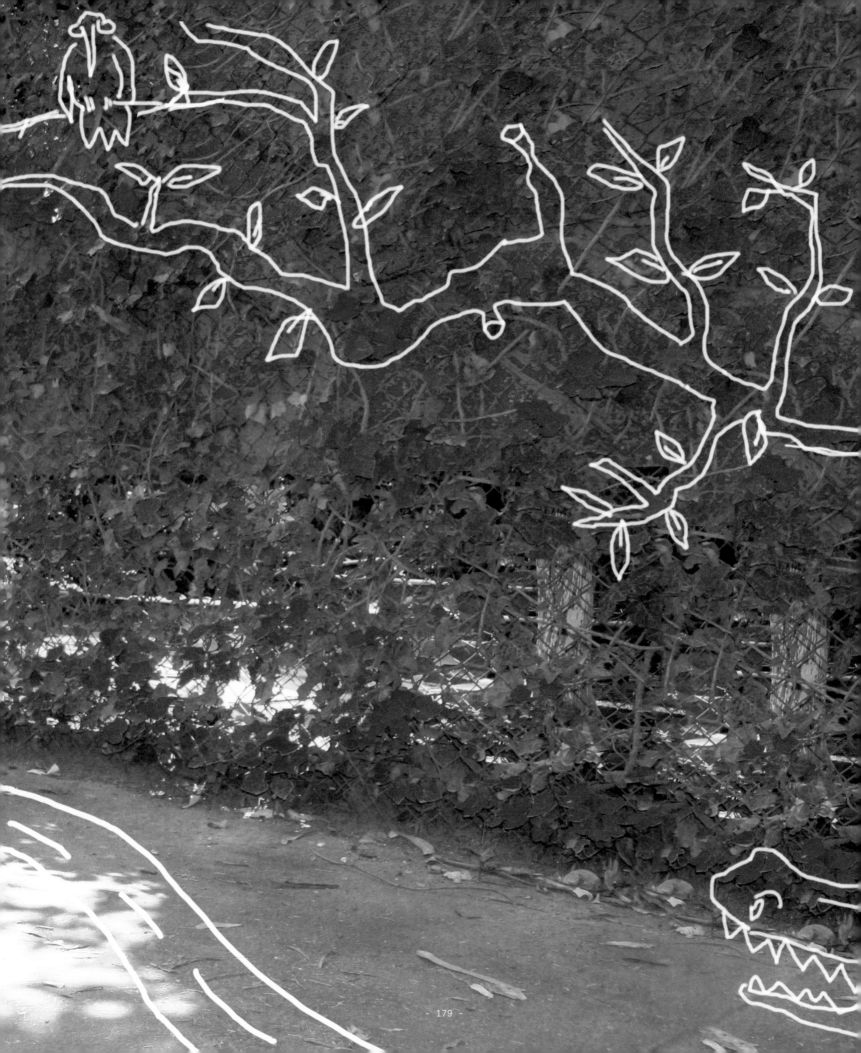

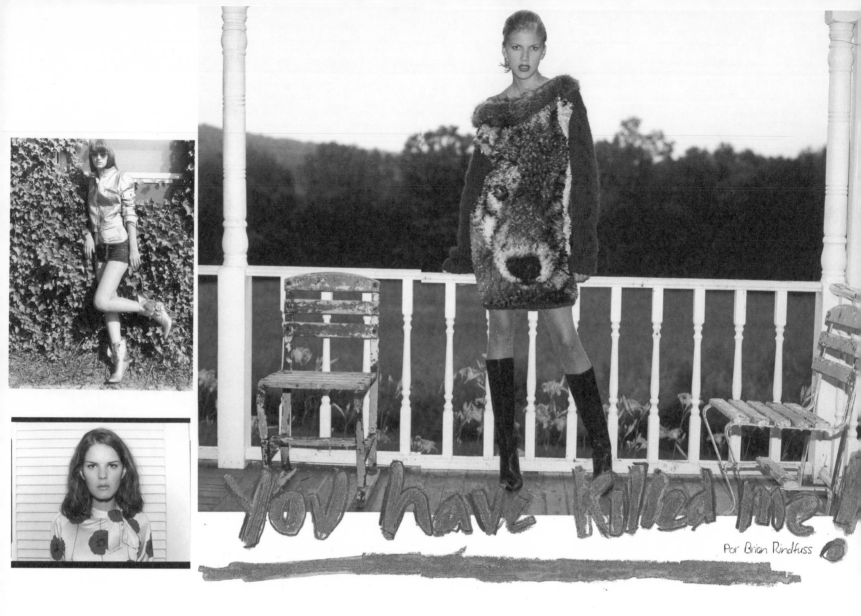

You have killed me!

Por Brian Rindfuss

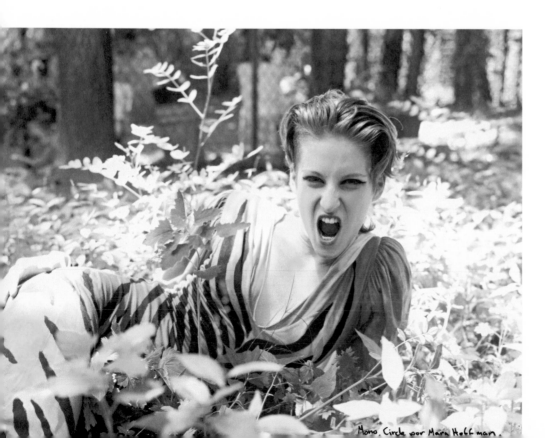

Mono. Circle por Mara Hoffman.

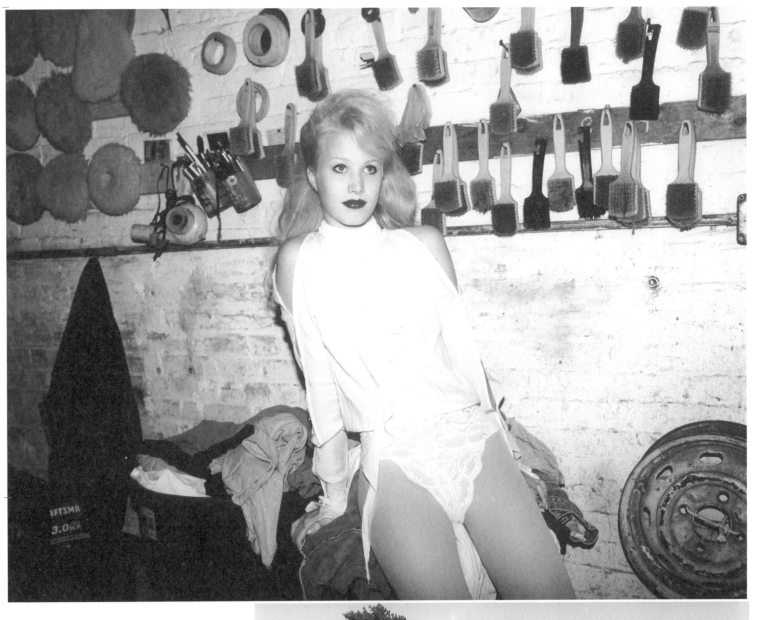

You Have Killed Me, Bryan Rindfuss, Photography, Blue Star Contemporary Art Center, USA.

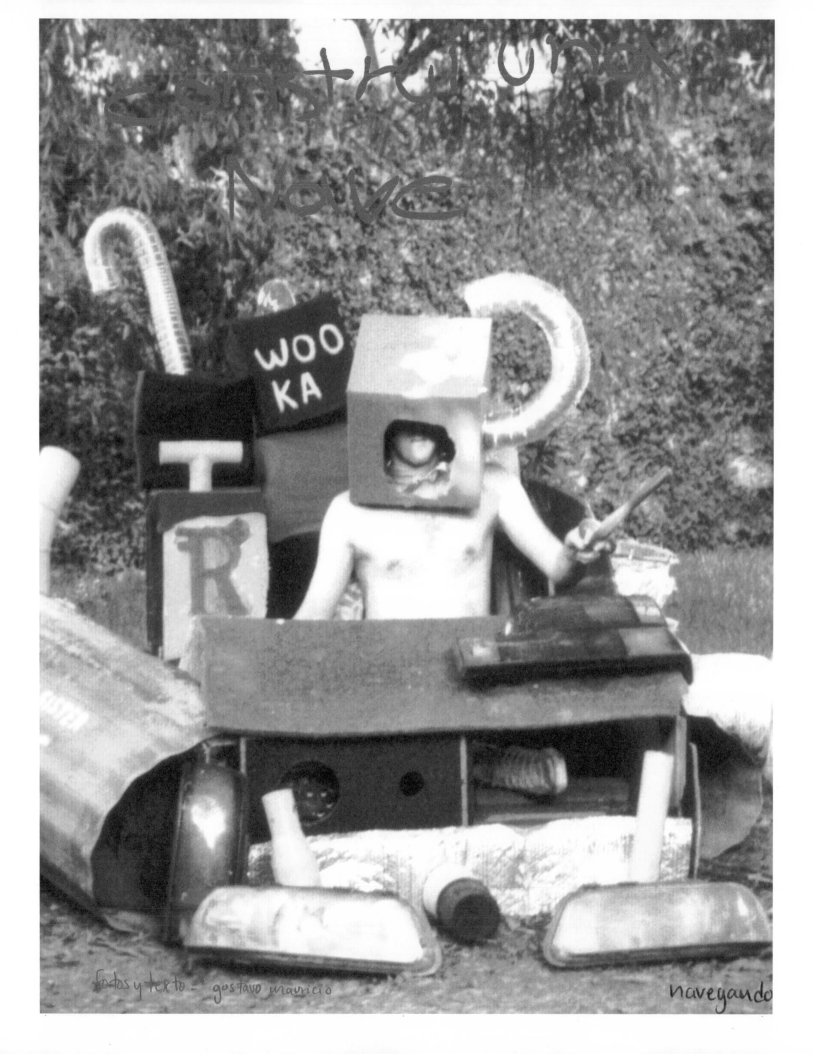

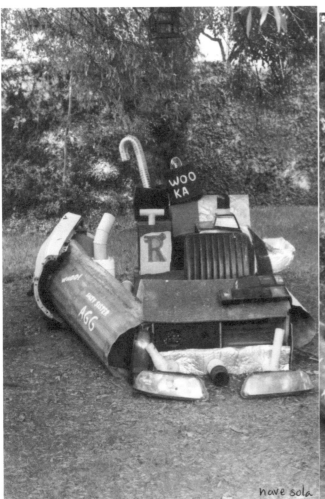

nave sola Interactuando

Listo

Construí una nave espacial y tiempal... funciona... un huracán llamado Emily pasó por la nave y la averió un poco, pero nada que una tarde de labor no pudiera arreglar... la nave funcionó aún mejor que antes... Luis Ezequiel tomó el registro y me dijo que Minka y Lola eran como mis *sidekicks*... yo, más bien pensaba que eran las criaturas nativas... después de pensarlo me vino mejor el que ellas fueran mis compañeras de aventuras... Esa noche acabé dentro de un cráter en medio del desierto nuevoleonés, cerca de un aereopuerto moderno... en el cráter se estaba llevando a cabo un festival musical... no había más de 70 humanos... los Delinquent Habits 2005 estaban tocando... hace tiempo, una amiga me contó que en la cede terrestre del teatro, donde se atienden todos los asuntos del teatro internacional, se cuestionaban si deberían incluir a un representante de México en la mesa redonda... la respuesta, supongo que unánime, fué un rotundo no, ya que todos concordaban que México era un país sumamente surrealista... un chavo en el cráter se me acercó y me preguntó; oye ¿tu vendes?... por desfortuna no se me ocurrió nada que venderle en ese momento y pues le contesté, "no"... tal ves le pude haber vendido mi nave... creo que el la necesita mas que yo... aparte, mi mamá ya me está molestando que ocupa mucho espacio y que la tire a la basura... lo malo es que no cabe en la basura... qué buenos recuerdos me traerá en un futuro esta nave... AGG salty sister..

Gustavo

Construí una nave, Catsup, Architechture, Mexico.

Vestido, TataNaka; camiseta, Mavi; pulsera, AVL.

Garden Fairy

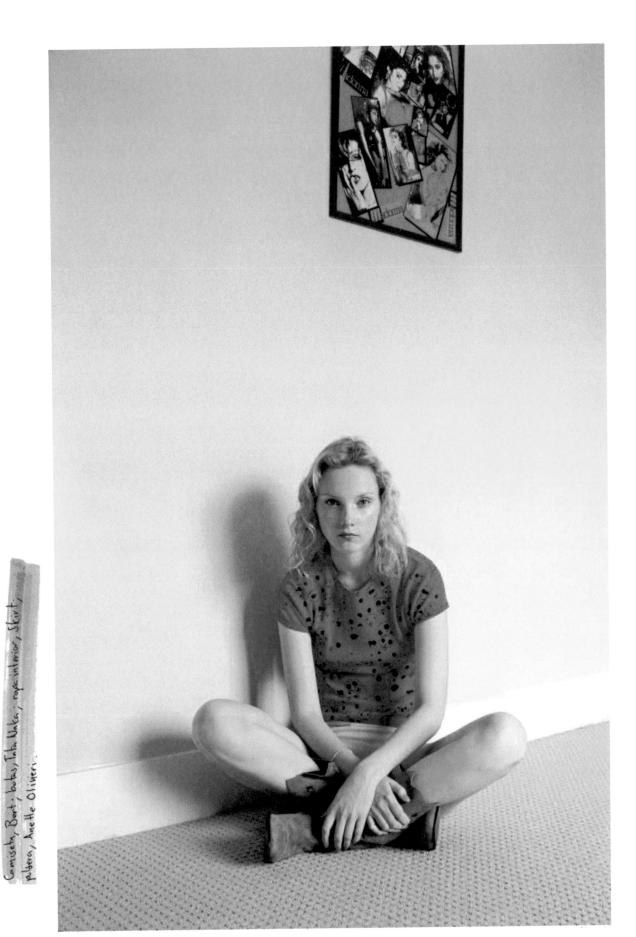

fotografía: Valerie Phillips
Coordinación de moda: Lou Winwood.
Assistente: Lily Lacw
Maquillaje y peinados: Talia Shabrook
Modelo: Illona/Select

Camiseta, Bart; botas, Tata Naka; ropa interior, Skirt;
pulsera, Anette Olivieri.

Garden Fairy, Valerie Phillips, Photography, USA.

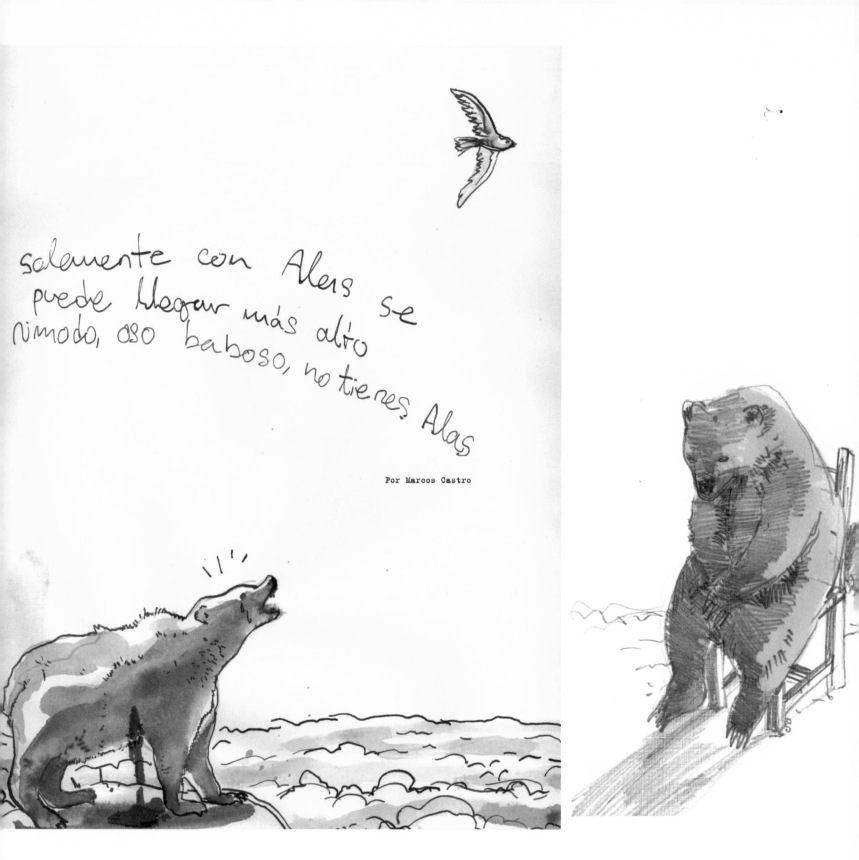

solamente con Alas se
puede llegar más alto
nimodo, oso baboso, no tienes Alas

Por Marcos Castro

Oso baboso, Marcos Castro, Illustration, Proyectos Monclova Gallery, Mexico.

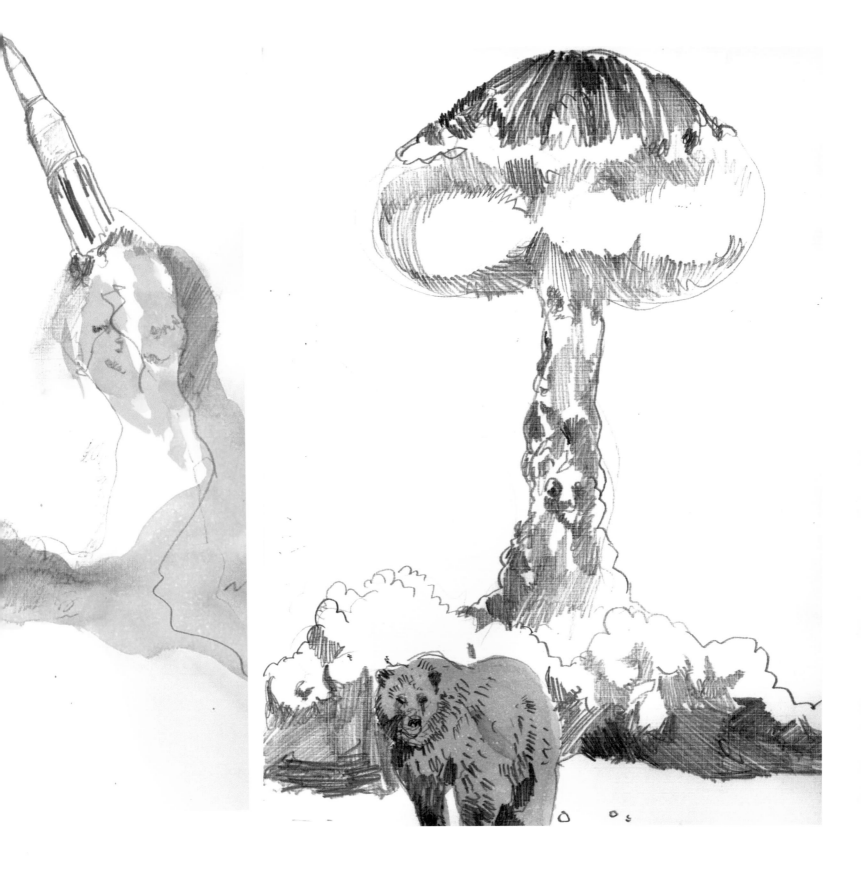

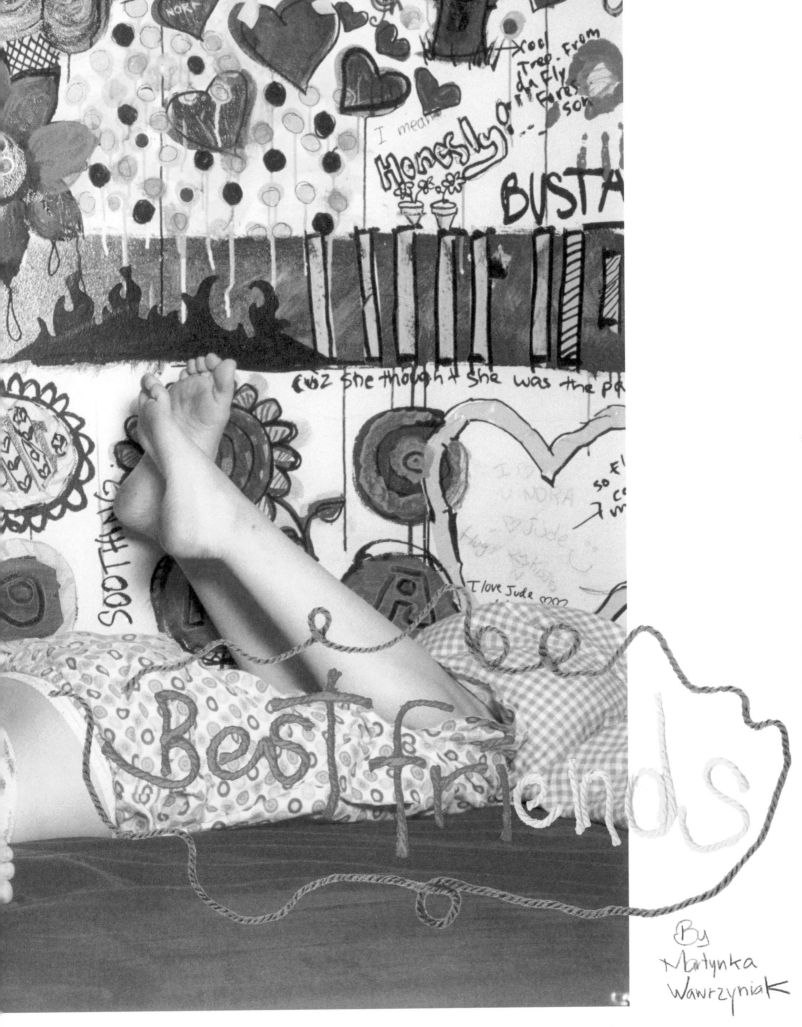

Best Friends, Martynka Wawrzyniak, Photography, tinyvices, USA.

Soldadita

By Jeff Olson

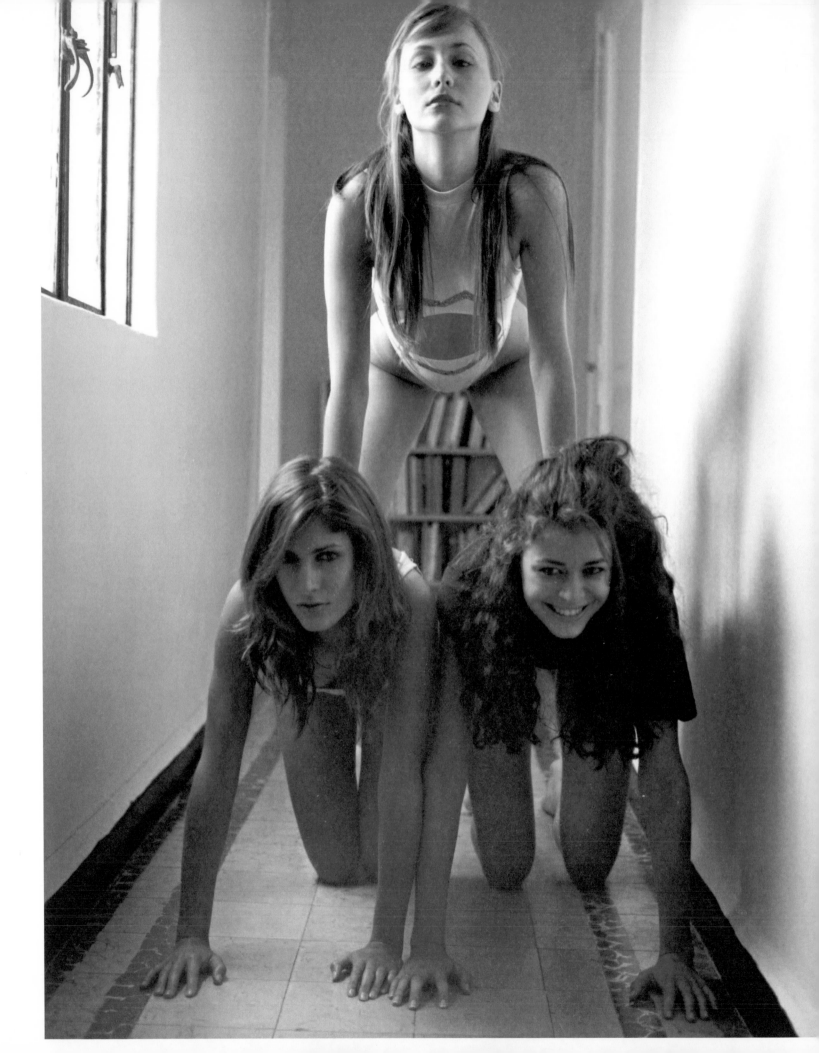

CAMPEONAS

fotos: napoleon habeica
coordinación: Paola Viloria

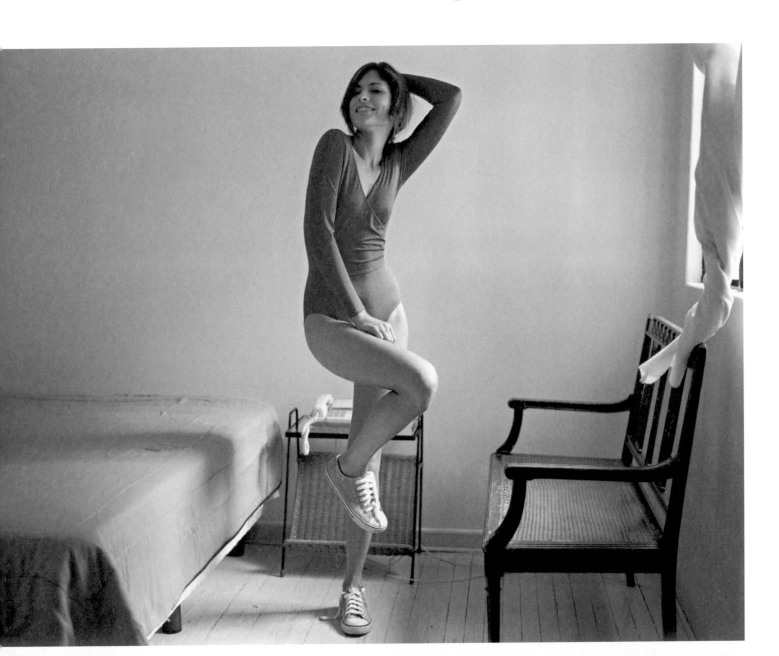

Campeonas, Napoleón Habeica and Paola Viloria, Photography and Styling, Proyectos Monclova Gallery, Mexico.

BL
END

»BLEND MAGAZINE IS ALL ABOUT AWARENESS; ABOUT SEARCHING FOR AND EXPLORING NEW VENUES AND POSSIBILITIES; ABOUT FRESH IDEAS AND BRILLIANT SOLUTIONS. AS SUCH, ECOLOGY IS AN UNDERLYING THEME THAT, FRANKLY, MANKIND CANNOT EXIST WITHOUT. ON A DAY-TO-DAY LEVEL, BLEND MAGAZINE STAFF CYCLE, WALK OR TAKE PUBLIC TRANSPORT TO THE EDITORIAL OFFICE OR TO APPOINTMENTS. THE CREATIVE DIRECTOR SHOPS AT THE ECOSTORE. THE EDITOR-IN-CHIEF DOES NOT OWN A DRIVER'S LICENCE OR A CAR - BY DESIGN. AS AN EXCITING PLATFORM FOR NEW CULTURAL EXPRESSIONS, BLEND MAGAZINE IS ALWAYS CAREFUL TO EMPHASISE THAT MOST IMPORTANT OF UNDERLYING THEMES: WITHOUT A HEALTHY EARTH WE WILL BECOME LOST LITTLE ORPHANS FOREVER IN SEARCH OF THEIR TRUE AND FIRST MOTHER. BLEND WANTS TO SUPPORT ECO-FRIENDLY PROJECTS AND USE THIS UNIQUE OPPORTUNITY PROVIDED BY SIDEWAYS TO GIVE AN INTERNATIONAL PLATFORM TO YOUNG CREATIVES.«

Blend is a unique, fresh and pure magazine for young creatives. It is the medium for people who want to know what's out there and around the next corner in the world of the fashionable and the cool. Blend magazine is edgy and tasteful with a high credibility rating. Focusing on the subjects of fashion, media, people, music and art, Blend considers itself to be essential reading for followers of the fast track creative world.

The magazine combines stylish photography with in-depth and exciting interviews with iconic figures such as Matteo Gambi (Guru), Andrea Rosso (55DSL), Fong Leng, Erin O'Connor, Bill Viola, Bernhard Wilhelm, MIA, David LaChapelle, Björk, Alexander McQueen, Goldfrapp, 50 Cent and The Game. But Blend is not just about big names; the magazine is also a platform for new creative talents of all shapes and sizes. It particularly focuses on upcoming designers, visual artists, creative misfits and musicians that are still underground or off-radar. By inviting them to become part of its creative network Blend often gives these new and up-and-coming talents the chance to create content, both 2-D and 3-D, for the print magazine and its digital site.

Blend magazine is a young, independent title founded by Jurriaan Bakker and first published in Amsterdam in November 2004. Contrary to standard practices of strict gender separation in the Dutch lifestyle magazine market, Blend is a magazine aimed at both sexes. Its readers are a growing and loyal crowd, ranging from young creatives, artists and early adapters, to young people with an honest and personal interest in new developments in the areas of fashion, lifestyle, art, music, media and design. Its concept, positioning and a selective choice of editorial subjects – both underground and 'upperground' – has also led to an increase in the number of mainstream subscribers who are learning to appreciate Blend magazine as an interesting and valuable alternative source.

Blend magazine does not restrict itself to the usual printed page and an Internet presence. In collaboration with the Dutch communication agency Container, the editorial team also develops different brand extensions, focusing on fashion, music, art and media. One such project is 60daysofspace, the first Dutch temporary store, which is open for just 60 days at a time in various city locations in the Netherlands. Under the heading: 'the best you never heard of', the store sells exclusive products that you cannot get anywhere else in the Netherlands. This guerrilla store concept is intended as a 3-D translation of Blend magazine. By offering a public stage to upcoming and known names in fashion and art, and by involving local artists, Blend magazine stages creative networks in real life and real space. After closing time, film nights, dance performances and product presentations are held in the spaces.

On a more commercial note, Blend and Container have also begun to develop concepts for advertising parties. Their first hit in this department was a kick ass laundrette service at the main Dutch music festival Lowlands for the jeans brand Wrangler.

don't you forget about me

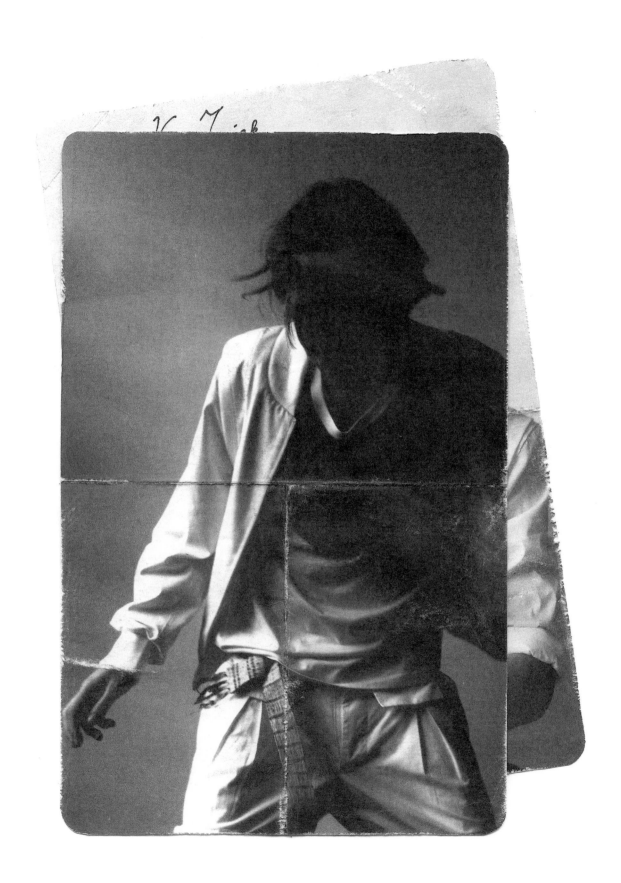

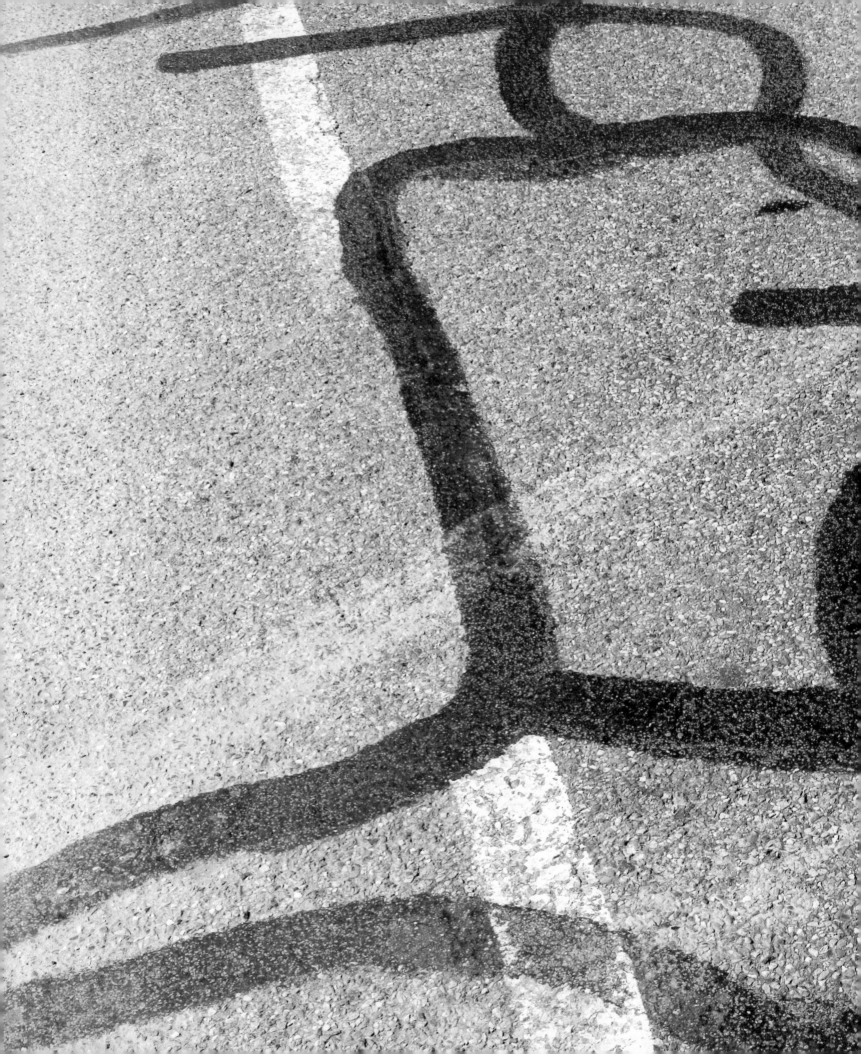

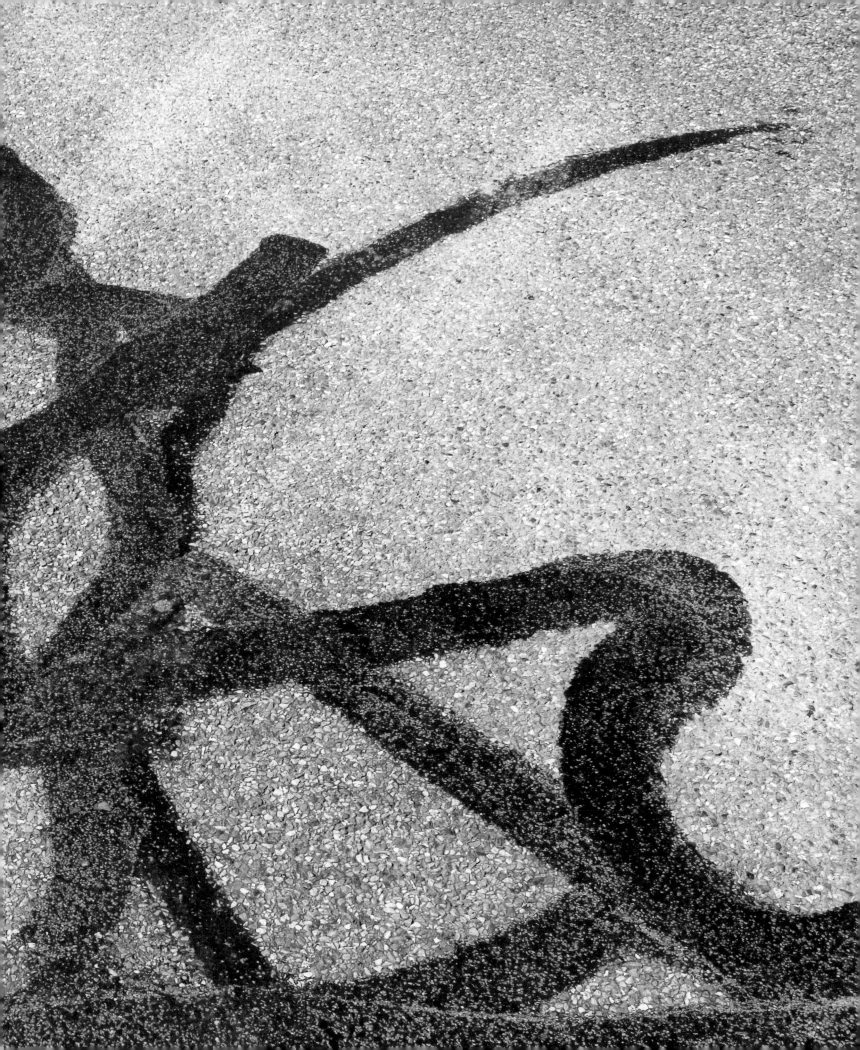

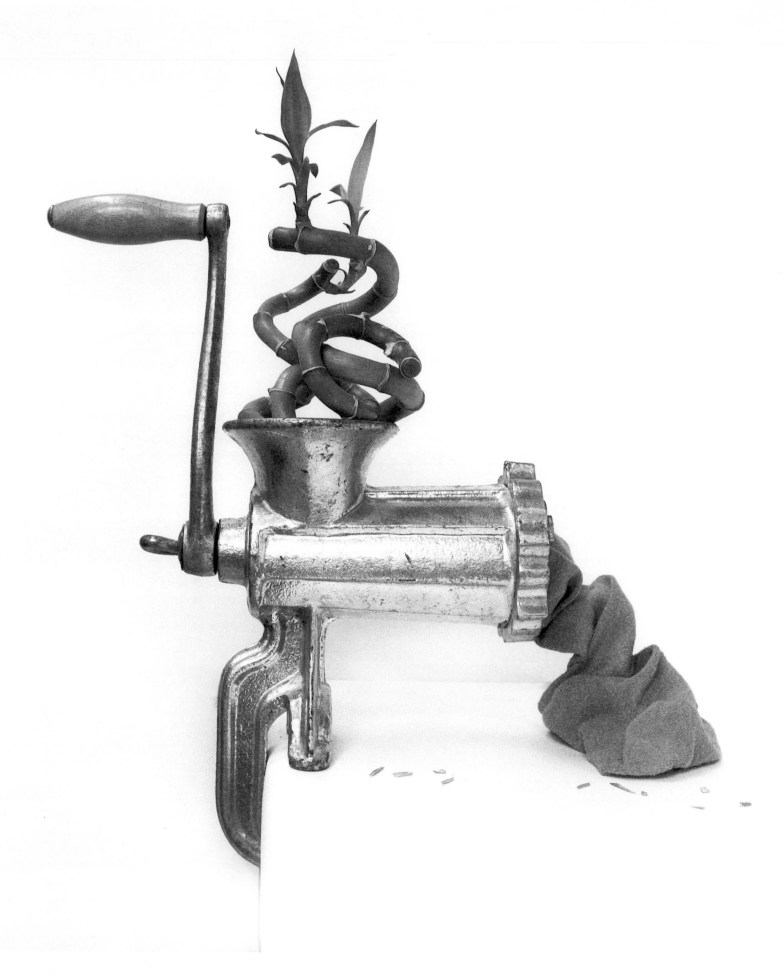

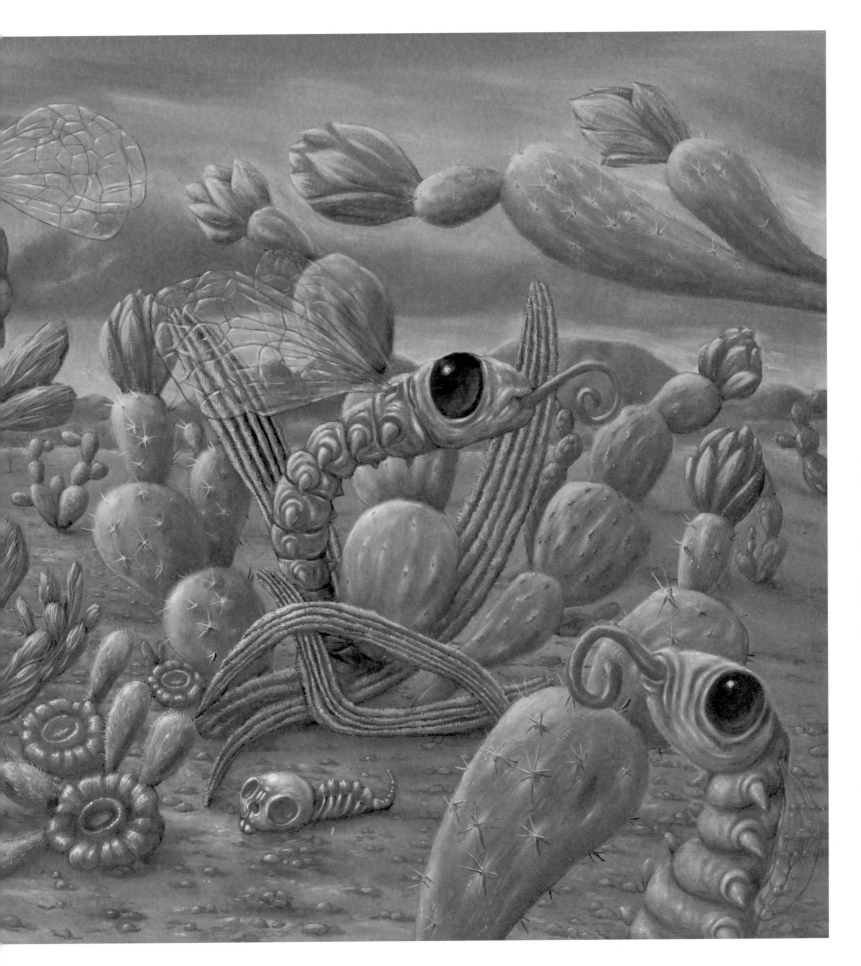

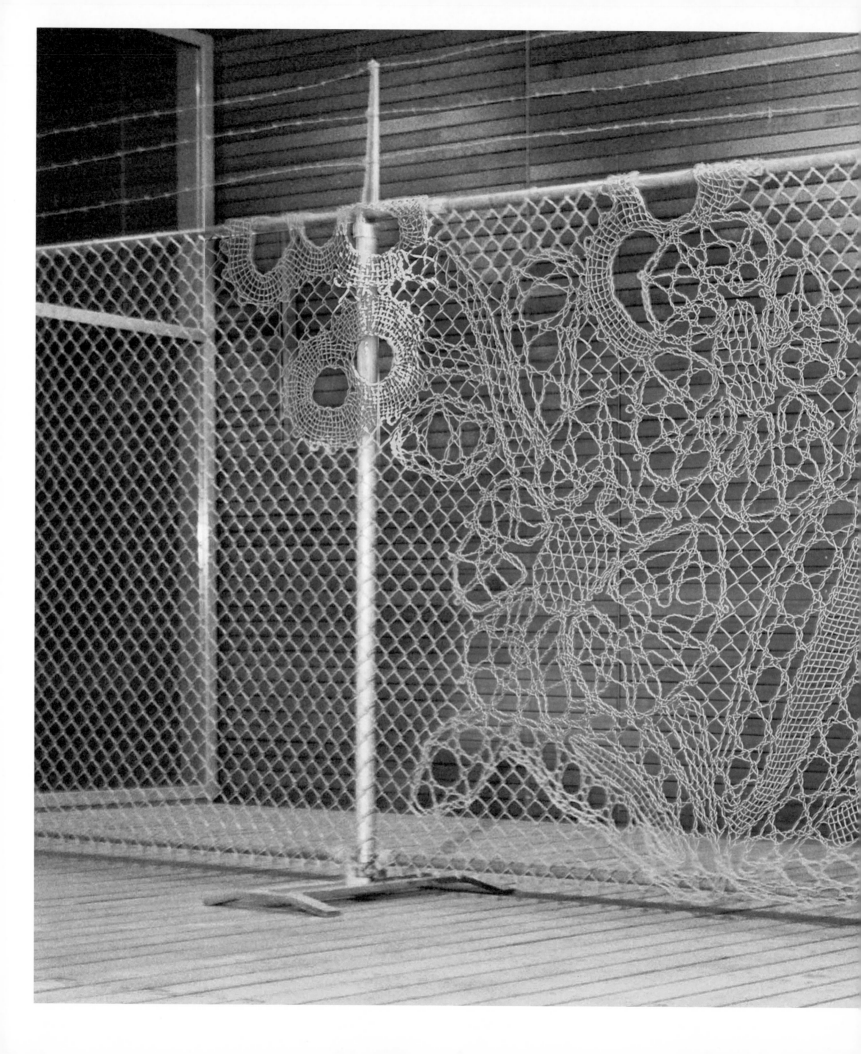

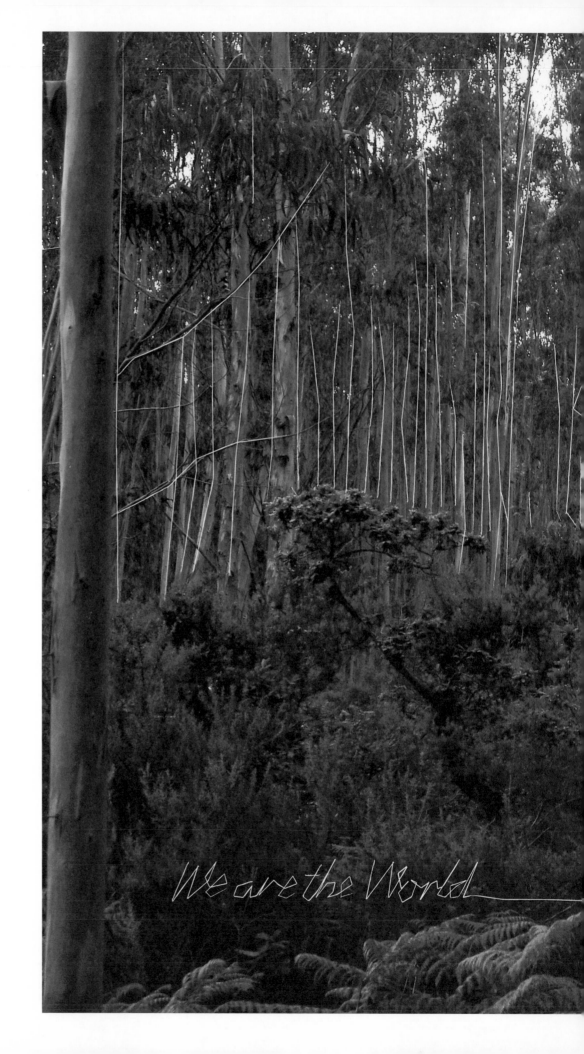

We are the World

This page
<u>WE ARE THE WORLD</u>
Joachim Baan, www.anothercompany.org
Graphic designer/Photographer, The Netherlands
© 2007 Joachim Baan

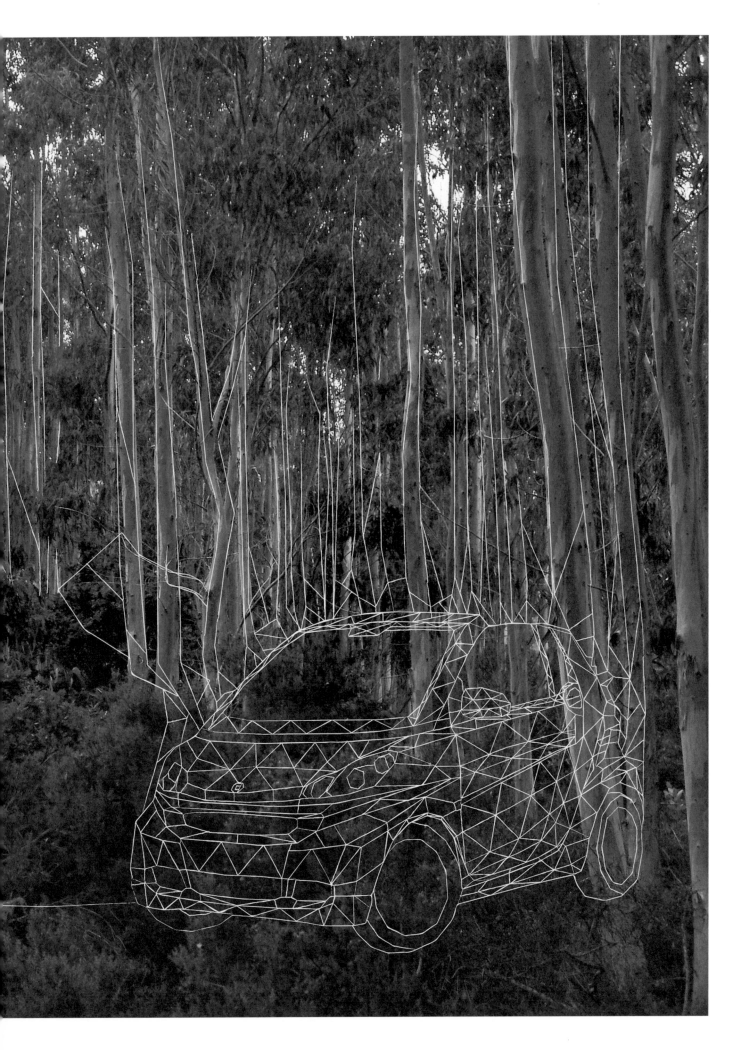

WAD

»ECOLOGY IS BECOMING A PRIORITY FOR EVERYBODY. IN FASHION, OUR PASSION, YOU CAN SEE THIS INCREASINGLY EACH SEASON, SO MUCH SO THAT IT'S NOW ALMOST A MUST. THE ONLY SHAME IS THAT THINGS HAVE CHANGED ONLY BECAUSE CONSUMERS BEGAN TO DEMAND IT. BETTER LATE THAN NEVER THOUGH, SO:

WAKE UP
ACT NOW
DON'T WAIT

DON'T WAIT
DO ACT
BE DIFFERENT.«

design and new shapes, but has also never been afraid of co-opting the past, as is the case with jeans, sports- and workwear.

WAD is urbanwear's spokesperson: it is the voice of this constantly evolving market's key labels, as well as a multitude of new ones (there are over 300!) that are demonstrating new dynamism and creativity (such as Andrea Crews, PHCY Industry and Superdry).

In 2006 WAD took Europe as a theme to show how all these urban European labels, and their market, have changed and matured. In 2007, WAD decided to expand its sweep by inviting guests to edit "their" issue. First up was with the Micelli family, well known in the luxury market, followed by Pedro Winter, the manager of Justice and Daft Punk, and Nadège Mezou, PR director of the Paris boutique Colette. The most recent guest editor was actress, supermodel and Karl Lagerfeld's favourite: Audrey Marnay.

Alongside the main issues, WAD has also published a series of supplements aimed at storeowners and buyers who want to access the kind of expert information that the magazine has been providing for the past 10 years.

WAD – We Are Different – is a leading magazine for urban fashion and culture, a mirror to your urban clothing identity. They say that clothes don't make a man (or woman), but they can define him (or her) and WAD is about revealing "cool-à-porter" clothes to passionate fashion consumers who know who they are.

Lovers of windsurfing, cars, interior design and design all have their own magazines, WAD is a magazine created specifically for lovers of everyday fashion-to-wear. Driven 50% by the label and 50% by the product, WAD traces for its readers the evolution and revolutions of this ever-growing urban market using text to explain the strategies of brands and designers, and images to show the latest fashions and trends.

Since the very first issue back in 1998 (which covered the "new basics"), WAD has adopted a different theme for each issue. The magazine explores how European fashion has grown and shaken up the world of fashion. Labels like G-Star and Elwood, Pepe Jeans, Gibson, Diesel, Replay, Sixty and Franklin & Marshall have all redefined what fashion means and how it functions. WAD has been there every step of the way as these labels have moved from plucky lightweight challengers to heavyweight champions.

The media has always talked about streetwear, but at WAD they prefer the term urbanwear because, they say: "these new trends were born in our cities". Right from the beginning, urban fashion has been defined by its modern use of graphic

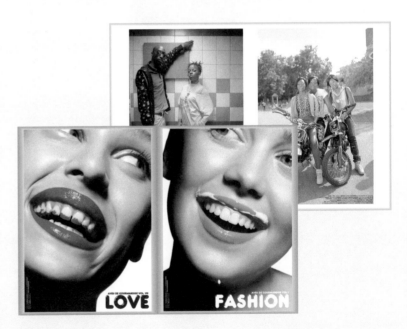

Beyond the print medium, WAD's reputation has also grown thanks to its WADKlub events in France and Europe, not to mention photography exhibitions held, its Paris headquarters, called the Local, which is located in an old printers' workshop. As of 2007 WAD also has a new-generation interactive website, exclusively dedicated to images.

Published in a fast-changing neighbourhood between the Gare du Nord and the Gare de l'Est in Paris, WAD has texts in both French and English and has a print run of 250,000 distributed worldwide.

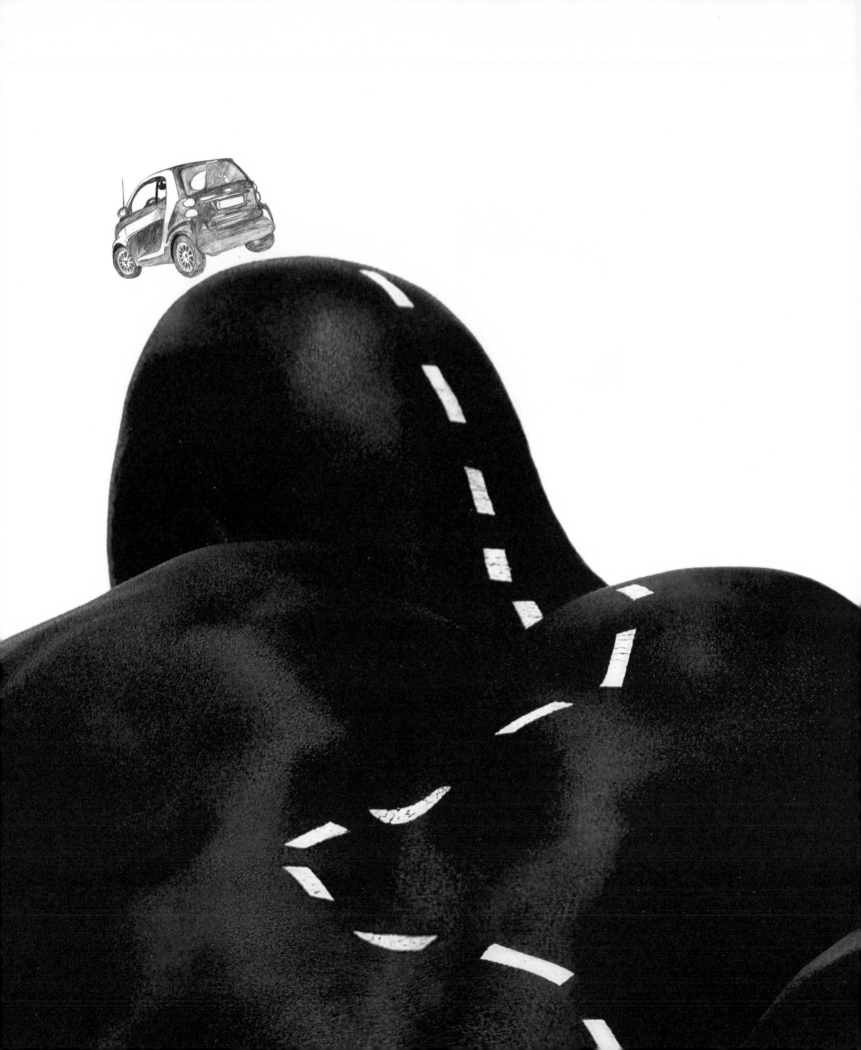

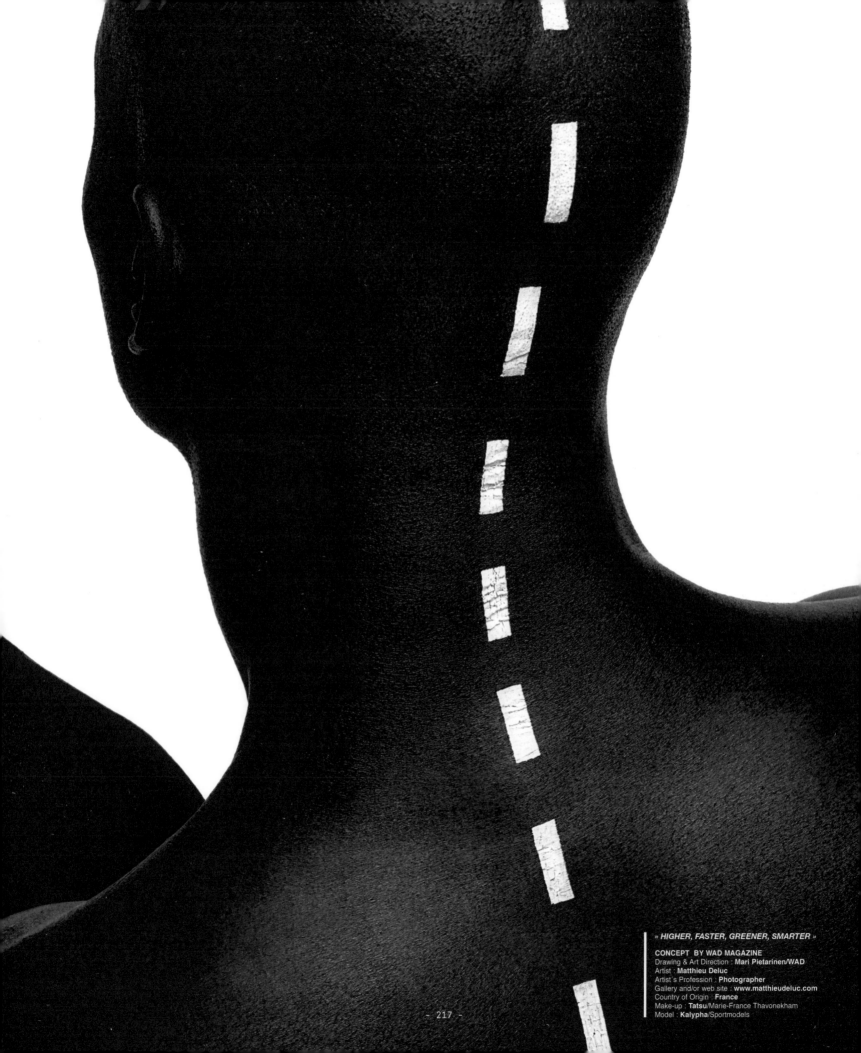

« *HIGHER, FASTER, GREENER, SMARTER* »

CONCEPT BY WAD MAGAZINE
Drawing & Art Direction : **Mari Pietarinen/WAD**
Artist : **Matthieu Deluc**
Artist's Profession : **Photographer**
Gallery and/or web site : **www.matthieudeluc.com**
Country of Origin : **France**
Make-up : **Tatsu**/Marie-France Thavonekham
Model : **Kalypha**/Sportmodels

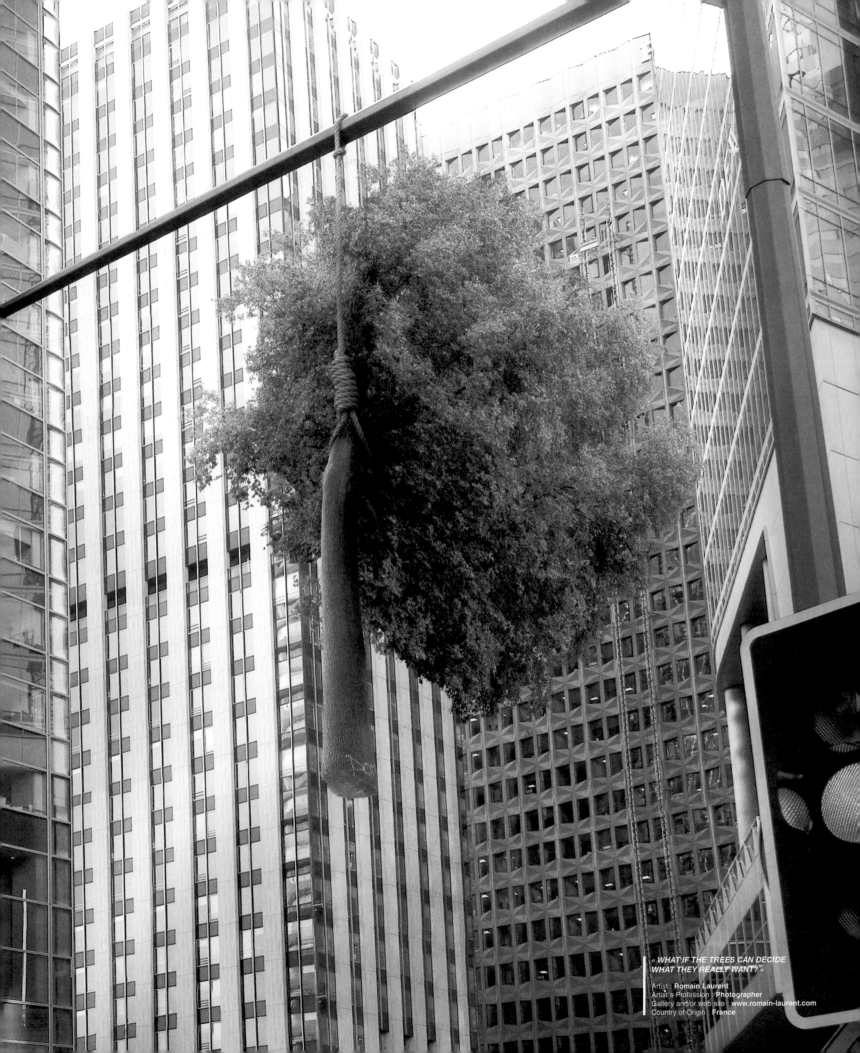

what would nature

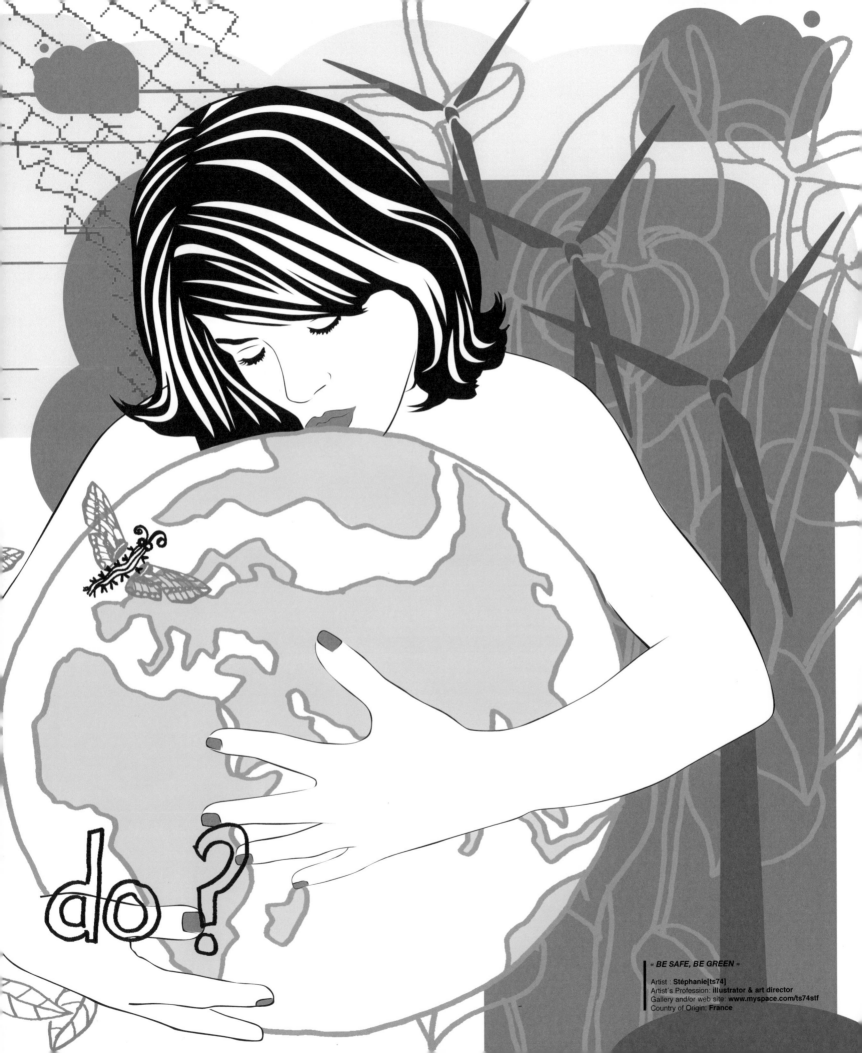

« BE SAFE, BE GREEN »

Artist : Stéphanie[ts74]
Artist´s Profession: illustrator & art director
Gallery and/or web site: www.myspace.com/ts74stf
Country of Origin: France

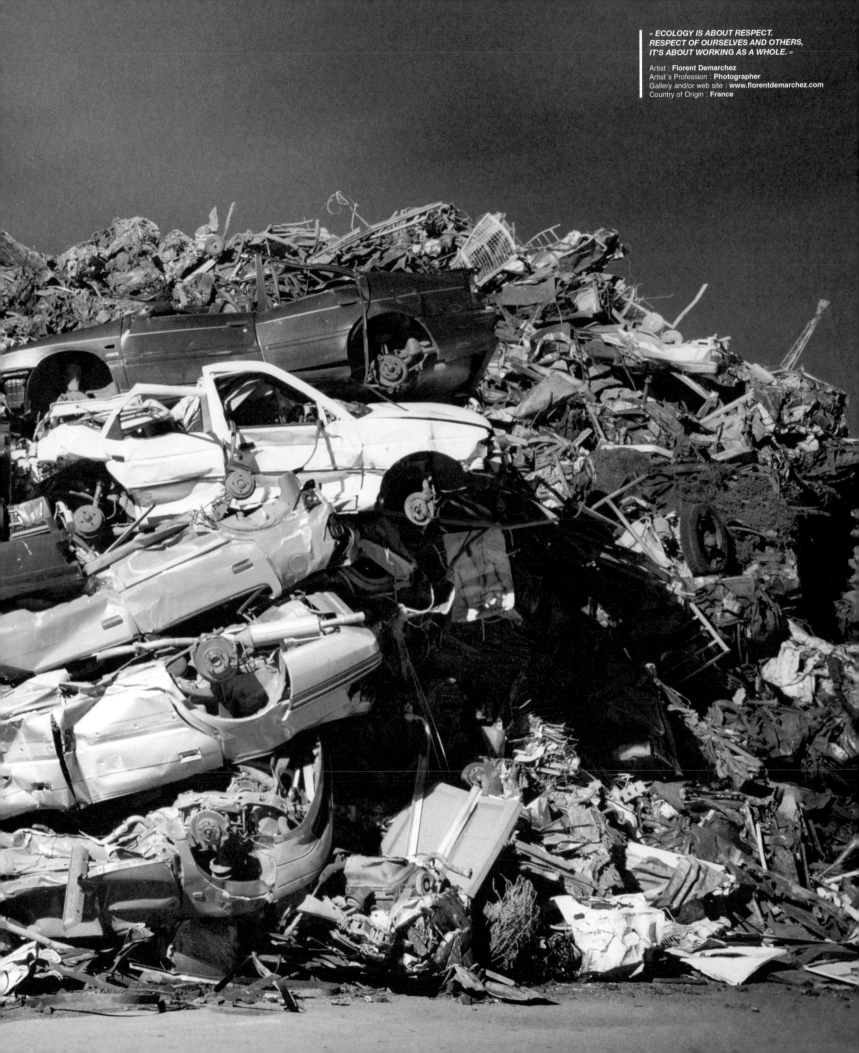

« ECOLOGY IS ABOUT RESPECT.
RESPECT OF OURSELVES AND OTHERS,
IT'S ABOUT WORKING AS A WHOLE. »

Artist : **Florent Demarchez**
Artist´s Profession : **Photographer**
Gallery and/or web site : **www.florentdemarchez.com**
Country of Origin : **France**

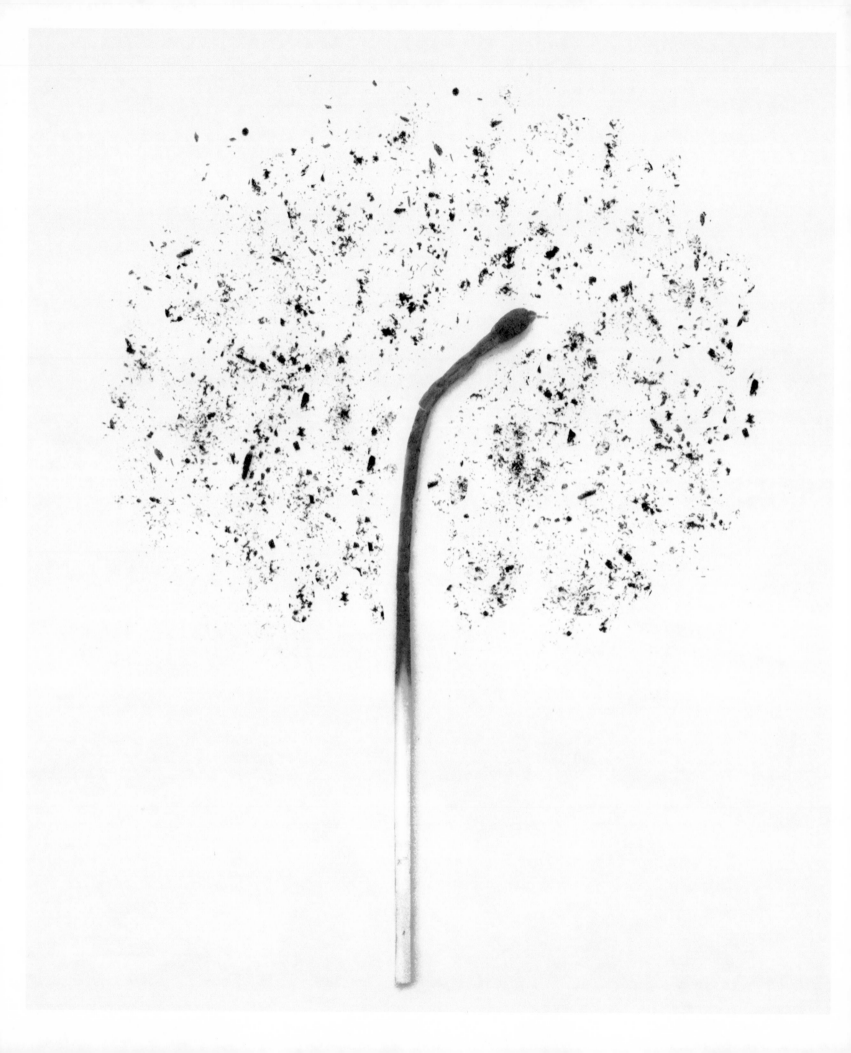

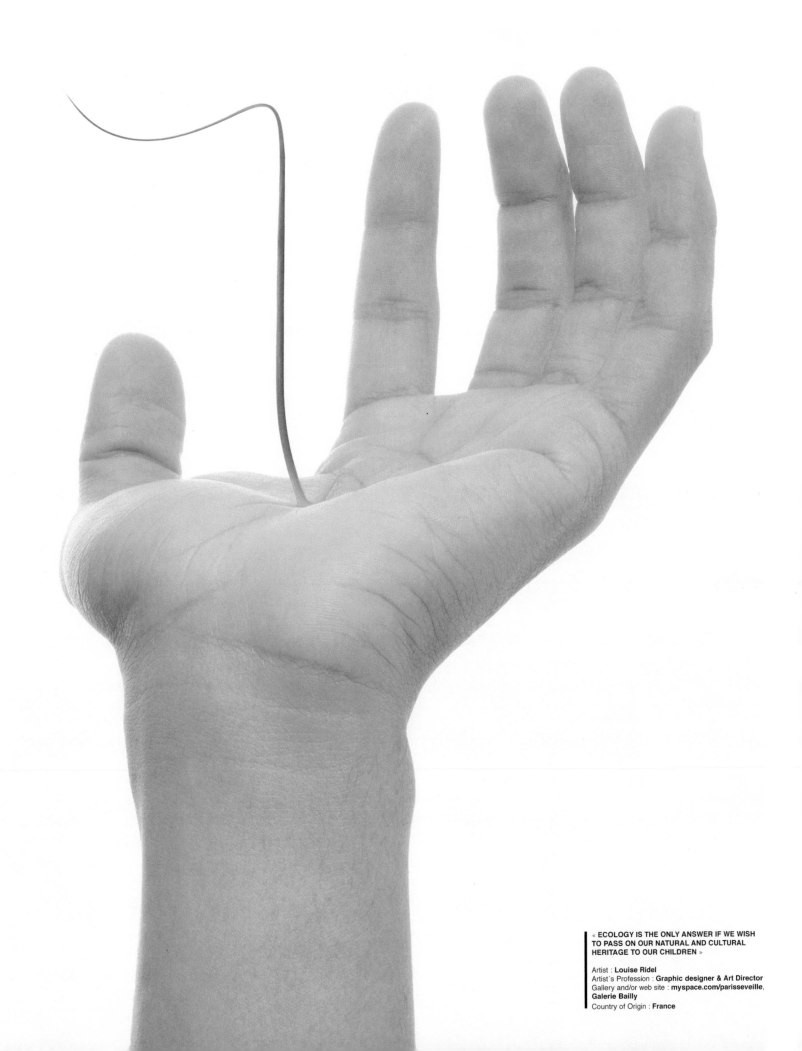

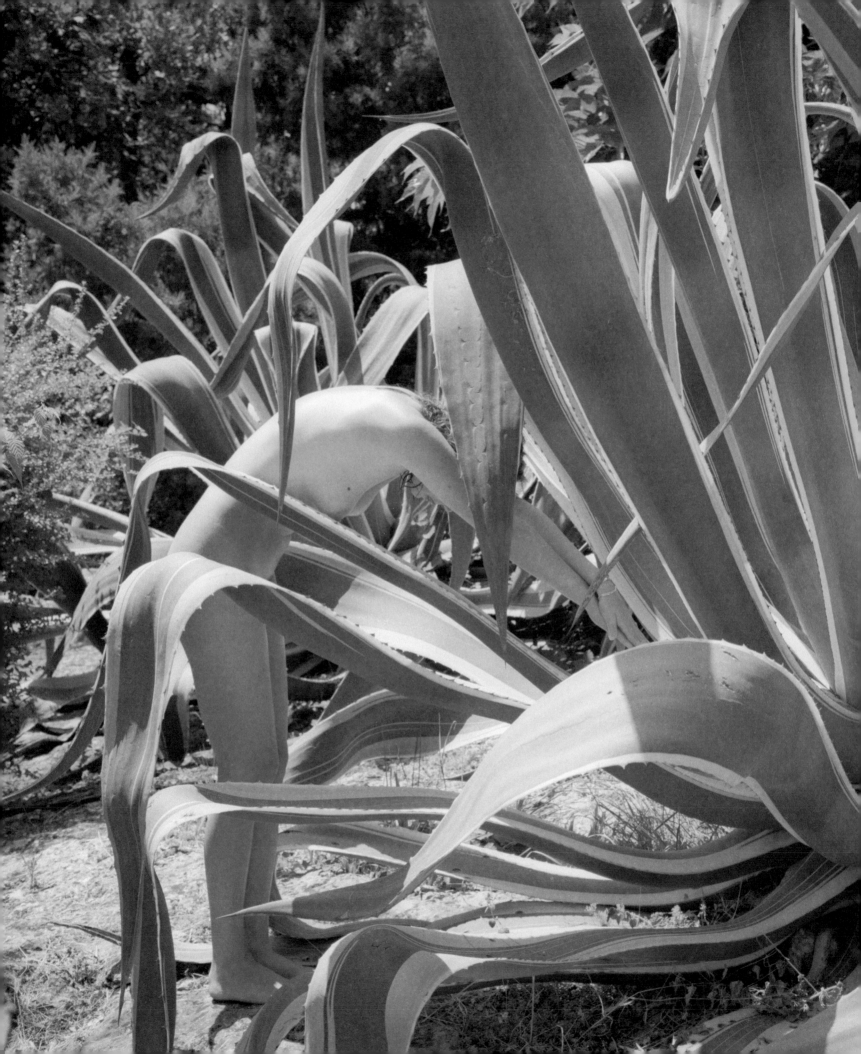

227

« *HUMAN NATURE* »

Artist :**Veronique July**
Artist's profession : **photographer**
Gallery and/or web site : **www.veroniquejuly.com**
Country of Origin : **France**

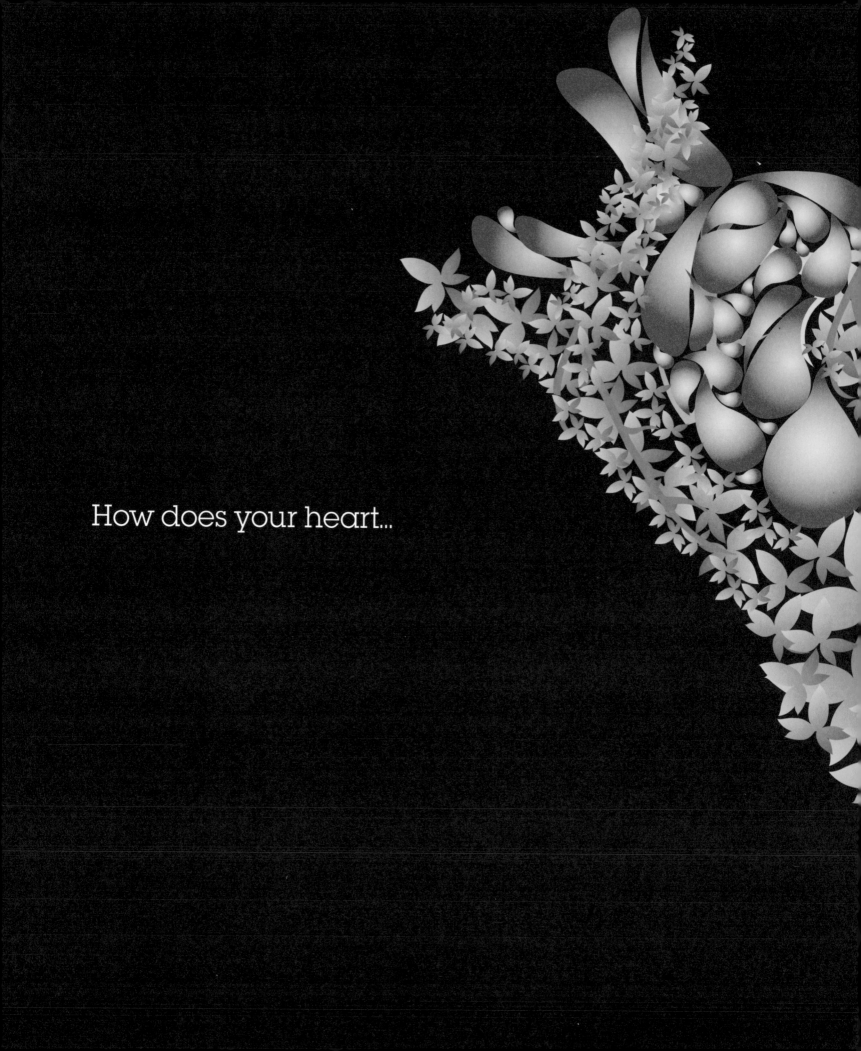

How does your heart...

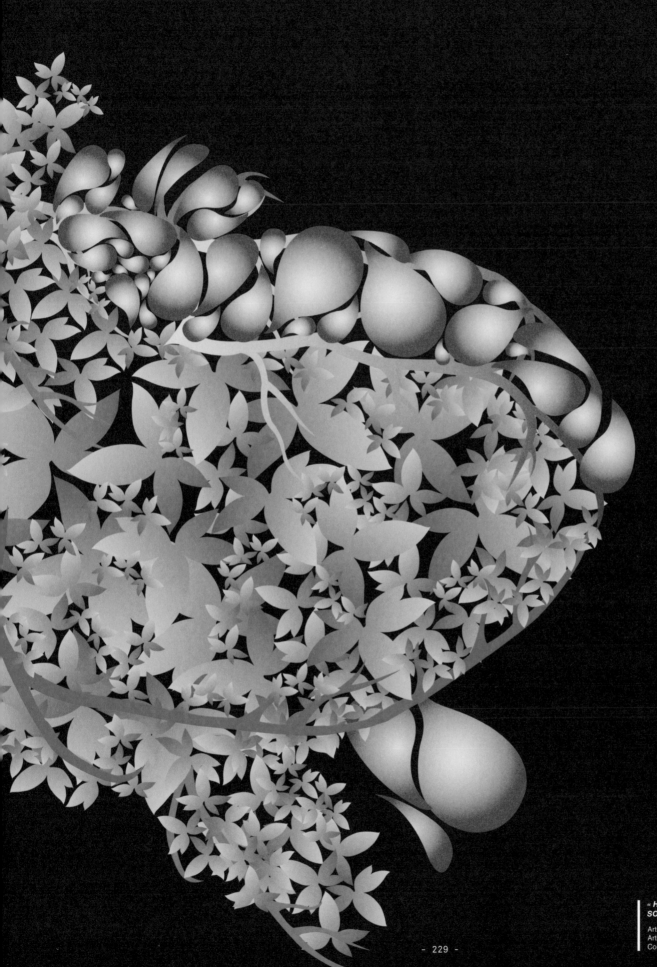

...beat ?

« HUMAN RACE LIVES AND DIES WITH THE NATURE.
SO, WATCH OUT! »

Artist : **Mari Pietarinen**
Artist's profession : **Graphic designer & Art Director**
Country of Origin : **Finland**

« RIDE A BIKE, BECAUSE NO PAIN NO GAIN »

Artist : **Philippe Gueguen**
Artist's profession : **Photographer**
Gallery and/or web site : **www.phom.fr**
Country of Origin : **France**

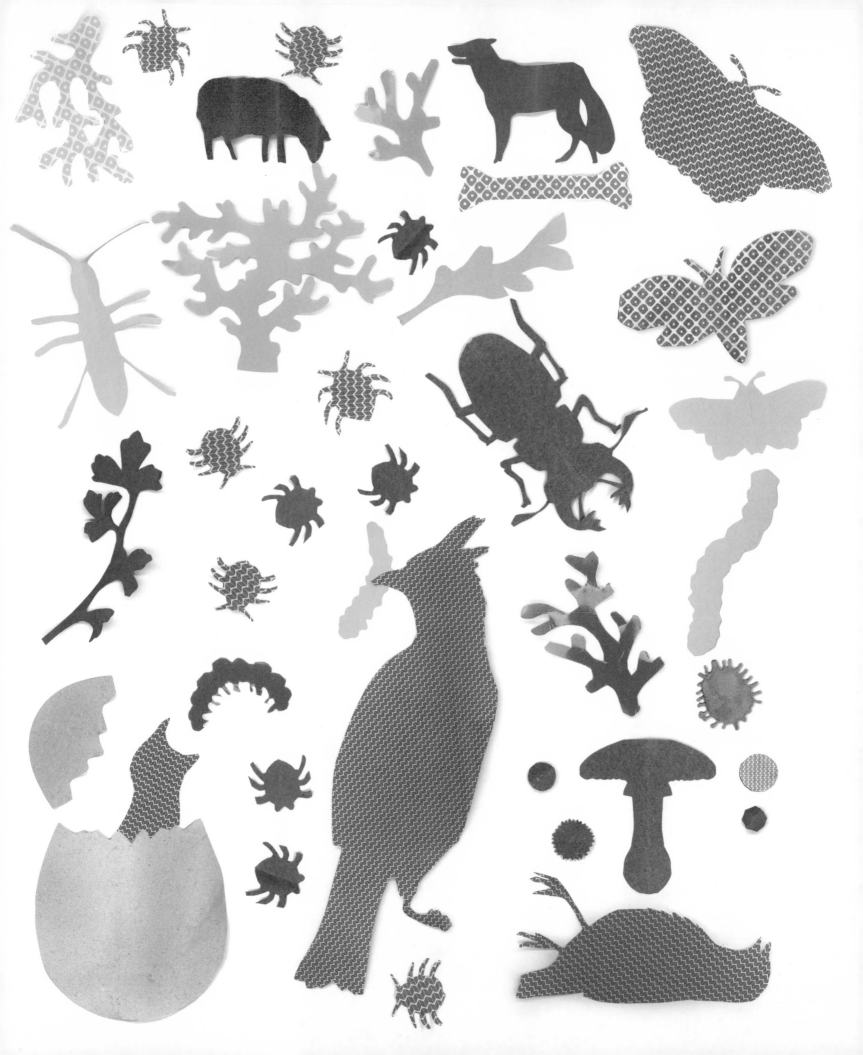

« *ECOLOGY IS MORE THAN SEPARATING THE WASTE AND BUYING ORGANIC YOGURT ONCE IN A WHILE.* »

Artist : **Silja Goetz**
Artist's profession : **Illustrator**
Gallery and/or web site : **www.siljagoetz.com**
Country of Origin : **Germany**

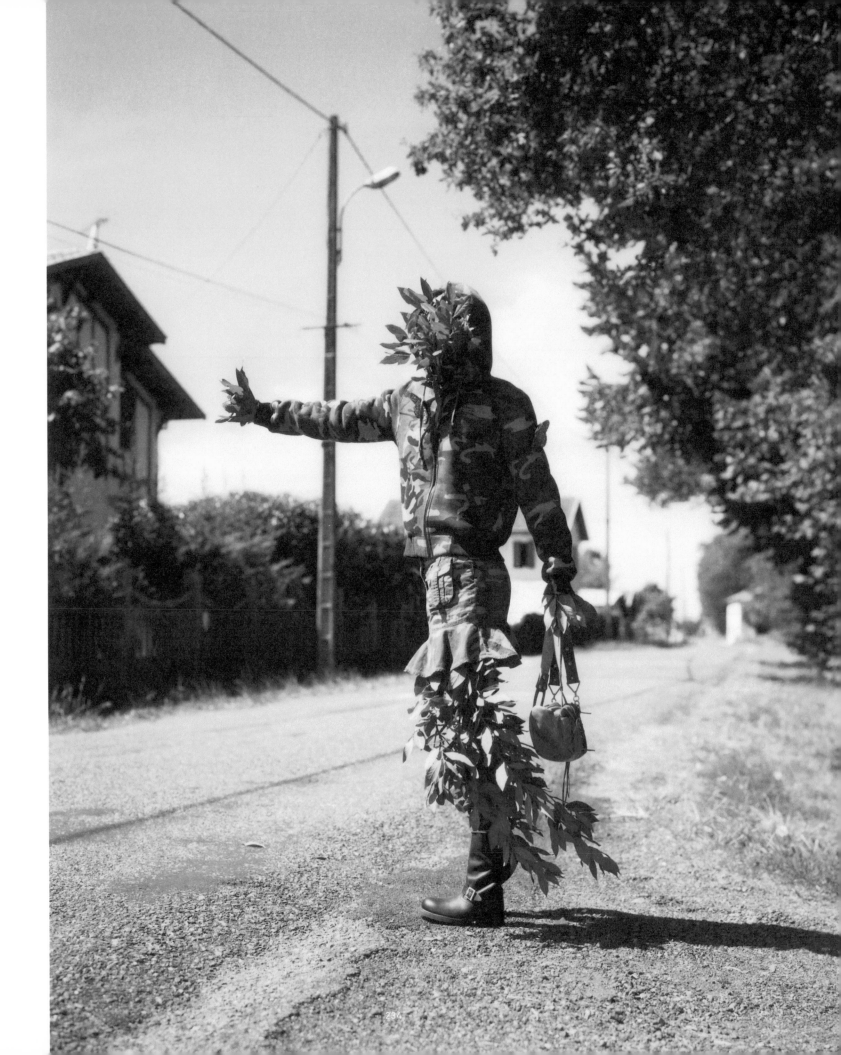

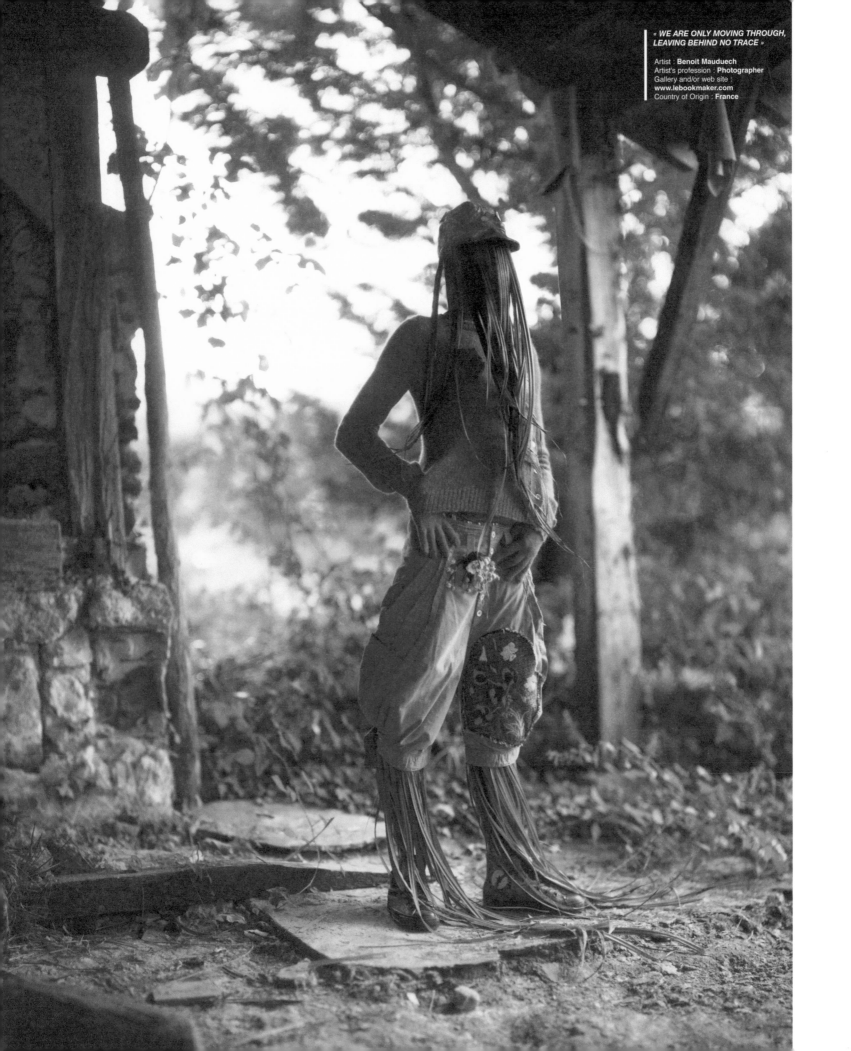

« *WE ARE ONLY MOVING THROUGH,*
LEAVING BEHIND NO TRACE »

Artist : **Benoit Mauduech**
Artist's profession : **Photographer**
Gallery and/or web site :
www.lebookmaker.com
Country of Origin : **France**

« ALL MEMBERS OF VASAVA ARE TOTALLY AGAINST ANY VIOLENCE TOWARDS OUR WORLD. WE ALL HAVE THE RIGHT TO LIVE HERE. STOP SELF-EXTERMINATION. »

Artist : **Vasava**
Artist´s Profession : **Creative Graphic Design Agency**
Gallery and/or web site : **www.vasava.es**
Country of Origin : **Spain**

SMARTLY NATURAL.

Artist Index

Imprint

www.smart.com

Edited by Christoph Kamps and Sophie Lovell
Cover & Design by Christian Schneider, Lisa Rienermann and Mario Lombardo
Proofreading by Sophie Lovell
Production management by Janni Milstrey for dgv
Printed by Offsetdruckerei Grammlich, Pliezhausen

Thanks to Lüder Fromm, Dominik Greuel and Peter Courtin from smart,
Tjorven Vahldieck, Stefanie Hennecke for project management at k-mb.de
and all creatives and artists who have participated in the project.

Special thanks to the international style magazines +81, Baby, Blend,
Dazed&Confused, Drome, INDIE, Neo2, NO Magazine, Style 100, TOKION and WAD.

Mixed Sources
Product group from well-managed
forests, controlled sources and
recycled wood or fiber
www.fsc.org Cert no. IMO-COC-028001
© 1996 Forest Stewardship Council

This book was printed according to the internationally accepted FSC
standard for environmental protection. The FSC logo identifies products
which contain wood from well managed forests certified in accordance
with the rules of the Forest Stewardship Council.

Published by Die Gestalten Verlag, Berlin 2008
ISBN: 978-3-89955-215-7

Bibliographic information published by the Deutsche Nationalbibliothek.
The Deutsche Nationalbibliothek lists this publication in the Deutsche
Nationalbibliografie; detailed bibliographic data is available on the
Internet at http://dnb.d-nb.de.

For more information please check: www.die-gestalten.de

Respect copyright, encourage creativity!